W9-DJB-662

# The Creative Photographer

# The Creative Photographer

**Revised Edition**

## by Andreas Feininger

Prentice-Hall, Inc., Englewood Cliffs, N.J.

*The Creative Photographer*, Revised Edition, by Andreas Feininger
Copyright © 1955, 1975 by Andreas Feininger

All rights reserved. No part of this book may be
reproduced in any form or by any means, except
for the inclusion of brief quotations in a review,
without permission in writing from the publisher.

Printed in the United States of America

Prentice-Hall International, Inc., London
Prentice-Hall of Australia, Pty. Ltd., Sydney
Prentice-Hall of Canada, Ltd., Toronto
Prentice-Hall of India Private Ltd., New Delhi
Prentice-Hall of Japan, Inc., Tokyo

Second Printing. . . . . . . . . May. 1975

Library of Congress Cataloging in Publication Data

Feininger, Andreas.
  The creative photographer.

  1. Photography.  I.  Title.
TR145.F395  1975          770          84-13922
ISBN 0-13-190611-9

# Contents

5

To avoid disappointment or misunderstanding:

**This is not a textbook for beginners.**

Rather, it is a philosophy of photography, a reflective analysis based upon the personal experiences and viewpoints of an occasionally opinionated photographer who expects to be criticized on certain points.

It was written from honest conviction in an attempt to make available, to anyone who cares to take the trouble to follow the author through the coming chapters, the results of some forty years of almost daily contact with photographic problems.

It is addressed to those photographers who are dissatisfied with the impact of their work which, although technically unassailable, is unexciting and conventional. It is hoped that the viewpoints and potentialities explored in the following chapters will help such readers to transform their knowledge into performance.

*Andreas Feininger*

# PURPOSE AND ORGANIZATION
# OF THIS BOOK

*The Creative Photographer* is the concluding volume in a series of three. The first, *Successful Photography*, deals with the technique of black-and-white photography. The second, *The Color Photo Book,* deals with the technique of color. Together, these two texts provide the basis for this book, which attempts to analyze and evaluate the scope and potentialities of photography as a medium of visual expression and communication.

**Unlike the first and second volumes, which are specifically addressed to the practicing photographer, this book is addressed to anyone who works with photographs—photographer, editor, art director, layout man—anyone who looks at pictures with more than cursory interest.**

It is axiomatic that any good, that is, effective, photograph is a combination of technical and artistic ability. It is evident, however, that technical competence is found more commonly than the ability to use such competence to create photographs which are satisfactory artistically. The first objective of this book is therefore to show technically adept photographers how to use their skills to produce meaningful photographs in which photo-technical perfection and artistic values combine to increase the power of the picture.

The second objective is to present to the reader observations and conclusions—the outgrowth of some forty years of experience and experimenting with photography—which I hope will stimulate him and be of use in the furtherance of his work. I realize that some of the concepts and views expressed are highly personal and may even contradict accepted theories and procedures. But I believe that if divergence from traditional standards is caused by a re-evaluation of these standards in the light of valid experience, then such divergence is not mere rebellion but growth. Growth is equivalent to progress, and progress has never been furthered by those

who make a fetish of tradition and stubbornly cling to the *status quo*. The first requisite for progress is change; more specifically: new ideas, improvement of old methods and development of new ones, deliberate and planned violation of academic rules. It is in this spirit that I offer my views, hoping that they may be accepted as contributions to the growth of modern photography.

*The Creative Photographer* is organized as follows:

**Part 1: An Approach to Photography.** What are the aims of photography? What is its scope? What can and should we expect from our pictures? What is typically photographic? Is there a formula for classifying photographs as good, bad, or indifferent? Can photographs have artistic values; and if so, do such qualities contribute to the impact of the picture?

These are some of the questions which I shall attempt to answer because I believe that it is the attitude of the photographer toward his medium which determines whether his photographs will fail or succeed.

**Part 2: The Subject.** The subject is the reason for making a photograph. Consequently, it is the most important picture component. All other factors which contribute to the effect of a photograph—style, technique of execution, composition—are subordinate in determining the significance and value of the picture. In this chapter, the subject is analyzed with regard to photogenic and unphotogenic qualities and is classified in various categories. Each of these is subsequently studied to determine the most suitable approach and means of treatment.

**Part 3: The Photographer.** A photograph evolves from the selection of the subject and the way the photographer approaches and handles it. The subject is the given element, the approach and handling are the variables. These variables are what makes the same subject, photographed by different photographers, appear either effective and significant or meaningless and dull. Effective photographs are not accidental. They are created by the personality, attitude, approach, imagination, and resourcefulness of a

photographer, plus a great deal of hard work and a touch of luck. In this chapter, those qualities will be discussed which, in my opinion, a photographer must have in order to become "good."

**Part 4: The Picture.** The picture is a means to an end—communication with people—not an end in itself. Pictures should be seen, not buried in files. However, no one is interested in a photograph unless it has something to say. It must have content, be informative, educational, entertaining, or convey feeling or mood. But content alone is not enough. Unless it is presented in a clearly understandable form, its meaning is lost, and the photograph is valueless. Thus, effective subject presentation becomes as important to the picture as content. Part 4 is devoted to an exploration of these factors.

**Part 5: The Picture Story.** The picture story is the synthesis of pictures and words, each complementing the other, united by a central idea and presented with feeling and imagination. It combines the efforts of editor, photographer, reporter, writer, and layout man. It is the result of teamwork by a group of people whose opinions, interests, and requirements should, but do not always, coincide. Discussion of the various factors that make or break a picture story is the subject of Part 5.

**A note of caution.** This book is not a collection of rules which automatically lead to the production of good photographs. Such a book does not exist. Furthermore, even if it could be written, its practical value would be questionable. For the creative mind abhors the restriction of rules, and the inartistic person is incapable of applying creative principles. But these are extremes. Most people are talented to some degree. Such talent, latent and therefore unrecognized, can be aroused and developed by stimulating example.

The purpose of this book is to acquaint the reader with the fabulous potentialities of photography; to induce him to perform experiments of his own; to awaken his interest and provide stimulation through discussion of the various aspects of, and controversies which surround, a subject to which we are both devoted.

# 1

## An Approach to Photography

### PHOTOGRAPHY IS PICTURE LANGUAGE

Picture language is the oldest form of graphic communication known to man. The prehistoric cave paintings of Altamira and Lascaux are a form of picture language. Thirty centuries before the birth of Christ, Egyptian priests developed another in the form of hieroglyphs. The Mayas of Yucatan invented a third. Modern alphabets are merely stylizations and abstractions derived from some earlier form of picture language.

And the latest, most perfect form of picture language is photography.

In contrast to the spoken and written word, a picture can be understood anywhere in the world. It can bridge the chasm created by differences of language and alphabet. It is a means for universal communication. And never before has there been a greater need for a universal language.

Without a universal language, universal understanding among peoples is impossible. And without such understanding, nations may eventually destroy one another as a result of ignorance and fear. We hate and fear and ridicule most those things about which we know the least. Knowledge leads to understanding, and understanding creates tolerance and sympathy. In

**15**

the "good old days," before advances in science and technology enabled man to traverse in a matter of hours distances that previously required months, misunderstandings among peoples and the resulting tragic consequences were more or less confined to limited areas. Today, in the age of thermonuclear weapons and intercontinental missiles, the consequences of such misunderstandings could conceivably assume cataclysmic proportions. Intelligently used, the picture language of photography can play a small but vital role in promoting universal understanding and averting global disaster.

In addition to being widely understood, a photograph is less equivocal than words. Words are used more and more to distort meaning, to promulgate half-truths, to create propaganda both at home and abroad. Words are also used—with less pernicious effect—in the course of everyday business to make exaggerated or fraudulent claims in advertising; ordinary, run-of-the-mill automobiles are labeled *special, super, custom,* or *de luxe;* inferior types of cameras and microscopes are advertised as *precision-made;* every food market built and run according to elementary sanitary standards is a *supermarket;* every manufacturer claims that his product is *the best;* every advertiser urges you to *buy now and save!*

It is no wonder that people have become distrustful of words. Of course, photographs can also be vehicles of misrepresentation. But such misrepresentation is more difficult to perpetrate and easier to spot than that existing in the spoken or printed word. Since what we see creates a stronger impression than what we hear or read about, such impressions are more easily retained. In reading as well as listening, a certain mental effort is required to translate the abstractions of letter and sound into the images which they represent. Unlike the printed word couched in abstract symbols, the photograph is a direct, visual representation of a subject or event and does not, in this sense, have to be interpreted by the brain.

As a result, the impact of a photograph is more direct, and its content less subject to misunderstanding. Words and phrases can be ambiguous, meaning one thing to one person, something else to another, nothing at all to a

third. But the picture language of photography, less abstract and consequently easier to understand than words, goes directly to the heart.

For example, the impact of the picture of a starving child is stronger than a verbal description of a famine. On reading or hearing about a famine, one might think that it is either a "sob story" or propaganda and conclude that the condition is probably not as bad as it sounds. But seeing the photograph of the starving child forces one to face the fact of famine and feel compassion. Such a picture must make every thinking person realize that, regardless of race or creed, starvation is human suffering and that, when neglected or hurt, all people are as much in need of help and understanding as you or I.

In the daily routine of life, people come in contact with pictures more and more—in magazines, newspapers, Sunday supplements, advertisements, movies, television. Increasingly, the written word is being replaced by picture language. The popularity of the comic strip and the cartoon grows, while the ability to spell correctly declines. Visual education is becoming an increasingly important technique: film strips and educational movies in schools, illustrated instruction manuals, the step-by-step sequence of how-to-do-it photographs. The machine-age invention of the machine-made picture, supplemented by the invention of the process of photo-mechanical reproduction (photo-duplicating) for unlimited inexpensive distribution, has set off a revolution as consequential as that which began with the invention of movable type.

It is primarily up to us photographers to satisfy this ever-expanding demand for pictures. To do this effectively, we must be aware of the implications of our work.

# AN APPROACH TO PHOTOGRAPHY

A negative can be compared to a die: just as thousands of identical objects can be produced from a single die, so, too, thousands of identical pictures can be made from a single negative. For example, any photograph that was used in *Life* was reproduced more than five million times and seen by more than fifty million people. In bygone days, when objects were made one at a time by hand, an occasional error was relatively inconsequential since only one item was involved. A die maker's mistake, however, can be very serious if passed unnoticed as it will affect many thousand items. In this sense, an ambiguous photograph, or one which gives a wrong impression, may be compared to a defective die in that, when reproduced, its faults are repeated in each reproduction. As a result, those who see it may form erroneous opinions of the subject or event which it depicts. And if the subject is important, the consequences may be serious.

Anyone who is aware of this will approach photography with a definite feeling of responsibility. Having worked for twenty years as a staff photographer for *Life,* the picture forum which had the largest audience in the world, I am highly aware of this responsibility, which has influenced my whole attitude toward photography. Because I believe that my experience may be of value to the reader, I will try to set it down in the following pages.

As far as I am concerned, photography is inextricably linked to life, and any photograph worth looking at twice is a reflection of life, of reality, of nature, of people, of the work of man, from art to war. Photography has contributed enormously to our common wealth of knowledge and experience, and every photographer is a potential contributor. The urge to contribute is one root of the creative drive which exists to a greater or lesser extent in everyone. We all know the desire to do something worthwhile, something that lifts us out of our everyday anonymity, something by which

we might be remembered and thus achieve a kind of immortality. The scale on which we work is immaterial, and so is the field in which we make our contribution, each contributing to the best of his ability. Civilization is built upon such foundation. We all learn from one another and from the heritage left by those who preceded us: knowledge, teachings, art, philosophies. Without the creative spirit of those who gave us this, we would still be living in caves, each laboriously making his own small discoveries, each starting anew. No aware person can fail to acknowledge the enormous debt he owes to those from whom he has learned. The only way he can repay this debt is to preserve the continuity and add his own contribution to the common fund. As a photographer to whom chance has given unusual opportunities, deeply aware of the degree to which my own success is built upon the struggles, experience, and work of others, I write this book in payment of my debt.

I see photography as one of the most important and beneficial discoveries ever made by man. But its application, in certain respects, has often failed in scope. A photograph must measure up to certain standards, and it seems to me that these standards are completely met by only a few photographers with exceptional awareness and training. The reason seems to be, not the inability of the majority to technically utilize the enormous potentialities of their medium, but a lack of awareness of what can be achieved through its use. I feel sure that with stimulating guidance many of these photographers would be able to produce pictures that are immensely superior to those which they now turn out.

My own approach to any photograph I take is based upon the following premises:

At present, photography, whether in the form of paper prints, color slides, motion pictures, or television broadcasts, is the only practical means for universal communication. Consequently, the more universal the appeal of a photograph, the greater its value.

No intelligent person would think of using language in speech or writing unless he felt he had something to communicate that might be of interest to

others. However, the majority of photographs made not only by amateurs, but also by many professionals, are devoid of viewer interest. They are equivalent to empty prattle.

Photography is picture language, but language is used only if one has something to say, something that is worth saying, something which makes sense.

Before I take a photograph I consider the following: Why do I want to take this picture? Will it be of interest to those who will eventually see it? Someone once described photography as "seeing for keeps." I always ask myself: Is the subject or event which I am about to photograph worth keeping?

Ideas and intentions are important, but even the best of these are wasted unless effectively expressed in picture form. The facility to express oneself clearly is as important in picture language as it is in writing. Mastery of the symbols of one's medium is essential to success. The symbols of the writer are words, carefully selected with regard to meaning, descriptive power, rhythm, sound. The symbols of the photographer are light, perspective, contrast, color, gray shade, sharpness, blur—to mention only the most important ones. The fact that these symbols are recorded in one form or another each time a photograph is taken does not guarantee that they appear in their most effective form. As a writer searching for the most descriptive word has many synonyms from which to choose, so a photographer has at his disposal a variety of symbols, each available in many different degrees, from which to select the one which will best express a specific idea. However, bound by a traditional approach to photography, lack of technical know-how, or inability to precisely define their aim, many photographers forego selection, leaving the result to chance and luck.

The foregoing summary contains what in essence may be called my personal philosophy of photography. Although subdivided here for clarity, its subdivisions are arbitrary. Actually, each is an integral part of the same idea. For practical purposes, this could also be called an *approach to a planned photograph* and formulated as follows:

**20**

## Interest

I am convinced that only genuine interest in a subject (whatever that subject may be) can stimulate a photographer to produce inspired work. There are, of course, other motivations for taking pictures: the need to make a living; assignments from an editor; a client to satisfy; the compulsion to imitate —consciously or unconsciously—a photograph which someone else has executed successfully before. But whatever the reason, the entire process of picture-making sinks to the uninspired level of mechanical routine unless sparked by genuine interest in the subject. Because interest is the energizing factor, it is the basis of every form of creative work.

## Knowledge and understanding

Interest promotes a desire to know more about one's subject and to search for pertinent facts concerning it. Without the knowledge which leads to an understanding of the subject, one cannot create interpretive and meaningful photographs. What is typical of the subject, what is superfluous, what must be emphasized, and what suppressed? In the interest of greatest clarity, these questions must be framed and answered by the photographer himself, whether he intends to photograph a person or has been assigned to cover a war. As an example, let us consider portraiture: Which aspects of a particular face constitute its interest or characteristics? Is it the structure of the underlying bone? The lines and planes of the face? The momentary expression? Is it a physical or some inherent, spiritual quality? What does the surface reflect: a happy, carefree disposition; a searching, thinking intellect; or a dull and sluggish mind? What meaning is traced in the lines from nose to mouth, the wrinkles around the eyes? What caused them? Of what do they speak to a sympathetic observer? Under the etching knife and pencil of a thoughtless photographer the whole life story documented in these lines and wrinkles can be erased. It takes an interested, understanding person to read such signs and interpret them in the form of a sensitively conceived photograph.

## Opinion and conclusion

Knowledge and understanding of a subject provide the basis for a personal opinion. Although a photograph is produced by mechanical means, selection, application, and the use of these means are subject to the photographer's will. And since no two photographers see, think, feel, and react exactly alike, pictures of the same subject taken by different photographers must therefore be different (except, of course, for astronomical, ballistic, and other photographs taken with more or less automatic equipment). Thus, a photograph can rarely be truly objective. Normally, it will reflect, to a greater or lesser degree, the personality and opinions of the photographer who created it. Far from being a disadvantage, this subjectivity can become a priceless asset. Although there are many instances in which objectivity is desirable—notably in the fields of science, medicine, and technology—this is not the case in creative photography, with which we are primarily concerned in this book. The quality of subjectivity is inextricably related to personality and imagination. Consequently, a subjective photograph is generally more imaginative and therefore more interesting than an objective rendition.* It shows the subject in a form that differs from that in which we are used to seeing it, giving the observer a new point of view, literally as well as figuratively speaking.

In many respects, the differences between an objective and a subjective approach are analogous to those between an inartistic and an artistic personality. An artist is more sensitive and observant than an inartistic person. His feelings toward his surroundings and people are heightened

---

* Even if no other reason existed, this would still be true because any photograph *ipso facto* lacks the three-dimensionality, the color (if it is in black-and-white), and the movement (in the case of subjects in motion) of the original which it depicts. As a result, it can never be objective in the strict meaning of the word and therefore is bound to give an incomplete impression of the subject. However, the moment one departs from the rigid concept of objectivity it becomes possible to indicate through the employment of suitable symbols those subject qualities which cannot be depicted directly. This immensely important aspect of photography will be discussed in depth later in the chapter on *The Picture*.

and more definite, and his reactions to the objects of his interest are more personal—that is, more subjective. It is no wonder then that this subjectivity, which in the true artist is the outgrowth of observation and reflection, is mirrored in his work. In his pictures, a photographer who is also an artist naturally emphasizes those qualities of his subject which he considers important to its characterization and suppresses those which, in his opinion, are confusing or of secondary importance. As a result, the subjective pictures which he creates produce a clearer and therefore stronger impression of the subject than would be produced by what might be called objective photographs. They often convey at a glance what might have taken the photographer-artist a long time to understand—a meaning which a less observant person might have missed altogether had he been confronted with the subject in reality. For this reason, the artist's subjective pictures are usually superior and preferable to strictly objective views. They present concisely edited, refined, and condensed impressions which can easily be understood by anyone. In contrast, objective renditions include all the confusing elements which were present at the moment the pictures were made, diluting or obscuring the impression of the subject or event which they depict.

Through analysis and evaluation of the facts he has collected, the photographer evolves his concept of the subject he wishes to depict. At this moment, his integrity is put to the test. Is he willing and capable to discard preconceived (and usually more or less inaccurate) opinions and see his subject free of prejudice? To have preconceived ideas about the subject one is about to photograph is natural and unavoidable. Actually, lack of such preconception would indicate a deplorable lack of imagination. What matters is the photographer's ability to check his preconceptions of his subject against facts gathered through firsthand observation. Do they match or differ? If they differ, the good photo reporter adjusts his opinion so that his subject is shown as truthfully as possible. Truth, of course, is an intangible quality. A Democrat, for example, may say (and believe!) that the Republicans are ruining the country; conversely, a Republican may say

(and believe!) the same of the Democrats. To each, his personal, subjective opinion is *the truth*. Similarly, two photographers may see the same subject in ways as diverse. This is particularly true in situations in which strong emotional forces are involved. In such instances, establishment of the truth is strictly between the photographer and his conscience.

What matters is that his opinion be honest. In a free, democratic society, anyone is entitled to his own opinion, and an honest opinion must be respected by anyone. The moment this ceases to be so, the society is no longer free, nor is it democratic. In essence, someone once said: I shall always respect another man's honest opinion, although I reserve the right to disagree with him. People are different; what seems right to one may seem wrong to another. But in our complex modern world, we are all irrevocably dependent upon one another and have to find ways of living together in peace. The basis for this ideal is mutual respect. The rights I demand for myself I must grant to others. If I claim the right to a subjective opinion, then I must grant others the same privilege. This applies whether the other person happens to be the man across the street or anyone anywhere in the world. Only through tolerance can we discuss our problems, compare our differences, find a common ground, and, by giving in on both sides, agree upon a formula acceptable to all. No one can ever have his way entirely for any length of time, be it person or nation. All nations have laws that regulate the privileges and duties of their citizens, but so far, no universally accepted laws exist for regulating the conduct of nations. Individuals are not permitted to destroy each other's property and to kill, but as long as they are ruled by ambitious politicians, nations can lawfully indulge in wholesale destruction and murder. It often seems forgotten that nations are composed of people, of individuals like you and me, and that what is unlawful for one individual should logically be unlawful for aggregations of individuals, that is, nations. By showing in their pictures that people are more or less the same, regardless of race or creed or political belief, photographers can make an important contribution to bringing about a better understanding between people and nations and thus do their share to further the all-important goal of global peace.

## Subject approach

Having arrived at definite conclusions, the photographer's next problem is to find a way to translate intangibles—ideas, feelings, emotions, moods —into the concrete form of a photograph. To most people, and to many photographers, the solution seems simple: one has merely to aim the camera, focus the lens, expose correctly, develop and print according to instructions, and *presto*—a good photograph. In other words, the creation of a photograph is generally regarded as a rather mechanical affair, an accomplished photo-technique being the prime requisite for success. The fallacy of this oversimplification is proven by the vast number of photographs which are technically perfect and yet, in spite of such perfection, say exactly nothing. The immense number of pictures published in amateur photo magazines, exhibited in photographic salons, displayed on calendars, featured in all the superslick ads in magazines and on TV, in general proves nothing except, perhaps, that perfection of photo-technique alone cannot make a photograph memorable. On the other hand, there are truly stirring picture stories and unforgettable photographs, such as: David Duncan's "This Is War"; Leonard McCombe's picture essays on the Navajos and "You Are My Love"; Eugene W. Smith's "Country Doctor," "Spanish Village," and "Midwife Nurse"; Eisenstaedt's portraits of Veblen and the disillusioned Attlee; Ed van der Elsken's "Love Story in Saint-Germain-des-Prés," Sam Haskins' "November Girl"—to mention only a few that immediately come to mind. According to academic standards, some of these pictures, not sharp and even blurred, cannot be considered technically perfect. Why, then, are they so incomparably stronger than the majority of photographs? What is the difference?

It is *a difference of approach.* Duncan, McCombe, Smith, Eisenstaedt, van der Elsken, Haskins, and all those photographers who produce great pictures have strong feelings for their subjects. They feel love, compassion, sympathy, or hate, but never indifference.

Before he can produce pictures which are emotionally stirring, a photographer must have a strong emotional response toward his subject. Otherwise, he cannot possibly arouse a similar emotion in those who see his pictures.

Primarily, then, the subject approach must be governed by interest and feeling. But since these are intangibles and a photograph is concrete, a way must be found to express such intangibles. Photo-technical problems enter into this. Many photographers assume that photo-technique is rigid and inflexible. They like to contrast the freedom which painters enjoy to the limitations of the photographic medium. They completely overlook the fact that a brush as well as a camera is merely a tool; that in the case of either painter or photographer it is the creative mind which selects the subject and its approach and directs the actions of hand and tool; and that there are proportionally as many bad painters as there are bad photographers.

## Technical execution

Once he has decided what he wants to say and how to say it, all a photographer has to do is assemble the equipment required to perform the given task—camera, lens, filter, film, and, if necessary, photo lamps—and use them in accordance with the established practice of photographic technique. Thanks to the perfection of modern photographic equipment and the high degree of standardization of methods and techniques, the actual execution of a picture in terms of focusing, exposing, developing, and printing can be reduced to a science. In this age of automated and electronically controlled cameras, lens-coupled range finders, photoelectric exposure meters, self-quenching speedlights, and time-and-temperature controlled development, dial readings have largely eliminated the need for laboriously acquiring the experience without which the successful completion of a photograph was previously unthinkable. Today, anyone who can read, follow simple instructions, and use an exposure meter, a thermometer, and a darkroom timer, can produce technically perfect negatives and prints.

## SUMMING UP AND CONCLUSIONS

The creation of any meaningful photograph is a process which consists of five stages:

1. **Interest:** the energizing factor.
2. **Knowledge and understanding:** the basis for a personal opinion.
3. **Opinion and conclusion:** the basis for a subjective approach.
4. **Subject approach:** the final shaping of an idea in terms of photographic means, based upon the photographer's reaction to the subject.
5. **Technical execution:** the mechanics of producing the picture.

Each of these stages is equally important. Unfortunately, few photographers realize the importance of the first four. Many are not even aware of them. Seen superficially, the creation of a photograph takes place at the instant of exposure. The *real* process of creation, however, takes place during the first four stages. Only during these preparatory stages does the photographer have the power to work out his picture in accordance with his plan. Only *before* he makes the exposure does he have the choice of selection and rejection, the opportunity for condensation, stylization, dramatization. Only during these stages is he at liberty to decide which ways, means, tools, and techniques to select as most suitable for the transformation of ideas into images. Once the exposure is made, the basic qualities of the picture are unalterably fixed, although they remain latent until the film is developed and printed.

Unfortunately, however, to the neglect of all the others, stage number five—the actual execution of the picture—is the one upon which the average photographer lavishes all his efforts. This explains why the majority of photographs are meaningless and dull. As previously noted, the attitude of the photographer toward his medium, revealed in his approach to his subject, decides the success or failure of his picture. For know-how is of very little use unless guided by know-why.

# The Scope of Photography

Photography is picture language. As words can be used to enlighten or corrupt, so photography can be used to give form to noble thought or arouse cheap desires, to make it possible to share experiences with others, to describe objects, feelings, and events.

Just as anyone who intends to write seriously must decide upon a definite field—journalism, creative writing, poetry, advertising, political propaganda—so the aspiring photographer must choose a specific sphere of work. For the scope of modern photography is so great that no one can cover all its branches and expect to excel in any. However, before a photographer can make a valid decision in regard to the nature of his future work, he must know the possibilities that exist in each field.

For practical purposes, although overlappings and duplications exist in the following groups, the whole complex of photography can be subdivided into three main categories:

**Utilitarian photography**
**Documentary photography**
**Creative photography**

Basically, these three categories apply whether the photographer is an amateur or a professional. An amateur, of course, has the priceless advantage of being his own master as far as choosing his photographic work is concerned. Although professional photographers are free to select a certain branch of photography, within this field they must usually accept and execute whatever work is assigned to them by an editor or client. In contrast, amateurs are fortunate insofar as they can concentrate upon the kind of subject in which they take a personal interest. Because of this, one might assume that their batting average would be higher than that of the professional who is often compelled to shoot subjects in which he has no real interest. This, however, is rarely true. Strangely enough, the average amateur does not take advantage of his fortunate situation. Instead of

28

developing his own interests, he usually works along traditional lines, photographing in a more or less repetitious and derivative manner those subjects that photographers have done successfully before. As a result, most amateur photographs are trite and uninteresting, whereas they could be as stimulating and exciting as the best professional work. It is a fallacy to assume that professional photographers produce pictures of superior quality and interest because they own better equipment or have better opportunities than amateurs. We all work with the same types of camera, use the same brands of film, and photograph the same subjects: people, objects of nature, scenes from daily life. As far as picture impact is concerned, no difference between the work of amateurs and professionals need exist, since professionals have no monopoly on those factors which underlie any kind of creative photographic work: interest in the subject, an approach toward photography based upon the characteristics of the medium, an ability to see and think in terms of pictures, and creative imagination.

It is hoped that the following brief survey will aid the student photographer in choosing the field of photography which is best suited to his personality, interests, and particular qualifications.

## UTILITARIAN PHOTOGRAPHY

The degree of objectivity determines the usefulness of the picture. The ideal is the perfect reproduction. The more fully standardized and automated the method of taking the picture, the better the result usually is. In this field, creative imagination on the part of the photographer can be a handicap rather than an asset. But a high degree of technical ingenuity may be required in order to solve the sometimes considerable technical problems involved in the making of this type of picture and in order to utilize to the fullest the often highly complex instruments needed for this purpose.

Typical examples of utilitarian photography are aerial photographs taken for mapping and surveying purposes; microphotographs of books, newspapers, records, and documents; copy work and photoengraving; medical

and industrial X-ray photography; certain branches of industrial and commercial photography pertaining to research, advertising, and promotion; and, of course, scientific photography from actinometry to zymology.

As implied in the term *utilitarian,* this type of photography generally plays the role of a handmaiden to some other profession, business, or science. Its main function is to record (in contrast to documentary photography, in which the main function is to inform and educate, and creative photography, the main function of which is to stimulate and inspire). Consequently, those who produce this type of picture are usually not professional photographers, but are air force personnel, laboratory technicians, scientists, researchers, and engineers who use photography to complement their written notes. Their interest in photography is neither artistic nor creative but strictly practical. To them, a photograph is a record the value of which is directly proportional to its accuracy, clarity, and objectivity. Their technical accomplishments are often spectacular and command my highest admiration and respect. But it is obvious that their approach to photography is of necessity very different from my own—which is that of a documentarian and photo journalist—and that they can hardly benefit from reading this book.

## DOCUMENTARY PHOTOGRAPHY

Unfortunately, the term *documentary* is sometimes understood to apply exclusively to the work of socially aware photographers who limit their activities to recording the more sordid aspects of society. I still use this term because its original meaning exactly defines the field of photography which I want to discuss here. According to my dictionary, *documentary* means: "Recording or depicting in artistic form a factual and authoritative representation . . . of an event or a cultural phenomenon." In this definition, two words stand out which together contain the essence of any documentary photograph: *factual* and *artistic*. The subject or event is factual, but its rendition is artistic.

In a documentary photograph, objective approach and creative-artistic presentation combine to render everyday subjects and events in the most pictorially effective form. As mentioned before, the average photograph lacks some of the most important qualities of a subject—like three-dimensionality and depth, color, motion. Add to this the fact that the subjects of average photographs are more or less commonplace, and it becomes clear why the objective approach, so indispensable in utilitarian photography, often leads to dull and ineffective pictures. The purpose of documentary photographs is to provide what basically amounts to informative and educational records. However, this purpose is defeated if such pictures are not compelling but dull. The dullness of everyday objects and events can effectively be relieved and presented in an attractive and even exciting form, if the photographer knows how to combine an essentially factual approach with creative-artistic presentation.

Examples of documentary photography include: political and news photographs; the type of picture stories featured by the great picture magazines *Life, Look,* and *Collier's;* the kind of photography originated under the Farm Security Administration and Roy Stryker and later taken up by the publicity departments of the Standard Oil Company and U.S. Steel; and the majority of amateur snapshots and travel photographs.

Of course, the mere fact that a photograph is classified in one of these areas does not prove that such a picture is an outstanding example of documentation. Many news and political photographs, as well as the majority of amateur snapshots, actually provide poor examples of documentary photography because they present their subjects in a form that is neither imaginative nor artistic. However, even such photographs as these can be of use to the student photographer if he compares them with good examples of documentary photography depicting similar subjects. Then he can easily see that the difference between a dull and an effective picture lies not in subject type but in subject approach—which in turn is determined by the personality, skill, and imagination of the photographer.

The following insert contains eight "Portraits of Professionals"—photographic studies of people which, by including certain clues, indicate what these men and women do for a living. Since a person's job normally accounts for a large share of his interests, it exerts a powerful influence on his life, and it is only natural that this should be reflected in his personality and, presumably, his face. Personality, profession, work place, and tools therefore combine to form an intangible but characteristic atmosphere which, provided it can be translated into terms of photography, can be used to produce a more revealing type of portrait than the ordinary kind of studio photograph.

Whether or not the following portraits are successful in this respect can be decided only by the viewer. Different people react differently to the same stimulus, and what is significant to one may leave another cold. Personally, I consider each of these attempts at personality characterization successful not only as a portrait in its own right, but also as study material and a source of ideas which can be useful to any reader who intends to make this kind of "professional" portrait himself.

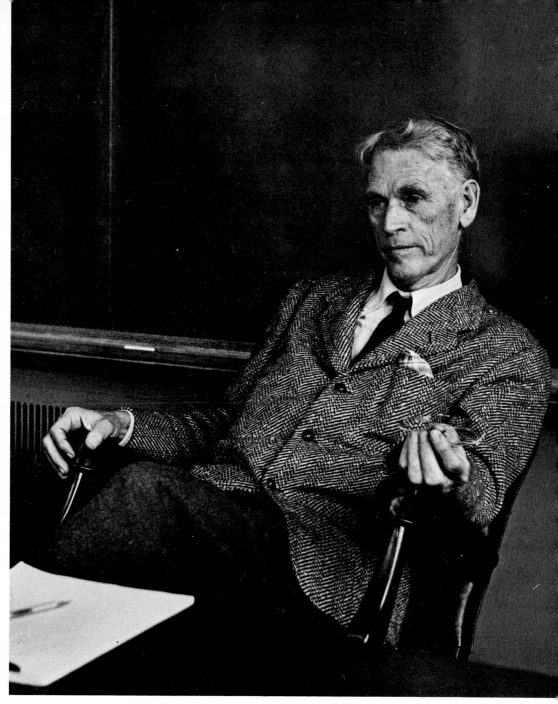

## Portrait of a thinker

Oswald van Veblen, mathematician and physicist, photographed by Alfred Eisenstaedt. Honesty, simplicity, and directness of approach make this an unusually convincing portrait. For a more detailed discussion and analysis of this picture see pp. 98–99.

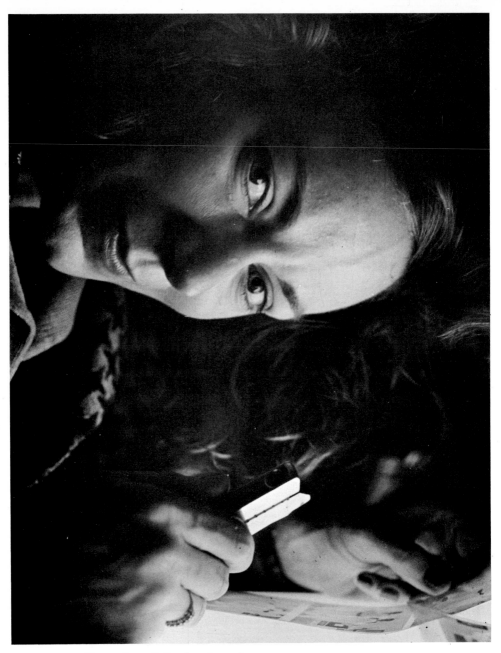

## Portraits of Professionals

"Timmy" editing her negatives, by Andreas Feininger. The light table provided the only source of illumination for this informal study. The negative-punch and film strip furnish the clues to the profession of this charming lady.

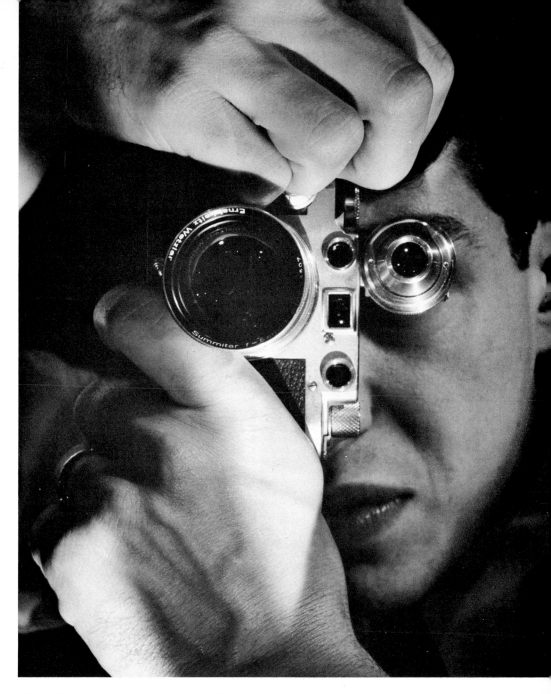

The photographer Dennis Stock, photographed by Andreas Feininger. The intensity of his "seeing" is almost palpable, the lens and view finder of his Leica become extensions of his eyes and mind. The grip that holds the camera is firm yet sensitive, the grip of a pro. Exaggerated perspective—distortion—was used here deliberately to symbolize nearness and evoke a feeling of immediacy.

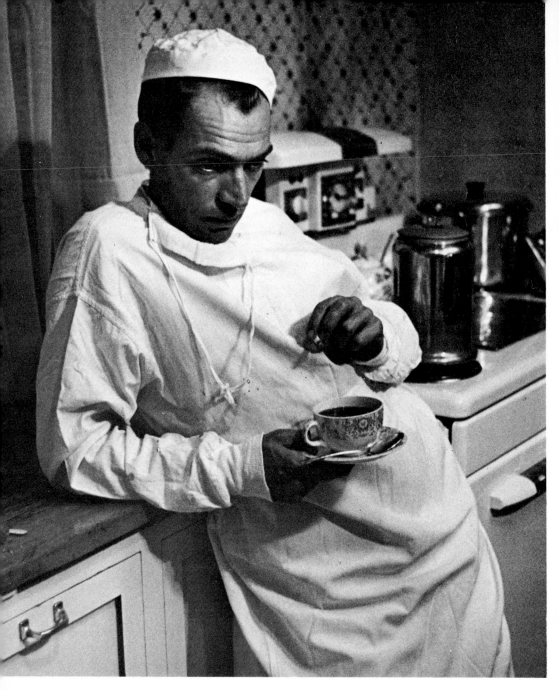

The Country Doctor, photographed by Eugene W. Smith. All the emotions which the Country Doctor experienced during his strenuous day are mirrored in his face when, utterly tired, he relives its events over a last cup of coffee. This is a classic example of depicting the intangible. More about this subject on pp. 98–102.

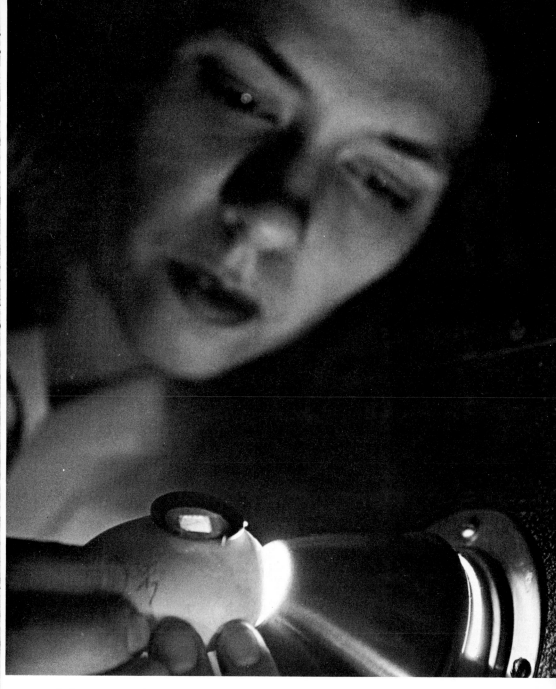

Laboratory technician examining a culture-implanted egg, photo-graphed by Andreas Feininger. The only light came from the candling machine. Any attempt at "improving" this illumination with additional light would have ruined the informal and authentic mood of this un-posed portrait. See also the discussions on light on pp. 211–224.

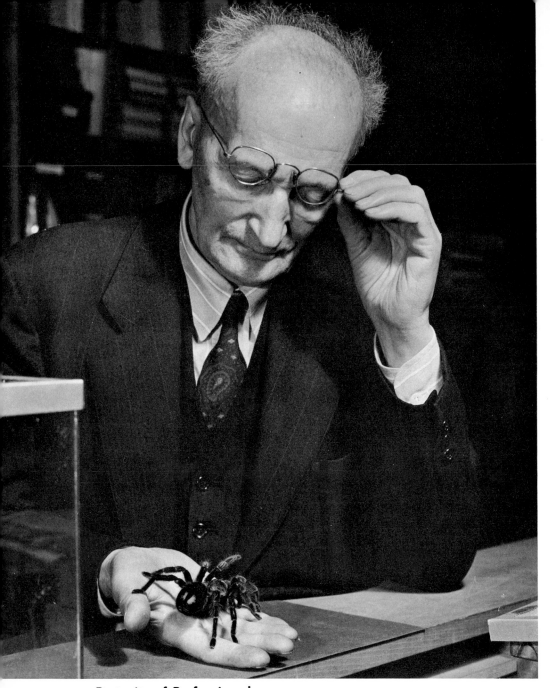

## Portraits of Professionals

The late Professor Alexander Petrunkevitch of Yale University contemplating a tarantula. Photographing the arachnologist in his workaday surroundings resulted in a more significant study than might have been possible to produce in a more formal portrait. This and the portrait on the opposite page were made by Andreas Feininger.

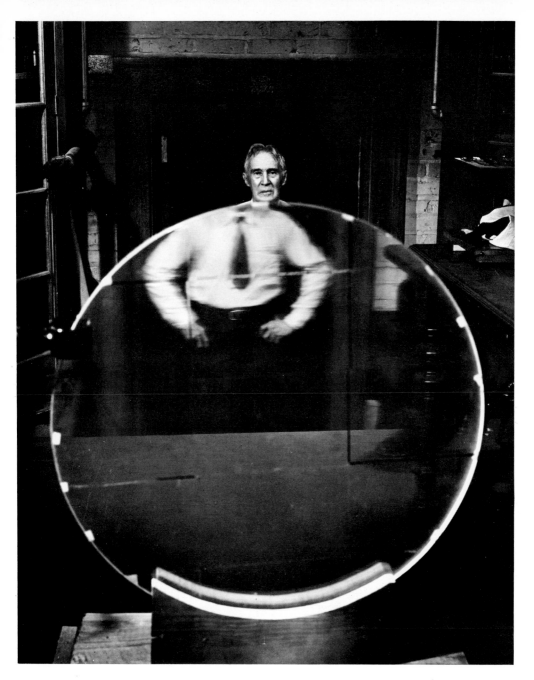

The physicist Dr. Robert Wood of Johns Hopkins University, photographed in his laboratory standing behind a giant diffraction grating (a device used in astro-spectroscopy to break down starlight into its components). In this case, it seems to decapitate the scientist, a strange and unexpected effect that leads to a startling portrait which by its very weirdness seems to reflect something of the "magic" of modern science.

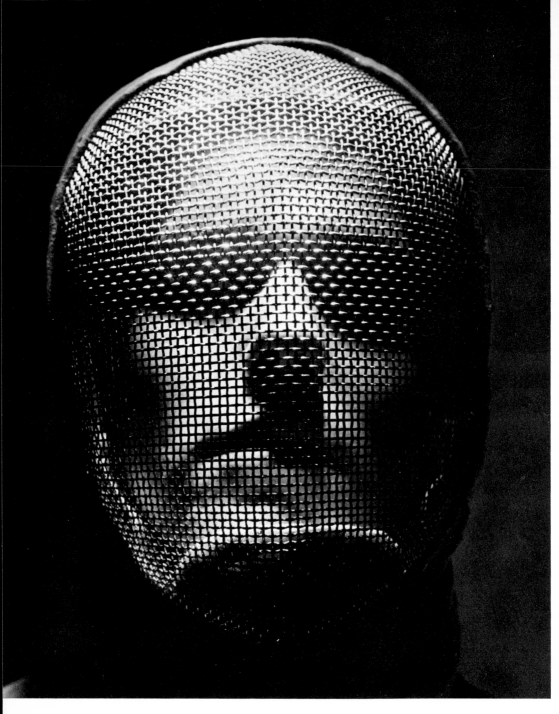

Portrait of a fencer, by Andreas Feininger. Deliberate stylization by means of toplight brought out the sculptural qualities of this strong young face, giving the picture an almost ritualistic feeling and thereby emphasizing the ceremonial character of the sport.

# CREATIVE PHOTOGRAPHY

If one were to draw a parallel between picture language and word language, documentary photographers could be compared to journalists, creative photographers to fiction writers and poets.

In contrast to documentary photography, which is basically descriptive, dealing with specific facts and events, creative photography is interpretive and symbolic. Its objective is to convey a mood, a feeling, an idea. In a creative photograph, the subject is generally no more than a vehicle that carries the idea which the photographer wants to express. For example: a photographer wishes to express the idea of a slum. To be successful, he must express in his picture all those qualities associated with the concept *slum*: overcrowding, unsanitary conditions, filth, decrepitude, lack of light and air. He goes into the ghettos and takes his photograph where he finds most or all of these conditions combined. The actual location—the town, the street, the tenement—is immaterial because the objective of the picture is to depict *not* a specific place (this would be the province of the documentary photographer), but a concept—the concept of a ghetto, a slum. This is a symbolic picture, and the actual location photographed becomes the symbol of all slums.

Those who work in the field of creative photography are artists. Their imaginative and creative faculties are far above those of the average photographer. Some are painters who also photograph. Many followed a different profession before they became photographers. They turned to photography because their former fields of activity did not offer them the opportunities for the creative work without which life seemed meaningless and dull. They are the *avant-garde* of photography who experiment in directions which later will be followed—first by a few imitators, then by the mass of anonymous photographers. Their work is always stimulating and often controversial. They are the ones who first explored and exploited the graphic control processes of bas-relief printing, solarization, controlled reticulation, and the negative print. Some of their work led to a dead end,

but most of it is very much alive. For instance: candid (as opposed to posed) photography; the use of "available light" (instead of the flash of the press photographer) even under the most difficult conditions; the use of blur to indicate motion; the symbolization of height through converging verticals. These methods and techniques were first developed and used by creative photographers who dared to break the rules of traditional photography. Once called "revolutionary" and worse, derided as faults and fads, these techniques are today part of the vocabulary of any articulate photographer.

## SUMMING UP AND CONCLUSIONS

Three basically different approaches to photography exist. These correspond to the concepts of straight reproduction, artistically controlled reproduction, and imaginative creation. No one approach is superior to the others, it is merely different. The photographer must decide in accordance with the purpose of his picture which approach he should use.

In this connection, it is interesting to note that the same three approaches also exist in other fields of art. In sculpture, examples of straight reproduction are those battle monuments whose figures are so faithfully reproduced that they appear to be cast from molds made directly from a living model. Good examples of artistically controlled reproduction—of the documentary approach—are, in my opinion, the portrait heads and busts by Jo Davidson. And exemplifications of the highest levels of imaginative creation include the work of the unknown sculptors which surrounds the portals of the cathedral of Chartres and, among contemporary artists, the sculpture of David Smith and Henry Moore.

In painting, the concept of straight reproduction is typified by the work of commercial artists and illustrators which appeared, for example, on the covers of Collier's and the Saturday Evening Post, and

was used to illustrate such *Life* books as *The World We Live In* and *The Epic of Man*. Painters whose work, in my opinion, exemplifies the concept of artistically controlled reproduction of the documentary approach are Grant Wood and Ben Shahn. Those whose work represents the highest levels of creative imagination are, to name only three, Van Gogh, Lyonel Feininger, and Picasso.

As it would be foolish to illustrate, for example, the *Life* books mentioned above in the manner of Picasso, so it would be wrong to apply a highly imaginative treatment to photographs intended for catalog illustrations. On the other hand, if the essence of a subject is something intangible and thus can be expressed only through a highly imaginative treatment, a straight reproduction would be ineffective. In other words, the approach cannot be isolated from the objective.

Selection of the right approach is therefore the first step in the making of an effective photograph. The consequences of this decision should become clear if we imagine how differently, say, an anthropologist, a physician, a normal young man, a "dirty old man," and a poet might react to the sight of a nude girl—seeing her, respectively, in anthropological, anatomical, sensuous, lascivious, and aesthetic terms. And if each of these people were given a camera and left to photograph this nude in his own way, the differences in approach would naturally reflect in their pictures, which might range all the way from the pornographic to the sublime.

## A Personal Concept of Photography

Almost any photographer who sees in photography something more than a way to make a living, who is aware of the potentialities of his medium, and who strives to improve his work, has fairly definite opinions and theories on

the subject. Personally, I am convinced that one of the main obstacles to the production of more effective photographs is the ingrained idea that photography is a mechanical, naturalistic means of reproduction. To me, for the reasons given hereafter, this definition seems superficial, inadequate, and misleading.

In my opinion, photography as a means of graphic expression is neither more nor less "mechanical" than painting or creative writing. A camera is, of course, a mechanical instrument—a tool—but so is the brush of the painter or the typewriter of the novelist. Furthermore, in each medium certain mechanical aids are necessary to express intangibles—ideas, thoughts, or images—in tangible form. *But* (and this seems to me the one important consideration) regardless of the medium, it is the creative mind which conceives the idea for the intended work, selects the subject, chooses the approach, decides upon the final form of presentation, and guides the hand and the tool!

The second misconception is that photography is a "naturalistic" medium of reproduction. Actually, a less naturalistic form of reproduction than a black-and-white photograph is hard to imagine. No black-and-white photograph, except perhaps the photographic reproduction of a printed page, can ever be a naturalistic reproduction of a subject for the following reasons: the subjects of most photographs have three dimensions, height, width, and depth; a photograph has only two, height and width. Most subjects have color; a black-and-white photograph contains only shades of gray. A typical quality of many subjects is motion; a photograph is a "still," it has none. In other words: although in a black-and-white photograph the subject lacks three of its most important characteristics—depth, color, and motion—such a picture is more often than not thought to be a naturalistic reproduction. What a paradox!

A reproduction is a copy which in every important respect duplicates the original. Obviously, any form of rendition that deprives a subject of three of its most outstanding qualities is not naturalistic and cannot be called a reproduction.

These points would be of little more than theoretical interest were it not for one important consideration: despite the fact that a photograph can never be truly naturalistic, it still has a quality of naturalism—or shall we call it pseudo-naturalism?—which the majority of photographers (and picture editors!) value more highly in a photograph than any other quality. Conversely, they frequently object in a picture to any effect that to them seems unnatural, making a subject appear different in a photograph from the way it appeared in reality—even if this difference should be the factor which makes the subject appear stronger, more interesting, or more significant. And by this shortsighted attitude they deprive themselves and their public of some of the most graphically expressive effects of the photographic medium.

The only branches of photography which to some degree approach naturalism are holography and stereo-cinematography. Only in their presence do we experience the illusion of three-dimensionality, see the subject in its familiar colors, watch it move, and, if film and sound are synchronized, hear the familiar sounds—people talking, waves pounding the beach, the cacophony of city traffic. And yet even these illusions are incomplete: we feel neither the heat nor the cold of the scene; although we may see branches moving and hear the wind, we do not feel the motion of the breeze; if we see someone eating steak, we can neither smell nor taste it.

It seems to me that these facts can lead to only one conclusion: since, by its very nature, a photograph is unnaturalistic, we must cease to strive for a naturalism which we can never achieve. Instead, we should take full advantage of all the fabulous potentialities inherent in the medium and should use it accordingly: as a priceless extension of our vision; as a means to explore our world and extend our horizons; as a powerful tool of research; as an instrument to make life richer by disclosing to us some of its aspects which we otherwise could not perceive because of limitations of our vision; as a disseminator of truth and knowledge; as the only language common to all.

Strange as it may seem, thus far only scientists and research technologists—that is, essentially fact-oriented, inartistic people—have exploited the full potentialities of the photographic medium in their respective fields. And the results have been more than rewarding, they have been spectacular. Astrophotographs, similar to the fabulous time machines of science-fiction, probe the unimaginable voids of outer space, permit us to look back in time, show us in ghostly smudges the images of galaxies as they appeared billions of years ago. Spectrophotographs reveal the composition of stars trillions of miles away as accurately as if we had specimens of their substance in our laboratories for analysis. Electron photomicrographs which boost our vision a hundred thousand times and more bring us ever closer to an understanding of the ultimate secrets of matter and life. Highspeed photographs taken with exposures as short as one millionth of a second turn lightning-fast motion into a still and permit us to leisurely study even the most rapid events. Radiographs made with X rays instead of light reveal the internal structure of our bodies—the beating heart, the fractured bone, the festering disease. Schlieren photographs make visible the air itself, the currents and eddies that wash around the wings of airplanes in flight, the shock waves that precede the bullet, and the turbulence that follows in its wake. Photographs made with infrared radiation penetrate miles of haze and dust-laden air, detect forgeries, show objects and detail in darkness. "Black-light" photography with ultraviolet radiation aids the criminologist a hundred different ways in his work. Polarized light, in conjunction with models made of transparent plastic, permits the engineer to actually see the play of stress and strain within the structures he designs.

The only other persons who, though perhaps to a lesser extent, have exploited the potential of the photographic medium for their own purposes are creative photographers inclined toward experimentation. And it is perhaps significant to note that the most successful and original of these did not choose photography as their original profession, but worked actively for years in other fields before they turned to photography.

Why is it that so many photographers still fail to utilize the full potential of

**46**

their medium? I believe it is because they know too much and think too little.

They know too much about the tradition of photography and pay homage only to the achievements of the past. Because they think too little, in their photographic work they seem to follow the maxim: "What was good enough for my father is good enough for me"—although I doubt that they would trade their modern refrigerators for the iceboxes of the past. It is safer to do traditional subjects in the traditional manner than to risk ridicule by striving for new and perhaps shocking effects; to wait until new trends are firmly established before accepting them; to conform to the standards set by the group; to leave progress to those "radicals" who have nothing to lose; and to forsake effort beyond the simple rules which guarantee "success."

A new and more constructive approach is needed to bring photography up to date and contribute to its progress. A camera, similar to a microscope or telescope, is an instrument of immense latent potentialities which can and should be used. Compared to the camera, the scope of the human eye is pitifully limited because clear vision begins no closer than approximately eight inches from the eye and extends no farther than a few hundred feet. Objects closer or farther away can be seen only in increasingly less detail or not at all. But the camera, if necessary in conjunction with a microscope or a telescope, extends the range of observation from minute fractions of an inch to infinity.

The eye cannot retain an image for any measurable length of time. Consequently, when we look at an object in motion, a sequence of rapidly changing images is superimposed one upon another on the retina of the eye, producing the effect of blur. As a result, we cannot distinguish clearly individual phases of rapid motion. But the camera, if necessary in conjunction with electronic flash, can freeze any desired phase of rapid motion and present it in the form of a tack-sharp photograph.

Atmospheric dust and haze seriously limit the range of our vision, and

darkness reduces it to zero. But on infrared sensitized film we can take photographs through miles of apparently impenetrable haze, and by illuminating a subject with invisible infrared radiation we can even take photographs in the dark.

Our eyes are receptive only to that narrow section of the electromagnetic spectrum which we know as light. But photographic emulsions can be sensitized to a much wider band of radiation, ranging from short-wave X rays through ultraviolet to long-wave infrared and radiant heat. Since these types of radiation possess properties that are completely unlike those of ordinary light, photographs taken with their aid can open completely new and unexpected vistas, showing us things which we otherwise could never see.

## Characteristics of Photography

To utilize intelligently the full scope of his camera, a photographer must be familiar with the basic characteristics of his medium. Unfortunately, the average photographer does not give much thought to these fundamentals because the actual taking of a photograph is so simple, and a recognizable image of the subject so easy to obtain. However, there is a vast difference between a recognizable and a significant picture, the one providing little of interest, the other providing much.

Many of the typically photographic characteristics discussed hereafter may at first appear too obvious to be mentioned. But unless the aspiring photographer is conversant with all the characteristics of his medium and their ramifications and unless he is familiar with the respective techniques, he cannot plan and execute effective photographs.

## Authenticity

Among all forms of visual representation, photography is unique in that there can be no question about one thing: the camera must have "eye-witnessed" the subject or event which was photographed. Paintings or drawings can be made from memory or created from imagination. But a photograph is a document insofar as it represents authentic proof of something recorded by the camera at the actual moment of happening. As mentioned earlier, the single photograph of a starving child is more convincing than a lengthy report on starvation. This quality of authenticity automatically gives a photograph a power of conviction which is not found in any other form of communication, pictorial or otherwise.

This quality of authenticity exists, of course, whether or not the photographer is aware of its existence. However, awareness of this unique characteristic gives a photographer an advantage over his less perceptive colleagues. Realizing that each time he trips the shutter he produces a document, the photographer is more likely to consider whether the subject or event is worth documenting. And, in contrast to the unthinking shutterbug who photographs subjects that are not worth recording, he rejects anything that might lower the overall quality of his work.

Whether he shoots for his own pleasure or for wide-scale publication, he will be honest in his work. Although it is said that "the camera does not lie," it is well known that photographs can be misleading. This may happen either because the photographer deliberately used the camera to perpetrate a lie or because he was not perceptive enough to see the truth, or not skillful enough to catch it in his picture. Common examples of camera lies are those candid shots in which a public figure was deliberately caught off guard—yawning when he should have been attentive, with mouth distorted when making a speech—in order to discredit him with the voters. Another field in which camera lies are not uncommon is nature photography. Again and again, unscrupulous photographers, too lazy or clumsy for honest field reporting, pose stuffed or freshly killed animals, anesthetized or chilled insects, or dead specimens from collections amid "natural surroundings,"

**49**

and pawn them off as the real thing. Needless to say, self-respecting photographers never consciously deal in such photographic lies.

That a photographer must often emphasize or exaggerate certain subject qualities to produce the most effective picture has nothing to do with falsification. On the contrary, for reasons previously mentioned, such exaggerations may be necessary to symbolize those subject qualities which are otherwise lost in transition from reality to photograph—as, for example, three-dimensionality, color (in black-and-white photography), and motion. Without such treatment, a photograph would be more likely to misrepresent the subject since it would then be incomplete as a record, lacking (or at best indicating only in sketchy and inadequate form) some of the most important subject qualities.

**Accuracy of drawing**

Another unique quality of the photographic medium is the absolute and automatic accuracy with which subjects can be rendered, an accuracy which is maintained throughout the picture, from the rendition of perspective down to the most minute detail.

To give an example: When we speak of perspective distortion, we mean that the relationship of foreground to background appears unnatural or that lines we know to be parallel in reality seem to converge in the picture.

However, upon reflection one always finds that this effect is a result of human failure and is not due to inadequacies of the photographic medium. Either the photographer used an unsuitable type of lens (usually a wide-angle lens), went too close to the subject with his camera, or arranged his subject badly; or the viewer, when contemplating such a picture, judged it according to his subjective standards of vision, failing to take into account the probability that the lens used to make the picture covered a considerably wider angle of view than that of the human eye. In any case, photographic perspective—that is, the projection of a three-dimensional object into the two-dimensional plane of the picture—is always geometrically

correct. If he does not like a particular form of perspective, an experienced photographer knows how to avoid it: by using a lens with a longer focal length or increasing the distance between subject and camera. But whenever we are confronted with a photograph in which the perspective appears "unnatural," we should approach it in the same spirit with which we approach, for example, an X-ray photograph, which also shows the subject in a form which is beyond the power of the human eye to see directly. Considered and evaluated in this sense, wide-angle photographs or pictures taken with fish-eye lenses (in which perspective is spherical) will no longer appear distorted, but will be accepted as another contribution which photography has made toward the extension of our vision.

In the field of visual communication, photography far surpasses any other medium in accuracy of reproduction of detail. The copper and steel engravings of the last century seem crude in comparison to tack-sharp photographs. Most photographers accept this unique quality as a matter of course, giving it no thought and often not even caring whether or not their pictures are critically sharp. Some actually consider sharpness a fault and, frustrated artists that they are, indiscriminately soften their pictures by means of diffusion screens in a desperate attempt to produce what they consider "art." Other photographers, aware of the possibilities which accuracy of drawing and sharpness of definition offer for the creation of more effective photographs, make sharpness a fetish and create pictures that are almost superrealistic in textural quality. Still others, holding the opinion that the eye cannot see things as sharply as the lens, take a middle-of-the-road approach. Of course, there are no rules to regulate the use of sharpness or softness in a photograph. However, the fact that photography can show us reality in a form more sharply defined and accurate than that in which we can see it directly is potentially an enormous asset of our medium. For this reason, in my opinion, sharpness should be cultivated rather than taken for granted or, worse, neglected. It should be employed to make people more aware of the manifold and wondrous aspects of our world.

51

## Speed of recording

A third unique quality of the photographic process is the speed with which the image is recorded. It usually takes only fractions of a second to make an exposure, whereas in writing or painting hours, days, or even weeks may be required to record an impression of a particular subject. This speed of recording is another valuable asset which is not inherent in other media, but it also has its disadvantages.

The advantages are obvious. When other means of recording are too slow because time is limited, when working conditions make speed essential, or when the eye cannot clearly perceive a very rapid event, photography is superior to any other means of recording and often provides the only method of obtaining any record at all.

However, the very speed and ease with which a photographic record can usually be made is a constant invitation to hasty and thoughtless shooting based upon the presumption that, according to the law of probability, if a large enough number of pictures are taken, one of them must be successful. That the odds are too great to recommend this method will be seen by even the most avid button-pusher if he counts the cost of materials and time wasted in negatives that are not worth the effort to print.

A less obvious disadvantage—excluding multiple- and time exposures—is the fact that a photograph records only a single instant in time. In contrast, a drawing or painting usually represents the sum total of many different moments or aspects synthesized by the artist into one all-embracing, almost symbolic concept of the subject. As a result, except in cases in which photography is deliberately used to arrest a specific instant in time, a photograph is often inferior to a painting or drawing because it emphasizes only the fleeting moment—the exceptional—rather than the more universal characteristics of the subject. Nevertheless, once aware of this problem (which exists particularly in portraiture), photographers can, by carefully studying their subjects and holding their fire until they are sure of what they want and how to achieve it, largely overcome this handicap.

## Polychrome into monochrome

This quality, although not exclusively limited to the photographic medium, is certainly the most typical characteristic of black-and-white photography. At first, shades of gray may seem a poor substitute for color. However, as I have already mentioned, any photograph is essentially unnaturalistic because it lacks the two vital subject qualities of depth and motion. Since these qualities cannot be rendered directly in any photograph, the abstraction of a third characteristic—color—is not too consequential as far as a photograph's degree of "readability" is concerned, although it can make a great difference in regard to the impression of the picture.

Since nature is colorful, color photographs are preeminently naturalistic. Yet most of nature's colors are rather superficial, inasmuch as they change constantly with the color of the light and the intensity of the illumination. Snow, for instance, is white; but is it *really* white? When the first rays of the sun strike the peaks of snow-capped mountains, the snow looks pink. By the light of the setting sun, it assumes a golden hue. Half an hour after sunset, it looks blue. Which one of these colors is real? Or true? Consider a person's face; the flesh tones are pink—but are they? Seen in light filtering through foliage or in forest shade, the tone of the face becomes greenish. In the open shade cast by a building, illuminated by light reflected from a cloudless blue sky, the same face has a bluish tint. Illuminated by sharp, direct light, those parts of the face that are in the shadow of a hat brim, for instance, appear nearly black. Which one of these colors, then, is true? Actually, how valuable and important are such colors to the true rendition of a face? Imagine color transparencies of this face—greenish in the forest, bluish in the open shade. Even though they accurately represent the actual color shades, would they appear natural to you? If such transparencies were compared with a good black-and-white photograph of the same face, wouldn't the impression created seem more natural, despite the absence of color, than that created by a greenish or bluish rendition?

Try to ascertain what is *typical* of a certain face: Is it the momentary coloration which so often depends upon superficial and constantly changing

factors like those mentioned above? Or is it not rather the form of the face as determined by the underlying structure of the bone, the modeling expressed in the play of light and shadow, the spacing of the eyes, the curve of the lips, the shape of the nose?

Objective analysis can result in only one conclusion: Whenever an uncompromisingly accurate (though often superficial) record of a momentary situation is desired, a good color photograph is most likely to fill the bill. But if a photographer wishes to capture the *typical* in his subject—those basic qualities unaffected by temporary or accidental influences which tend to distort—then a black-and-white rendition is potentially superior because it is more flexible. This is, of course, provided that the *typical* which the photographer wishes to capture is not the subject's color. The very fact of the greater abstraction of black-and-white allows for more control of rendition, thereby enabling the photographer to emphasize important qualities of his subject and minimize disturbing influences. Realization of this should cure any sense of inferiority which a photographer who works in black-and-white may feel.

From the purely graphic point of view, if we go further to analyze black-and-white photographs, we will often find that it is *not* the number of differently graded shades of gray that gives them character and strength, *but* the unadulterated black-and-white. Black provides strength; white provides radiance and luminosity. Together, black and white are more than merely a substitute for color. Their combined effect is equivalent to the creation of *new values*—graphic values which in this form do not exist in nature—which more than compensate for the loss of color. Through black-and-white photography, new and powerful visual experiences can be created, for pure black-and-white has an inherent abstract beauty. Regardless of the subject of the picture, a harmonious effect can be created through a well-balanced composition based upon nothing but a good relationship of black to white. Most abstract photographs and photograms owe their attraction to sensitively balanced abstract shapes of black-and-white. In the graphic sense, without such balance no photograph can ever

be esthetically satisfying. To be able to appreciate, apart from its subject content, the abstract beauty of the black, gray, and white of a photographic rendition, is the mark of a sensitive photographer.

The best way to learn to appreciate the impact and beauty of black-and-white is to study pictures in which these qualities are prominent, to observe nature and evaluate its manifestations in terms of light and dark, and to experiment in creating pictures which consist predominantly of black and white.

From the artist's point of view, black-and-white photography offers an interesting solution to the age-old problem of translating reality into an abstract and artistic form while at the same time preserving (and even emphasizing) its characteristics. That a real need for such abstractions exists is proven by the fact that for several thousand years monochrome and polychrome forms of rendition have existed side by side, without one replacing the other. Furthermore, many top photographers who certainly can afford to use color exclusively still do a large part of their work in black-and-white precisely because it offers certain graphic means of expression which do not exist in color photography.

For example, consider the photograph of the skyline of midtown Manhattan reprinted elsewhere. The only way of achieving this type of monumental perspective which presents the different buildings, regardless of their distance from the camera, in virtually their true proportions to one another, was to use an extreme telephoto lens and take the picture from several miles away. However, seen from this distance, the actual colors of the subject, never particularly interesting or strong, were almost completely washed out by masses of intervening haze and dust-laden air. As a result, the skyline appeared pale and insignificant. Had it been shot in color, nothing could have been done to intensify the insipid color, and such a picture, although it would undoubtedly have been more naturalistic than a black-and-white rendition, could never have done justice to this monumental subject. But in the black-and-white photograph, pure black and white (which did not exist in reality) could be introduced to give the picture the punch and power

pp. 108–109

55

which the subject demands. By using a red filter to cut the haze and by printing the negative on paper of extra hard gradation, wishy-washy colors were replaced by stark and graphic black and white. In this case, simplification (the relinquishing of color) became the means for condensation and intensification, and the self-imposed limitation enabled me to create abstract effects which far surpass the actual impression of the scene.

In comparison to photographs in black-and-white, color photographs seem to possess a higher degree of naturalism if they accurately represent the colors of the subject. However, since human color perception is highly subjective, even slight deviations from the color rendition considered to be correct are usually sufficient to make certain color photographs actually appear less naturalistic than photographs in black-and-white. By comparison, black-and-white photographs are *ipso facto* so unnatural that divergence from accurate color translation into shades of gray of corresponding brightness value has little or no influence upon the degree of "naturalism" of the picture. As a result, a creative photographer is free to alter tone values. He can increase or decrease the overall contrast of his picture or with the aid of filters render specific, preselected colors lighter or darker. He can thus improve the tone separation in his picture and place the emphasis where he feels it belongs. Thus, skillfully color-translated black-and-white photographs, as opposed to color shots, can have a measure of the abstract beauty that distinguishes a fine marble sculpture from a shop-window dummy. If done with imagination and skill, such pictures can, through their graphic black-and-white impact alone, often surpass the actual impression of the subject itself. If this is accomplished, reality has been transformed into art.

## Transition from light to dark

Better than in any other graphic medium—with the possible exception of airbrush techniques—black-and-white photography enables one to achieve the most delicate shades of gray tones and transitions from black to white. As a result, a black-and-white photograph can give impressions of

roundness, volume, and depth that are difficult to accomplish in any other medium and impossible to surpass.

To make the fullest use of this characteristic, the photographer must be a skillful technician. Negatives that are overexposed or underdeveloped are lacking in contrast. Negatives that are underexposed or overdeveloped are excessively contrasty and often deficient in the intermediate shades of gray. But negatives which because of unsatisfactory contrast range must be printed on paper of hard or soft gradation never produce prints that show the same rich and subtle transitions from light to dark as negatives of satisfactory gradation which can be printed on normal paper.

## Transformation from positive to negative

Photography provides the only means for accurate and fully automatic reversion of positive images into the negative form. Usually, a photographic negative is a means to an end: the positive. But it seems to me that the possibility of producing negative prints, although one of the most obvious characteristics of the whole photographic process, is remarkable enough to warrant closer attention on the part of creative photographers who wish to explore all the potentialities of their medium.

Until now, the principle of the negative has been utilized for practical purposes only in the form of blueprints which show white lines on a darker background. This type of reproduction, commonly used for the duplication of technical drawings, is, if anything, easier to read than the positive form. White lines stand out more clearly on a dark ground than dark lines on white—which in bright light tends to cause halation and eyestrain. Blueprints offer conclusive proof that negative renditions can be as easily understood as positives, particularly if relatively abstract subjects are involved.

To a much higher degree than positives, negative prints show definition within shadow sections which are of course rendered light. For this reason, since the well-illuminated sections are clearly defined in either positive or

negative prints, whenever reversion from one form to another is permissible, negative prints may be preferable to positive prints. Furthermore, as in the case of blueprints, negative prints emphasize to a higher degree than positive renditions the structural characteristics of the subject which they depict. And superimposed but slightly off-register negatives printed in conjunction with positive transparencies offer interesting possibilities for graphic abstractions—the so-called bas-relief prints.

Negative prints, in the form of finished photographs, are still unusual and thus automatically eye-catching. In conjunction with their clarity, this should make negative pictures especially good vehicles for advertising technical products whose semi-abstract but often uninteresting shapes are to a particularly high degree dependent upon an eye-catching form of presentation.

### From close-up to infinity

One of the most useful characteristics of the photographic process is the almost unlimited range of vision of the camera. At a distance closer than approximately eight inches, the normal eye sees nothing clearly; objects farther than a few hundred feet away are seen in less and less detail, or seen at all only if they are sufficiently large. But lenses can produce clearly defined pictures at distances ranging from fractions of an inch to infinity. We can see the sun, the moon, and the mountains near the horizon; but we perceive such distant objects on a scale too small to make detail apparent, whereas long-focus photographic lenses (and, to a much greater extent, telescopes) span distance, bringing faraway objects into closer range, and produce greatly magnified pictures rich in fine detail. And at the opposite end of the scale, short-focus, close-up lenses (and microscope and enlarger) introduce us to a microcosmos which without such devices would have remained forever hidden.

### Wide to narrow angle of view

Whereas the angle of vision of the human eye is unalterably fixed, pho-

tographic lenses can be designed to cover practically any desired angle of view, up to and even beyond an angle of 180°. This means —literally!—that cameras can be built that can "see behind their backs" (like certain insects and fishes). To realize what this means, stretch your arms horizontally until your fingertips point in opposite directions. If you had such a super wide-angle camera hanging from a strap around your neck, lens pointing straight ahead, a picture taken with it would include all the view encompassed by your widespread arms, including the fingertips of both your hands.

The perspective of such extreme wide-angle photographs is, of course, not rectilinear, but spherical, like the perspective seen in the mirrored spheres used as Christmas tree or garden ornaments. In a photograph, rectilinear perspective renders straight lines straight; spherical perspective renders them curved. However, as we will see later, this curved perspective, far from being unnatural, actually conforms more closely to reality than rectilinear perspective. Since this phenomenon of spherical perspective has practical applications, it is another example of a typically photographic quality which, intelligently used, can provide totally new visual experiences.

## Light-accumulating ability

The dimmer the illumination, the less we see, regardless of how long we look at an object and how much we strain our eyes to see it. The film, however, reacts differently to low-level illumination. As long as there is any light available, no matter how weak, pictures can still be produced if the film is exposed for a sufficient length of time. For, unlike the eye, the photographic emulsion accumulates small quantities of light and adds them up until the total is strong enough to leave an impression on film. This typically photographic quality is of the utmost importance to astronomers and astrophysicists because it enables them to photograph stars and galaxies too faint to ever be seen even through the most powerful telescopes. To the average photographer, this aspect is normally of less interest—except in

one case: when taking photographs at night, he can get perfectly detailed pictures if exposures are sufficiently long. However, if overexposed, night photographs will show too much detail—as much as pictures taken in broad daylight—and thus will lack the darkness, mood, and mystery of the night.

## Motion-recording ability

Human vision is too slow to enable us to clearly see distinct phases of rapid motions. Before 1877, when Muybridge answered the question by taking sequence photographs with specially constructed devices, no one knew whether or not the four feet of a galloping horse ever left the ground simultaneously. (Information of this kind was important to the painters of the great battle scenes which were in vogue during that period.) Today, high-speed photographs can freeze even the wingbeat of a hummingbird.

Once again, photography provides a means for widening man's horizons by allowing him to see phenomena which otherwise would remain invisible. Many cameras, well within the reach of the average photographer, provide shutter speeds of up to 1/1,000 sec. Such speeds are sufficiently high to freeze all but extremely rapid motion, particularly if the photographer knows how to reduce the angular velocity of his subject by panning—by using his camera like a shotgun on a flying bird, that is, by following the subject with the camera and exposing at the same time. And electronic speedlights are now available with flash durations that range from 1/500 to 1/1,000,000 sec., making it possible to record single phases of ultra-rapid events or to stop motion when inadequate illumination prevents the use of sufficiently high shutter speeds.

## Isolation and concentration

Our eye cannot single out from the confusion of our surroundings a specific section, free from the disturbing influences of adjacent areas, and present it to our consciousness in the form of a self-contained, independent picture. The camera accomplishes this each time we take a photograph.

**60**

Unfortunately, the fact that every picture is a self-contained, isolated unit seems so obvious that it usually is not given any attention as such. Yet, since it is inevitable that we isolate a section of reality each time we take a picture, we may as well take advantage of this fact by presenting this area—the subject of the picture—in the strongest and graphically most effective form.

To produce this desirable result, the photographer must present the subject free from non-pertinent, distracting influences, and he must present it in a form that is both characteristic and artistically pleasing. To fulfill these conditions, a photographer must first determine the purpose of his photograph and decide the meaning he wishes it to impart: Is it to state a concrete fact or to convey an intangible feeling? Is the subject to be treated as a specific case, or is it to be considered as representative and therefore symbolic? Is the subject itself to be documented, or should its implications be emphasized? Accordingly, the picture may take the form of a long shot (to show the relationship between subject and surroundings) or a closeup (for the most concentrated documentation by means of maximum rendition of pertinent detail). The quality of the light may be selected for sharp documentation or for symbolization of mood. The key of the picture may be kept lighter or darker in accordance with the mood of the subject. Furthermore, consideration must be given to the contrast range of the photograph: which will be more effective—softer or harder? Finally, the subject must be composed in a way that is both interesting and graphically effective.

## From infrared to ultraviolet

Unlike the eye, which is sensitive to only that narrow band of the electromagnetic spectrum which we perceive as light, photographic emulsions can be sensitized to a much wider wave band, extending from short-wave X rays and ultraviolet far into the region of long-wave infrared and radiant heat. Since these radiations possess properties which are completely unlike those of light, photographs taken with their aid can reveal phenomena which otherwise we would not be able to see.

Whereas most of the applications of these differently sensitized emulsions are of interest mainly to specialists—particularly astronomers and astrophysicists, medical researchers and biologists, physicians (X ray), the military (infrared), and criminologists (ultraviolet)—the infrared-sensitized films, which are available at larger photo stores, can be of use to the average photographer.

Infrared-sensitized films are available in both black-and-white and color. Their main characteristic is the ability to penetrate atmospheric haze, resulting in sharp and well-detailed pictures in cases where the eye can see little except apparently impenetrable fog. In addition, in black-and-white, infrared film renders green foliage generally as white and open water as black. In color, green foliage appears a brilliant red. Special filters are required, and the instructions for use packed with the films must be followed implicitly.

## SUMMING UP AND CONCLUSIONS

Like any other art or craft, photography has its specific scope and limitations. There are certain tasks which photography can do particularly well; others for which it is less suited; still others for which it is not suited at all. To draw a parallel: wood and metal are equally useful materials, but they are not interchangeable. Each obeys particular laws and has its own typical forms, qualities, and applications. No one would, for example, think of making the barrel of a rifle of wood and the stock of steel. Similarly, no good photographer would ever think of using photographic means to imitate painting; nor would any good painter ever strive in his paintings for photographic effects. Those who overstep the boundaries of their medium produce only kitsch.

The scope and the limitations of photography are determined by the potentialities and characteristics of the medium, discussed above, the essence of which can be summed up as follows: A camera is a machine.

Its product, the photograph, is *ipso facto* basically "true." Consequently, any interference with this machine-made precision and any tampering with the truthfulness of the image by means of posing, retouching, or manual interference violates the spirit of photography and automatically leads to bad pictures.

However, as briefly mentioned before, the fact that a camera is a machine does *not* mean that photography is an entirely mechanical process. In my opinion, a camera is a machine only in the sense that, for example, a piano is a machine. Both are of little value in the hands of a person who does not know how to use them. Any child can strike notes on the piano and pick out a simple tune, but nobody would call this making music. And any inexperienced person can snap a picture, but such a snapshot will not necessarily be a meaningful and interesting photograph. In order to produce *good* photographs, a photographer must know and be able to utilize the potentialities of his camera as a good pianist must know and be able to utilize the potentialities of the piano. Only then will he realize that the lens can do *more* than merely duplicate on film the images which he sees with his eyes; that photography is *not* a popular substitute for painting; that *a camera is an instrument for intensified seeing;* and that only he who makes the fullest use of the potentialities and characteristics of photography can consistently produce successful photographs.

## Good, Bad, or Indifferent?

I have referred to *successful* photographs so frequently that I feel it is time to state the qualities which, in my opinion, make a photograph *good*.

I realize, of course, that a specific photograph may mean different things to

different people. The picture that won the highest award at a pictorialist's convention may hold no interest for a documentary photographer, and a hidebound landscape enthusiast may find a nude obscene.

However, although it is obvious that no specific rules exist for classifying photographs as good or bad, I believe it is possible to isolate and define—in more or less general terms—certain basic qualities which are *always* found in *good* photographs and are absent in bad ones. As an example, let us consider impact. Impact is synonymous with shock, a quality which arouses emotion. If a photograph has impact, it will make the observer *feel something*—make him react, take notice, laugh, be saddened, or arouse compassion, love, disgust. Any photograph to which an observer reacts emotionally, which he likes or dislikes but to which he is not indifferent, has impact. And any picture that commands such a response is a *good* photograph because it has fulfilled its purpose. Conversely, a photograph that does *not* produce an emotional response of some kind is without impact and consequently *bad*. This seems true to me regardless of the fact that different people may react differently to the same photograph, the degree depending, among other things, upon their interest and sensitivity. Impact then is one of the qualities which a photograph, in my opinion, must possess in order to qualify as *good*.

When asked, people usually cannot explain exactly *why* they like or dislike a certain picture. But when they see a good photograph, they recognize it as good—usually subconsciously, without being aware of particulars —because it has some or all of the following qualities:

**Stopping power**
**Impact**
**Meaning**
**Graphic qualities**

# STOPPING POWER

It is that quality in a photograph which forces an observer when leafing through a picture book or magazine to consciously notice a specific picture.

Today, people are so satiated with photographs that a picture must be quite unusual to be given a second look. Of course, the photograph of a spectacular event which, photographically speaking, is a "natural" will always command attention. Such pictures, however, are the exception rather than the rule. The majority of photographs depict ordinary people, objects, scenes, and events—subjects which are all too familiar. Without stopping power, photographs of such subjects would go unnoticed in the mass of pictures—and an unnoticed photograph is a wasted statement. Consequently, stopping power is one of the essential qualities of any good photograph, the device which a photographer uses to insure his pictures receive proper attention.

Stopping power in a photograph can be defined as that quality which makes it in some respect outstanding or unusual. It can be achieved in three different ways: by using an unusual treatment which makes commonplace subject matter graphically exciting; by recording only unusual subjects; and by photographing unusual subjects in a graphically exciting form. Needless to say, the first of these possibilities is the one most commonly encountered, while the third produces the most spectacular results.

## Unusual treatment

The average photographer, pointing the camera straight ahead, shoots outdoor subjects at midday in bright sunshine, indoor subjects with flash. Obviously, unusual pictures are produced by a different approach. However, under no circumstances should a novel approach be employed for novelty's sake alone because the resultant photograph would merely be "arty." The approach should always be determined by the characteristics of the subject and the purpose of the picture. The following lists some suggestions:

## Space rendition

The average photographer takes his pictures with a lens of standard focal length stopped down for maximum sharpness of depth, the camera pointed straight ahead. Naturally, all photographs taken under such conditions are more or less alike. Such uniformity can be avoided in three different ways:

1. Instead of shooting with a lens of standard focal length, use either a telephoto or a wide-angle lens.

According to academic tradition, telephoto lenses are used solely to render in sufficiently large scale distant subjects which a lens of standard focal length would render too small. Wide-angle lenses are used solely if the distance between subject and camera is too short to successfully permit the use of a lens of standard focal length. However, both telephoto and wide-angle lenses possess certain inherent qualities which make possible the creation of striking pictorial effects. Long-focus telephoto lenses normally require a greater than average distance between subject and camera and thus produce less distortion, i.e., less difference in scale between near and far objects (or the near and far end of an object), than lenses of standard focal length. As a result, objects are rendered in more natural proportion to one another and often a monumental type of perspective results. On the other hand, short-focus wide-angle lenses allow for shorter than normal distance between subject and camera, and thus through deliberate distortion make it possible to symbolize the concept of nearness and create almost surrealistic space effects. Consequently, even when circumstances are such that a lens of standard focal length could be employed, creative photographers, aware of these possibilities, frequently use telephoto or wide-angle lenses to produce more striking pictures.

2. Instead of shooting horizontally, shoot more or less upward or downward, showing the subject in what is known as a "worm's-eye" or "bird's-eye" view respectively. Of course, such an approach is not always possible and should be used only if compatible with the character of the subject and the purpose of the picture. Specifically, a worm's-eye view

creates a feeling of height and can be used to advantage whenever the subject of the picture is tall, imposing, or symbolic of strength and power. A bird's-eye view gives the impression of depth, symbolizes the feeling of vertigo one has in looking down from a great height, and is one of the most effective means for producing overall pictures which at a single glance explain a complex setup.

3. Instead of stopping down the diaphragm for maximum sharpness in depth, take the picture with the lens more or less open. According to academic tradition, fast lenses are used wide open only if lack of light precludes the use of smaller apertures. However, if the lens is used more or less wide open (a technique called *selective focus*), the photographer can direct the observer's attention to a specific, preselected zone in depth. This zone will appear sharply defined in the photograph, whereas objects beyond and in front of it will appear increasingly blurred the greater their distance from the plane of focus and the larger the diaphragm aperture. The resultant contrast between the sharply defined zone and the increasingly blurred background and/or foreground produces a more convincing illusion of three-dimensionality and depth than that produced by a picture which is uniformly sharp. Consequently, even if it is possible to use smaller apertures, photographers who are aware of this effect frequently shoot with the lens more or less wide open.

### Illumination

As previously mentioned, the average photographer shoots outdoor subjects around noon in bright sunshine, interior subjects with flash. In contrast, a creative photographer utilizes many types of illumination, knowing the characteristics of each and employing them to achieve specific effects. To produce a desired effect in a photograph one must of course be familiar with the various types of illumination; specifically, consider the following "unusual" types:

**1. Diffused light.** Outdoors: light from a hazy or evenly overcast sky; indoors: "bounce light," i.e., light directed against the walls or ceiling.

Diffused light does not cast harsh shadows and therefore is particularly suitable for photographing people.

**2. Early morning and late afternoon sunlight.** Because of the long slanting shadows which it casts, this is a particularly plastic type of illumination eminently suited to landscape and architectural photography.

**3. Backlight.** Light coming toward the camera more or less from the direction of the subject. Backlight is the most dramatic type of illumination, unsurpassed for the creation of stark and graphic effects.

**4. Available light.** The type of illumination existing at the time and place of taking the picture. It is usually more conducive to the production of effective photographs than auxiliary illumination, that is, additional light in the form of photofloods, speedlight, or flash—to which the average photographer resorts whenever the available light is too weak to permit the use of high shutter speeds and small diaphragm stops. Although the use of auxiliary illumination considerably facilitates the production of technically perfect negatives, this practice, unless executed with feeling and skill, easily destroys the mood and atmosphere that are typical of the subject. Many photographs taken in available light are less sharp and more grainy than pictures of comparable subjects taken with the aid of auxiliary illumination. But they don't have the synthetic quality which characterizes most pictures taken with auxiliary light and consequently are more true to life. And, as I will attempt to show subsequently, creative imagination can turn even such apparently undesirable qualities as unsharpness and graininess into the means for producing particularly effective photographs.

**Simplicity**

The simpler and more direct the statement, the clearer and stronger it will be. Try to isolate the subject proper as much as possible and to eliminate all else. Outstanding examples of this approach are certain fashion photographs by Sharland (p. 251) and Avedon which show the models as if suspended in empty space against a uniformly neutral, very light, and

almost substanceless background. Technically, this is accomplished by placing the model within a *light-tent,* which is a boxlike enclosure made of white paper. A completely uniform, shadowless illumination is then produced by directing the light of several powerful lamps (or speedlights) against the walls and ceiling of the tent, illuminating the model with indirect, reflected light. The striking effect of such pictures is characterized by extreme simplicity and clarity of presentation which combine to show the subject—the fashion, the dress—in the strongest graphic form.

The sophisticated approach based upon extreme simplicity is, of course, *not* limited to fashion or indoor photography. With suitable modifications and variations of degree, it can be used advantageously in any other field of photography since one of the few universally valid principles for effective presentation of any subject is simplicity.

## Contrast

Most photographers strive in their black-and-white photographs for a transformation of color into gray shades of corresponding brightness. However, the abstract character of black-and-white photography makes it particularly well suited to a bolder treatment based upon the graphic effects of stark and unadulterated black and white. If symbolization is more important than documentation, color values should be translated into contrast of black and white rather than into corresponding shades of gray. By combining pure black and white with a few well-chosen gray shades, poster effects of surprising stopping power can be created, particularly if the composition is simple and the lines and forms of the subject are clear, bold, and strong.

Tonal simplification is most easily accomplished if a photograph is made through a red filter and printed on paper of hard gradation. I know that one of the first principles of academic photography is to avoid chalky whites and inky blacks. But, in my opinion, there is absolutely no justification for such a rule, and photographers who insist on observing it needlessly deprive themselves of an effective means for creating striking photographs.

## Close-ups

One of the most common faults of the average photograph is that it contains too much subject matter. Typical examples are sweeping landscapes (in which individual objects are rendered so small that the result is completely ineffective) and pictures of people taken "full figure" (in which the center of interest—the face—is rendered so small that it appears almost unrecognizable). The cause of this undesirable impression is, of course, the fact that the distance between camera and the subject was too great. It may be caused by an unconscious desire to reproduce on film as nearly as possible what the eye saw in reality. However, for reasons which were briefly mentioned and will be fully discussed later, a literal translation of reality into picture form is impossible and, if attempted, often leads to disappointing results.

An always successful method for avoiding such undesirable results is to use the camera as an instrument for intensified seeing and render the subject in the form of a close-up. If the subject is a landscape, photograph only a typical detail like a rock formation or a group of trees. If the subject is a skyscraper, crop off its top in your picture and thus make it appear to go up and up interminably. If the subject is a person, photograph only the head. And if you have to make a portrait, show only a section of the face. In other words, close in upon the subject, concentrate on the essential, eliminate the superfluous. By showing less, you actually achieve more—something which otherwise might have been lacking: stopping power.

The superior stopping power of close-ups as opposed to medium-long and long shots is due to three facts:

1. A close-up is a more critically edited version of the subject than an average shot, a more concentrated form of rendition not diluted by surrounding nonessential detail. For this reason, it is a simpler form of pictorial statement, and in photography simplicity is synonymous with clarity and strength.

2. A close-up shows the subject proper in larger scale, with better rendi-

tion of essential detail and texture. As a result, it gives a more significant impression of the subject than a photograph taken from farther away in which essential detail is rendered too small to be effective.

3. Since the majority of photographs are medium-long or long shots, close-ups are still comparatively rare and rare pictures automatically have greater stopping power than ordinary ones.

## Atmospheric conditions

Since most outdoor photographs are taken on sunny days, a simple way to produce photographs that are different is to take pictures under other atmospheric conditions—haze, mist, fog, rain, or snowfall. There is no doubt that sunshine is one of the most elementary and enjoyable pleasures of life. But it is also one of the facts of photographic life that photographs taken in bright sunlight are rarely dramatic—perhaps sunshine is normally too peaceful to be compatible with drama—and that in the long run sunshine pictures become boring.

The two most popular outdoor subjects are landscapes and people. I can see only two reasons why they are photographed mainly in sunshine instead of, for example, in rain: because it is simpler—plenty of light is available for fast and easy shooting; and because it is more comfortable. However, these seem rather poor excuses to someone intent on getting effective photographs. After all, a little effort and discomfort are not such a high price to pay for unusual pictures. Furthermore, there are plenty of rainy and stormy days in the year. Why, then, limit oneself to the documentation and interpretation of life in only one type of weather?

## Unsharpness and blur

Although photographs normally should be sharp and most unsharp photographs are blurred as the result of some error, occasionally unsharpness and blur can serve to symbolize intangibles which otherwise could not be expressed in photographic form. In particular, unsharpness conveys a

feeling of dreamlike unreality, whereas blur, which photographically speaking, is directional unsharpness, symbolizes motion and speed. Unsharpness results if the lens is not sharply focused upon the subject, if the picture is made with a relatively large diaphragm stop, or if a diffusion device was used. Blur is caused by shooting a moving subject with a shutter speed that is too slow to freeze its motion or by moving the camera at the moment of exposure. Both effects will be fully discussed later.

### Film grain

Like unsharpness and blur, graininess is also normally considered a fault in a photograph. However, similar to a discord in music which precisely because of its harshness conveys a feeling which the composer could not otherwise have expressed, so "grain," correctly used, can on special occasions be the only means for symbolizing certain intangible qualities, such as coarseness or brutality. After all, a photographer out to document life cannot limit his activities to recording only its pleasant sides. Frequently, he may have to shock or even outrage the viewer of his pictures to make him aware of his responsibilities as a citizen or of a danger that may threaten him, particularly when reporting on war, crime, or disaster. In such cases, slickly finished pictures easily appear unrealistic, as unrealistic as slickly finished promotion stills from a Hollywood movie. Often, it is precisely the coarseness of its rendition which gives a grainy picture the feeling of harsh reality—as if the photographer had been shooting under pressure while in danger himself and had no time to do a smoothly finished job.

## SUMMING UP AND CONCLUSION

To be fully appreciated, a photograph must be studied. However, before it can be studied, it must of course have caught the eye of the viewer. But only pictures that are different from the run-of-the-mill type photograph will command such initial attention—which is a prerequisite for further appreciation from a public satiated with

looking at photographs. To command attention, a photograph must have stopping power.

However, stopping power alone is not sufficient to make a photograph a *good* photograph. In the competition for the viewer's attention, necessary as this quality is to a picture, it still is comparable only to a flashing light—a device to attract attention. Despite its importance, stopping power is no more than a rather superficial picture quality. Any flashy photograph has stopping power and will thus be noticed but only, as previously said, to be rejected as "arty" or phony. In order to produce the desired effect upon the observer, a photograph, in addition to stopping power, must have two other qualities: impact and meaning.

## IMPACT

Impact can be defined as *emotional* stopping power, stopping power that affects the observer not visually, but emotionally. It is an intangible quality, difficult to describe in concrete terms. Whereas a photograph that has visual stopping power will momentarily catch the eye, a picture that has emotional stopping power or impact will command a deeper kind of attention, its meaning or feeling being bypassed only by those almost devoid of sensitivity.

Before he can create photographs with impact, the photographer himself must feel the emotions which, via his picture, he wishes to impart to others. This is the main reason why I consider genuine interest in a subject one of the first conditions for the making of good photographs. If a photographer does not experience a response to his subject, he obviously cannot produce work which contains any emotional quality—and, just as obviously, an observer on seeing it must remain unmoved.

The reaction of a photographer to his subject may be a sensitive apprecia-

tion of the exquisite construction of a seashell; the awe-inspiring, almost religious serenity felt in the redwood forests of California; compassion for children who have nowhere to play beyond the garbage-littered back lots of big cities. The response may stem from admiration for the talents of an actress or her sex appeal, disgust with an obnoxious politician, or hatred of war. What matters—and what usually makes the difference between pictures with and without impact—is whether the photographer reacted emotionally to his subject, or whether he was indifferent and simply shot the picture as part of his job. In the first case, he may succeed in transferring to his work something of what he felt in the presence of his subject. In the second, he will produce a picture which, for all its worth, might just as well not have been made.

As it is impossible to establish rules for the creation of art, so it is impossible to instruct photographers on how to produce photographs which will have impact. However, although specific rules for the creation of this elusive quality do not exist, it seems to me that certain ideas evolve and that from these certain suggestions can be made. How helpful such suggestions can be, is questionable. Personally, I believe that the work of photographers like Eugene W. Smith, Leonard McCombe, or Ed van der Elsken is emotionally stirring *not* because these photographers follow certain secret rules, *but* because they are sensitive artists who do not photograph subjects which leave them emotionally unaffected.

A photograph that has impact gives the observer some kind of emotional shock. It may be slight, producing a mild response or calling forth comment in appreciation of the thing achieved, or it may create a moving impression which turns the mind to deepening thought. Seeking the cause of such reactions, I analyzed a number of photographs which, as far as I am concerned, have impact. I found that all these photographs had one quality in common: they were genuine. By this I mean that there was about them nothing phony, nothing faked or posed. On the other hand, I have scarcely seen a photograph that was obviously posed, arranged, or contrived that

seemed to me worth a second look. To me, genuineness, naturalness of situation, spontaneity, and absence of unwarranted interference on the part of the photographer are basic requirements for the creation of impact.

This quality of impact can exist independently of good technique. As a matter of fact, some of the most moving photographs I have seen were technically inadequate—grainy, unsharp, or blurred. But far from detracting from a sense of genuineness and realism, such faults actually seemed to heighten these impressions by stating that these pictures were taken in the rush and excitement of the event or in difficult or dangerous situations. In a sense, technically imperfect photographs of this particular kind seem comparable to handmade objects which, in contrast to machine-made merchandise, show small imperfections and irregularities—objects which, precisely because of these faults, are more appreciated and sought after than the technically perfect but somehow impersonal and unexciting article. Furthermore, the fact that a technically bad photograph can exert more impact than a slick and finished picture proves conclusively that technical perfection of this sort is no criterion for the true value of a photograph, and that it actually can be in conflict with the purpose of the picture.

## MEANING

To hold the viewer's attention, a photograph must have something to give. It must have a meaning. It must be informative, educational, exciting, amusing, or inspiring. There is scarcely a limit to the variety of different meanings which can be embodied in photographs: the meaning may constitute an appeal to the heart (for example, a poster for a charity drive); it may be sex appeal; it may be an intent to deliberately shock the viewer into an awareness of some condition by calling attention to it. Refusing to look at shocking pictures is like not daring to look at reality. Some things must be

faced, whether or not we like it. And a meaningful photograph is one of the most powerful instruments for arousing public reaction.

In photography, the unforgivable thing is the meaningless photograph.

Usually, the meaning of photographs taken by professionals is clear: a picture is meant to advertise and promote a product or a service; to tell a story as part of a documenting picture sequence; to provide a record of one kind or another, ranging from portraits to scientific photographs.

Most amateur pictures—casual snapshots and vacation photographs—fall under the heading of personal records and have no meaning beyond this. But another group of amateur pictures exists—those seen in photographic salons and in the pictorial sections of some photo magazines—which, in my opinion, are completely meaningless. One really wonders what was in the photographer's mind when he took such pictures as: coils of rope lying on a wharf; nudes contorted in an effort to casually conceal their faces or parts of their anatomy; old men with beards; old women clutching crucifixes in gnarled hands; spectacles resting on open books; fake monks dressed in burlap; apple-eating freckled boys; and still lifes composed of spun-aluminum plates and vases—the eternal photographic clichés, the pictures without meaning. Consider their modern equivalents: the subject shot with a fish-eye lens when this lens is the last type that should have been used; the "zoomed" time exposure of a girl or a face; the colored gels indiscriminately used in front of photo-lamps; the zebra-striped nude; the "interesting" distortions—heads the size of basketballs; enormous hands or feet; the multiple exposure senselessly repeating the same subject in different colors; the color "posterization" of no particular interest made only because the photographer felt it was "the thing" to play with Kodalith.

Occasionally I ask photographers why they make such pictures. What they reply is in essence: Why not? Others take such pictures and do very well, get them hung in exhibitions and printed in magazines. Why shouldn't I?

This is a futile approach to photography, an attitude which repeats on a smaller scale the lack of individual thinking which exists in our time. People get their opinions ready-made from newspaper columnists and TV commen-

tators who edit and digest the news, slant it to fit a particular policy, and serve it authoritatively to the reader or viewer who, convinced of his own inferiority, forfeits his right to form an opinion of his own, accepts any hogwash as true, and repeats another's opinion until he believes it to be the outcome of his own thinking.

How far uncritical acceptance is part of our civilization is illustrated by the type of advertising to which we are daily exposed: the impressive sounding, completely meaningless terms used in automotive ads—gyromatic, supermatic, ultramatic transmission; oriflow ride, airflyte, dual jetfire engines. What do they mean? Nothing really; as little as the singing commercials or the moronic slogans in cigarette ads: A TREAT INSTEAD OF A TREATMENT, THEY SATISFY, THEY ARE MILDER. Or the paid testimonials: "I drink . . . ," "I use . . . ," "I smoke. . . ." WHO CARES? Apparently too many people do, otherwise hard-headed businessmen wouldn't invest money in this type of ad.

Thoughtless acceptance is also found in the realm of vision. Most people are habitually unobservant and nonselective, being conditioned to see only those things which they are shown in the form of pictures in magazines, in movies, and on television screens. Unfortunately, the subjects presented in these media and the form of their presentation are generally stereotyped, repetitious, and dull. Fortunately, there are some notable exceptions. Most stimulating in this respect are the documentary movies such as Robert Flaherty's *Man of Aran* and *Nanook of the North;* Walt Disney's True Nature Adventures, from *Seal Island* to *The Vanishing Prairie, The Vanishing Wilderness,* and *Cry of the Wild;* and the kind of lively, factual, and imaginatively presented picture story which was most consistently found in *Life*.

Apart from their esthetic value, these examples of photography at its best, through their meaningful approach, can make the observer appreciate heretofore unnoticed aspects of life. In addition, they can serve to teach the student photographer the following interesting facts:

A photograph becomes more interesting and enjoyable the more meaning-

ful it is, the more it gives, and the better it tells its story—i.e., the more clearly and interestingly it is presented.

Provided that a photograph has a meaning, it does not matter to what field or branch of knowledge, science, or art, this meaning applies. Not every subject appeals to *all* people. As long as a photograph says something interesting and says it well, the photographer has not wasted his time. It is partly for this reason that, for example, *Life* was subdivided into different departments—News, Science, Art, Modern Living, Religion, Sports—to assure that everyone could find in it something that was of interest to him.

Photographs of interesting subjects imaginatively presented can promote in people a greater sense of awareness. For this reason, the photographer has an implied responsibility toward his work.

For example, through his photographs of sweatshops taken at the turn of the century, Lewis W. Hine aroused public indignation and contributed much to the abolition of child labor practices. His awareness of the responsibility of the photographer comes out in his words: "There were two things I wanted to do. I wanted to show the things that had to be corrected. I wanted to show the things that had to be appreciated."

And in its May 6, 1946, issue, *Life* ran a story on the shocking conditions in an insane asylum, arousing such storms of protest that sweeping reformations were made. A sequel to this story published in the November 12, 1951, issue of *Life,* showed how much conditions had been improved.

I cite these two examples of responsible photo reporting because they illustrate something which seems important to me: the fact that a good photographer must be unbiased enough to report on both the bad *and* the good. Young photographers in particular, idealistic and impressionable as they are, have a tendency to limit their reporting to the seamier aspects of our society and to neglect documenting the good. This seems wrong to me because, important as it is to point out existing evils, constant unrelieved preaching defeats its own purpose by ultimately making people so used to such evils that they become insensitive to them. On the other hand, an immense amount of good can be accomplished by stimulating example.

Pictures which show the good things in life, the accomplishments great and small, the progress that is being made, provide encouragement and create constructive enthusiasm to contribute to the common good.

Surprising as it may seem, the majority of picture stories that were published every week in *Life* dealt with subjects that are accessible to most photographers: ordinary people doing ordinary things; landscapes; cities and towns; objects for daily use. And although a few of these subjects were shot with the aid of special equipment, the overwhelming majority were photographed—mostly candidly—with ordinary 35-mm. cameras, occasionally supplemented with simple bounce light or fill-in flash.

The number of worthwhile subjects waiting to be photographed is limitless. *Anything in which a photographer is genuinely interested is worth photographing* because if it is of interest to him, it stands to reason that it will also have meaning to some other people. No person is so unique that he cannot find others to share his interests. If you are an amateur looking for picture possibilities without actually knowing where to look, I suggest that you look where your interest lies. What do you like to do? Travel? Fish? Hunt? Ski? Sail? Garden? Are you interested in automobiles, new or classic? Girls? Stamps? Flowers? Dogs? Or are you interested in sociological problems and people, their activities, the way they live? And by interested I mean *genuinely,* with sympathy and understanding, not "because people are good subject matter" and "character studies" are always accepted by photographic salons.

Actually, it does not matter *what* you photograph, nor *how* you photograph it, as long as you don't surrender your inalienable right to express your personal opinion in picture form by identifying yourself with a group or school which dictates what you must do; as long as you photograph *what you like in the way you think it should be done;* as long as you know *why* you do it; and as long as your work is the outgrowth of conviction.

If this comes out in your photographs, people may still disagree with you, but no one will be able to question your integrity as a photographer, and your pictures will have meaning.

A person may be highly idealistic, compassionate, and understanding toward people. He may be perceptive of his surroundings and gifted with imagination. But these qualifications are wasted unless he knows how to present his ideas effectively on film and sensitized paper. For although a photograph is the product of a machine, photography is a medium of such flexibility that it is always possible to depict a subject in many different ways. From these, the photographer must select that which is best suited to bring out the characteristic qualities of his subject and to produce the kind of picture he wants. To be able to do this, he must be familiar with the whole complex of photo technique.

Photo technique is the only phase in the production of a photograph that can be taught. For this reason, and because of its undeniable importance to the outcome of the picture, it has become the subject of innumerable books and articles, most of which, however, more or less neglect to point out that photo technique is only *one* factor in the process of making a photograph. As a result, the value of photo technique is so exaggerated that it completely overshadows the importance of the other factors. The inevitable consequence of this attitude is, of course, the fact that photographs are most frequently judged *not* according to their story-telling qualities (as they should be), but according to their technical excellence. Many people—not only laymen, but also such professionals as editors and art directors —automatically and unthinkingly prefer a photograph which is sharp and smooth to one that is blurred and grainy, even if blur or grain were precisely the means which the photographer deliberately used to symbolize intangibles which he could not otherwise have expressed in picture form.

**pp. 27, 198–201**

Anyone who wishes to make good pictures must overcome this academic attitude. For instance, in a still photograph that is perfectly sharp, it is almost impossible to create a convincing impression of motion. No difference exists between the picture of an automobile traveling at ninety miles per hour and another one of a car that is standing still—*if both photographs*

are *equally sharp*. However, the fact that an automobile is traveling at high speed may be the very reason for taking the picture (for example, in covering a race). How, then, does a photographer expect to indicate the high speed of the car in his picture if he uses an exposure short enough to "freeze" its motion? The only way to create an impression of such motion in a still is through blur, a so-called fault; the more blurred the image of the speeding car, the more pronounced the feeling of speed.

In my opinion, the whole complex of photo technique can be divided into two stages. First, we have what might be called the *elementary techniques*—exposing, developing, and printing. These techniques are subject to specific rules. But in addition to these elementary techniques, we have in photography a large number of *selective techniques*. These techniques, which are based upon the choice and utilization of different types of photo equipment and material—lenses, filters, films, developers, papers—are extremely flexible. They give the photographer great freedom in interpreting his subject and allow him to select precisely the best form of space rendition, color translation into shades of gray, extent of contrast range, overall key of the picture, and motion symbolization. These will be discussed in the chapter on *The Picture*. p. 203

## THE TEST OF TIME

One of the criteria by which art experts and critics judge the artistic value of works of art is to observe how well they stand the test of time. Paintings and sculpture which defy academic tradition are at first almost invariably rejected by the contemporary public, whether created by the French Impressionists of the last century or more recently by Picasso or Henry Moore. However, as the years go by, people begin to see that what once seemed strange because it was unfamiliar, was actually only the inevitable projection of tradition into the future. And as time catches up with the work

which was too advanced to make sense when it was originated, its real value becomes apparent since now it can be evaluated and appreciated in its proper relationship to the work that preceded it and by which it is followed.

A somewhat similar process of gradual evaluation and acceptance or *final* rejection seems to go on in photography. Almost without exception, the work of experimental photographers who question the validity of academic tradition is at first ridiculed and rejected as a fad. Without going into the history of photography, I need only mention such violations of photographic tradition as the discovery by the German photographers of the early Twenties of the significance of the close-up; the value of angle shots and converging verticals for the expression of dominance and height; the replacement of flash with available light which followed the candid work of Erich Salomon; the utilization of photographically precise rendition of texture and detail which was pioneered by Edward Weston; and the deliberate use of controlled unsharpness and blur as means for suggesting emotional intangibles, movement, and action by the documentary photographers who were the first to utilize the full potentialities of the 35-mm. camera. These typically photographic means of expression—once called fads and worse—are now accepted as a matter of course and used by progressive photographers and photo journalists all over the world.

Realization of this should cause one to reserve judgment on new approaches in photography until the spell of novelty has worn off. One often tires of what at first seemed exciting merely because it was new. More frequently, in time one learns to appreciate what at first one did not understand.

On a more personal scale, application of the test of time can be used by anyone to test the value of a photograph—at least as far as he is concerned. If you were impressed with a photograph when you first saw it, and if you still think of it at times as months or years go by, then you can be sure that it was good.

Because a powerful and stirring photograph is an emotional experience which one remembers.

Whether or not a photograph can be a work of art is an old and still hotly debated question. If I seem to bring it up in this book, it is not because I want to prove that photography is "Art"—a topic which I consider immaterial—but because I believe that a discussion of the relationship of photography to the fine arts, and painting in particular, can be profitable to any photographer who strives for a deeper understanding of his medium. For the same basic principles underlie any kind of creative work. No matter whether or not one regards photography as one of the arts, application of these principles to the making of a photograph is bound to benefit the picture.

## WHAT IS ART?

Probably no other word in the English language is so loosely defined and has so many connotations as *art*. To be sure that the reader understands my usage of the word *art*, I must begin with a precise definition of its meaning.

My dictionary lists ten different connotations of art. The most relevant reads: *Application of skill and taste to production according to aesthetic principles*. It is a rather vague and unsatisfactory definition.

John Sloan in his book *Gist of Art** gives us some much better definitions; for example: "*Art is the result of a creative impulse derived out of a consciousness of life*"; but he adds that this "*definition of art does not specify good art*" (p. 19).

---

* John Sloan, *Gist of Art* (New York: American Artists Group, Inc., n.d.), pp. 19–38. Reprinted by permission.

In the same book, Sloan says: "*Art is the response of the living to life. It is therefore the record left behind by civilization*" (p. 21).

And: "*There never will be any standard of art. What a terrible thing it would be if everyone knew and agreed upon what was good. . . . Anything is art that originated as a response to life*" (p. 31).

And: "*I believe there is no progress in art. While we may derive our impulses from different subject matter than the artists of four hundred years ago, the underlying purpose is just the same. The man who scratched his concepts of animals on the roof of a cave in Spain thousands of years ago, just had a space to work on and something to work with and he put down his ideas. That is what the artist does today. I never could agree with the ultra-modern artists who wanted to burn the paintings in the museums, implying that what they were doing was progress. There isn't any advance. Some art is greater than other art, but there is no change in the inherent character of art. The mental technique today is the same as it was fifty thousand years ago. . . . Art springs from an interest in reality, the concept of the thing itself*" (pp. 22–23).

And: "*You can be a giant among artists without ever attaining any great skill. Facility is a dangerous thing. When there is too much of technical ease the brain stops criticizing. Don't let the hand fall into a smart way of putting the mind to sleep. . . . Some things are too well done and not done well enough. . . . On the other hand, don't be fooled into thinking your work is better than it is because the technique is fumbling*" (p. 38).

Vincent Van Gogh wrote: "*I still can find no better definition for the word art than this: Nature, reality, truth; but with a significance, a conception, a character which the artist brings out in it and to which he gives expression; which he disentangles and makes free and clears up.*"

Summing up the essence of these definitions of art by two authorities whose competence is beyond question, and condensing it into one sentence, one might conclude: *Art is creative response to reality and life, and a work of art is the organized subjective expression of this response manifested in any one of many different media, from cave painting to photography.*

**84**

For it is a fact that although both Van Gogh and Sloan were thinking of painting when they defined their concepts of art, their definitions also fit photography.

For what it is worth, here is my own definition: *Anything created by man in a constructive spirit from honest conviction which moves me emotionally is a work of art, be it a painting, a poem, a building, or a photograph.*

# THE PLACE OF PHOTOGRAPHY

Compared to the fine arts, photography is such a relatively new medium that it is still difficult to assign it a place in proper relationship to other arts and crafts. However, I believe that an attempt to define the place of photography can be of practical value to both photographers and laymen because it may help them to realize more clearly the aims, scope, ramifications, and limitations of photography.

Creative thought progresses along two main branches: science and philosophy. Science collects and evaluates facts in terms of measurement and is analytically descriptive. Philosophy evaluates the results produced by science, relates them to human experience in general, and gives them purpose and meaning. The scientist searches for facts and knowledge, the philosopher for values and wisdom. Science creates technology; philosophy leads to art. At its best, photography seems to me to combine the essence of both these disciplines.

The technological-scientific contributions to photography are of course evident in the mechanics of the camera, the optics of the lens, the chemistry of photographic emulsions and processes, and the factual-objective precision of rendition inherent in the machine-made picture. The artistic-philosophical content is found in the esthetic values, the meaning, and the impact of the photograph. No wonder then that it is impossible to decide whether photography as a medium of expression is primarily mechanical or

artistic—a craft or an art—since obviously it is a *synthesis of both technique and art*. Without the contributions of science in the form of the appropriate instruments, materials, and methods, no photograph could be made. Contrariwise, without its content of philosophical or artistic values manifested in the meaning and form of presentation of the picture, even a technically faultless photograph is nothing but an empty shell.

A *good* photograph is the subjective interpretation of a manifestation of reality through use of mechanical means.

But isn't this basically true of any work of art?

For example, let us consider a piece of modern sculpture, say, a figure by Henry Moore. Although it is a highly abstract version of the human form, no one can deny that it is a "subjective interpretation of a manifestation of reality." For in one way or another, art is always a reflection of reality. The human mind cannot conceive of anything of which it does not have explicit knowledge. As proof I need only mention the inability of the human mind to grasp the concepts of infinity and infinite space, not to mention the impossibility of visualizing four-dimensional space. Or the impossibility of imagining a new color that does not exist in nature. Even the fabulous monsters and devils invented by medieval painters consist merely of parts of the human anatomy and those of various animals imaginatively combined.

We can be sure that even the most highly abstract work of art is based upon nature and reality. However, it is nature evaluated and re-created in the light of the experience of the artist. In creating any work of art, man always contributes something of himself to his work. Without such contribution, all anyone can ever produce are more or less imperfect *reproductions* of reality. It is precisely this *subjective* contribution of the creative mind which elevates man's work to art; it is the factor which, as Lewis Mumford puts it so expressively, distinguishes a creator from a creature.

But let's go back to Henry Moore. Regardless of how creative the concept of a work of art, in order to become tangible it must be realized in some physical way: on canvas, paper, or film; in wood, stone, or metal; with

brush, pen, or camera; by chisel, grinder, or polishing disk; on violin, piano, or guitar. For any work of art is subjective interpretation of a concept, a vision, a thought, or a manifestation of reality *through the use of mechanical means*.

Now let's see how well this definition applies to photography. No one denies that a photograph is produced *through the use of mechanical means*. However, doubts will unquestionably be voiced as to whether a photograph can be a subjective interpretation of anything. In other words: How great is the photographer's control over his medium in regard to the subjectivity of the interpretation?

## SUBJECTIVE CONTROL IN PHOTOGRAPHY

Despite the fact that a photograph is produced by mechanical means, photographers who are perceptive to differences in degree of the various components upon which their pictures depend, have an astonishingly large measure of control over the final appearance of their work. This control can be exerted at four different stages:

**1. Selection.** As a painter chooses his subjects in accordance with qualities which make them particularly suited to rendition in the form of a painting—no matter whether naturalistic or abstract—so a creative photographer selects his subjects on the basis of photogenic qualities— p. 116 qualities which make them particularly suited to rendition through the utilization of typically photographic characteristics. For he knows that no matter how interesting, important, or emotionally stirring they are in themselves, unphotogenic subjects can never make *good* photographs. And p. 117 of what use is it to render subjects which by their very nature can never become effective in photographic form?

The validity of this reasoning is by no means negated by the fact that unphotogenic subjects are constantly photographed by photographers who

either lack the perceptiveness to distinguish between photogenic and un-photogenic subjects or have to satisfy a client, be it the editor of a picture magazine or the art director of an advertising agency. However, such photographs merely serve to illustrate my point. The dullness of this type of picture proves that unphotogenic subjects should be left to artists working in other media—painters, illustrators, sculptors, writers. For whereas the photograph of a *photogenic subject* may show at one glance something that could not be expressed half as eloquently in words, so literary subjects exist which, although hopelessly unphotogenic, make stirring and exciting reading when handled by a good writer.

p. 97

**2. Timing.** Even a basically photogenic subject does not always appear at its best when first seen by a photographer. The angle of approach, the direction of view, the quality of the illumination, the time of day, the season, or the atmospheric conditions may not be favorable. If movement and action are involved, the photographer may hit a dull moment when first encountering his subject. In such cases, a photographer can choose to shoot the subject as he finds it (making excuse for his ineffective picture with an unconvincing "That's the way it was"), or wait and take the picture when conditions have improved sufficiently to enable him to get the type of photograph he really wants. Needless to say, good photographers are fully aware of the importance of this kind of timing.

**3. Approach.** Any subject can be photographed in an almost infinite number of different ways. No two photographers tackling the same subject with identical equipment under identical conditions will ever produce identical pictures; and the more creative and imaginative they are, the more different their versions of the subject will be. For example, one of the subjects most often photographed is the city of New York. To see it from a new point of view seems impossible. But Ernst Haas produced a series of pictures of New York which was so completely new in concept, so stimulating, and so provocative, that the editors of *Life* devoted twenty-three pages in the magazine to them (September 14 and 21, 1953). And when fashion photography seemed to have run into a dead end, along came pho-

tographers like Richard Avedon, Erwin Blumenfeld, and Hiro, who photo-graphed seemingly dull and stereotyped subjects in breathtakingly new and exciting ways.

Such differences in result are caused by differences of approach. Because specific stimuli produce different reactions in different people—depending upon a person's background, training, sensitivity, perceptiveness, interest, and imagination—*different people see different things in one and the same subject*. And the more imaginatively gifted and photographically articulate they are, the more clearly will such differences show up in their pictures —until finally they develop a style of their own. As any art expert can tell, without knowing the painting or looking at the signature, whether it is the work of Cézanne, Van Gogh, Renoir, or Gauguin, so an experienced picture editor can tell, by recognizing the style, whether a photograph was made by Edward Weston, Blumenfeld, Halsman, Karsh, or Eugene W. Smith.

**4. Technique.** Different photographs taken of the same subject can produce very different impressions, depending upon whether they show the subject in the form of a long shot or a close-up; whether they are taken with a standard, telephoto, or wide-angle lens; shot through a yellow, red, or blue filter; illuminated by front, side, or back light; rendered sharply, diffused, unsharply, or blurred; printed lighter or darker; enlarged on paper of high, medium, or low contrast. In other words, as far as the technical side of producing a photograph is concerned, a photographer is free to choose from a large variety of means and methods, each producing a different effect. As a result, if a photographer knows what he is after in a picture and is a competent photo-technician, he has an astonishingly high degree of control over the appearance of his picture. For example, by using an appropriate type of illumination, he can make a dark subject appear light or a light subject appear dark. By accordingly selecting his viewpoint and a lens of a particular focal length, he can make space appear deep or shallow, control the size and relative proportions of the components of his picture, and give his photographs any desired scale. By shooting with a

suitable shutter speed, he can suggest, emphasize, minimize, or obliterate at will the impression of motion. And so on.

In practice, this high degree of control effectively offsets certain restrictions to which a photographer, in contrast to a painter, is subjected—restrictions which result from the technical nature of photography, but which can largely be overcome through selection of the appropriate means and techniques.

## A NEW FORM OF ART

Approaching the end of my analysis of photography and evaluating the result, I feel it is legitimate to say that photography is a completely new form of art. Not a craft, but an art. My reasons for this conclusion are as follows:

A craft is a strictly manual art based upon dexterity and skill. But, as I have tried to show, the making of good photographs requires *more* than manual dexterity and skill; it requires thought, feeling, perceptiveness, imagination, and taste. And these are qualities which belong to the province of the artist.

The practitioner of a craft is a craftsman, an artisan, but not necessarily an artist. However, since the making of good photographs requires artistic qualities, it follows that photography must be more than a craft; it must be an art. And the good photographer must also be an artist.

Photography should be judged not by its worst, but by its best examples. A poor photograph, of course, is no more a work of art than a poor painting. But despite the fact that there are infinitely more paintings without artistic merit than paintings that are great or even good, no one denies that painting is an art. Similarly, although the percentage of bad to good may be even higher in photography than in painting, no one can deny that a photograph can be as emotionally stirring as a great painting—although

each affects us in a different way. But then, a painting also affects us differently than music or poetry; this is only natural since painting, music, and poetry are different forms of art.

I believe it is time to recognize photography as one of the arts, *not* because I wish to flatter myself or other photographers or to make us feel important as a group, but because I believe that it is justified by the results that have been achieved in this field.

Recognition of photography as an independent form of art automatically implies that it is subject to its own specific laws and limitations. Photography is not a substitute for painting, and a photographer is not a pseudo-artist who must assuage his inferiority by imitating as far as possible the effects of the finer arts. Accepting this, and once rid of the compulsion to imitate, photographers in general would feel more inclined to fully utilize the typical characteristics of their *own* medium. They would take pride in being photographers.

Recognition of photography as an independent form of art would also imply that a photograph at its best has artistic value. As a result, photographers would become more conscious of the fact that theirs is not a rigid, mechanical medium, but one which permits them to express individuality, thought, perception, imagination, and taste. They would realize more clearly that personality is more important than equipment, that know-how is valueless unless guided by "know-what" and "know-why." They would raise their aim and, conscious of their responsibility, would try to give content and meaning to their work.

Furthermore, photographers would realize that photography and painting, though equal in the arts, are two completely different media of expression—as different as painting and music, or sculpture and poetry. They would see that a painter creates by building up his composition, by adding form to form, whereas a photographer creates through selection and rejection. One works by addition, the other by subtraction, although in the end the result is the same: condensation, simplification, organization, clarification—because these are the basic principles of art.

## SUMMING UP AND CONCLUSIONS

Regardless of whether or not photography is considered a form of art, it is a medium of communication in its own right—equal to, although different from, painting or writing—and, like any other form of communication, subject to its own specific laws and limitations.

Quarrels concerning the acceptance or rejection of photography as a form of art are pointless because they contribute in no way to the improvement of anybody's pictures. What is important, because it can lead to the making of more effective photographs, is awareness of the dual nature of the photographic medium: the fact that the best photographs are based to approximately equal degrees upon technique and art.

Realization of this should enable a photographer to improve his work in three ways:

1. Through deliberate utilization of the technical aspects of photography, by using the camera to make discoveries in the realm of vision, a photographer can show things which otherwise could not be seen because of limitations of the human eye, thus contributing to man's knowledge.

2. Through deliberate utilization of the artistic aspects of photography, he can produce photographs which show everyday objects from new and stimulating points of view—making people aware of heretofore unnoticed beauty—and thus contribute to the esthetic pleasures of life.

3. By combining the technical and artistic aspects and resources of photography when documenting reality and life, he can produce meaningful and moving photographs which can help people to better understand themselves, their neighbors, and peoples of other nations, thus aiding man in the quest for universal understanding and peace.

Although it is the youngest of all the arts and follows its own specific laws, photography is subject to the same universal and timeless principles. From the substance of his surroundings, the photographer gathers impressions which he evaluates in the light of his own experience, interest, and personality. Discrimination, selection, and rejection precede the making of his picture. Organization and clarification transform his raw material into a form which through abstract graphic black-and-white, symbolic suggestiveness, and dramatic intensity of presentation can surpass by far the impressions which the eye received at the moment the picture was made. If this is achieved, reality is transformed into art.

# 2

## The Subject

### A CHOICE OF APPROACHES

Most photographers take photographs of specific, predetermined subjects. Since their interest is in the subject, and the photograph only a means to an end, the subject is the most important component of the picture. The other factors which contribute to the making of a photograph—the tools and techniques of execution, composition, and style—play only subordinate roles in determining the significance and value of the picture.

Other photographers take a different approach. To them the camera is a means for self-expression. Their photographs reveal more about themselves than about the subject. Their picture-taking is driven by the same creative urge that forces painters to paint. As long as they can make photographs, they do not particularly care what kind of subject they photograph. They take their cameras and go out in search of subject matter in much the same spirit that a painter takes his easel, paints, and canvas and goes out to paint whatever catches his eye and imagination.

Although these two approaches are diametrical opposites, neither is better than the other. Each can lead to the production of fine photographs, provided that two conditions are fulfilled:

1. *The approach must be compatible with the personality of the photographer.* The first approach is that of a professional photographer, a

photojournalist, a documentary photographer, or a scientist whose objective is to record specific subjects. The second is that of an artist in search of material for creative work.

An artistic person forced to use the first approach is likely to feel too hampered to do his best. This has been proven again and again in cases in which highly talented photographers were assigned by picture editors to cover specific subjects. Very often they failed, although when left to their own devices and free to execute their own ideas, they did outstanding work.

On the other hand, an inartistic person using the second approach is likely to fail because he has too much freedom of choice but not enough sensitivity to make the right decision. Unable through lack of artistic ability to recognize subjects suitable to creative work, he usually takes the way of the insecure and imitates the work of others. This fact accounts for the flood of pictures of winding roads and brooks composed in accordance with academic demands for leading lines and S-curves; the view carefully framed by branches or doorway; the nudes in senseless poses. If such photographers would forsake this kind of picture, adopting instead the first approach, they could immensely improve the quality of their work.

2. *The subject must be compatible with the characteristics of the photographic medium* (pp. 48–62). It must be suitable for rendition with typically photographic means. This applies regardless of whether one chooses the first or second approach, whether the photographer is a professional or an amateur, or whether he shoots pictures on assignment or solely for his own satisfaction.

Modern photo-technique is so highly perfected and flexible that there is scarcely anything—from germs to galaxies—that cannot be photographed. However, from this abundance of subject matter some pictures are produced which are interesting and even exciting, whereas others are uninteresting and dull. In my opinion, the causes of such dull and ineffective photographs are threefold:

*1. The photographer was not competent* to handle the specific job. Ways and means for extending the scope of a photographer's work will be discussed in the chapter on *The Picture*.     **p. 203**

*2. The subject was unphotogenic*, i.e., unsuitable to rendition by typically photographic means. The qualities which make a subject photogenic will be discussed elsewhere.     **p. 115**

*3. The subject had no viewer interest*. It was trite, hackneyed, or had been "done to death"—the typical photographic cliché. Rendition was derivative.

## PHOTOGRAPHIC AND LITERARY SUBJECTS

As an aid in determining whether or not a contemplated shot is likely to come off, subjects can be classified in two categories: photographic and literary.

**Photographic subjects** are those that have qualities which make them suitable to visual rendition. These characteristics will be discussed later.     **pp. 115–116**

**Literary subjects** are those that have qualities which can be expressed adequately only in words—subjects which stand as symbols, subjects with a story behind them. As an example, let's take a battle monument—the more or less stereotyped figure of a general on horseback. In themselves, most     **p. 100**

such monuments are extremely dull and without artistic merit. They stand as symbols, the interest being primarily in what they represent: a symbol of something that cannot be photographed, a cause won or lost for which men died, the reverberations of battle, agony, heartbreak, and pride. The *real* story is the story behind the monument, the story that effectively can only be told in words.

Other examples of literary subjects are the house in which a famous personality was born; the celebrated view from the lookout point where four different states can be seen simultaneously; all objects of "historical interest" but undistinguished appearance; the theater, particularly the drama. Experienced photographers know that such literary subjects generally make disappointing pictures and stay away from them.

## TANGIBLE AND INTANGIBLE SUBJECTS

People and objects are tangible subjects, feelings and moods are intangible subjects. It may seem as though only tangible subjects can be recorded by the camera, for how can one photograph a feeling? However, although many of us may not realize it, we constantly photograph intangibles. For example, the people we photograph are subject to emotions which are mirrored in their gestures and faces; objects and events appear in different moods in accordance with the conditions under which they are seen.

As part of a series on great mathematicians, *Life*'s Alfred Eisenstaedt once had to photograph Oswald van Veblen. To the average photographer, this may seem an easy job: take a close-up of the face, well lighted and sharp, and there you are. Or are you? Would such a picture give more than a physical likeness? Would it show who the man is, what he does? Would it make it clear that van Veblen is one of the great thinkers of our time? Obviously not.

Now turn to page 33 and see how Eisenstaedt solved the problem. First of

all, notice that he did *not* take a close-up of the face, since he needed space to photographically express the kind of work which van Veblen does. Van Veblen is primarily a thinker. This presupposes quietness and solitude. The emptiness of blackboard and memo pad suggest this. They are ready to receive the flow of thought. The problems van Veblen deals with are of a magnitude far beyond the comprehension of the average brain. He needs time. And his perfect relaxation suggests precisely the feeling of endless time. One senses that this picture is genuine, not posed. Notice the hand holding the spectacles which van Veblen took off to shut out everything that might interfere with his thoughts. Consider the gaze that penetrates beyond the wall, contemplating the universe.

This photograph is *more* than just a portrait of a man. To me, it suggests thought more convincingly than Rodin's famous statue *The Thinker*. It is one of the truly great photographs. And it is great because Eisenstaedt succeeded in photographing an intangible concept: thought.

Confronted with the finished result, almost any photographer can analyze a photograph and see whether or not it is good. What makes a *good* photographer is the ability—based upon knowledge, perceptiveness, and imagination—to know what to look for, to know how to get it, *to visualize a picture before it is made*.

One of the great, one might even go so far as to call it classic, picture stories which is based almost entirely upon intangibles is Eugene W. Smith's "Country Doctor" (*Life*, September 20, 1948). For a period of six weeks, Smith accompanied Dr. Ceriani on his visits in and around Kremmling, Colorado, and recorded not just persons, places, and events, but feelings and moods, hope and despair, drama and tragedy, mirrored in the anxious faces, in the gestures and poses of doctor, nurses, and patients. And on the last page of his essay, as in the final chords of a symphony, he sums up in one great picture the feelings which the country doctor experienced during p. 36 his strenuous day when, utterly tired, he relived its events over a cup of coffee. The expression of kindness and compassion captured in this photograph is extremely moving.

An intangible quality immediately recognized by anyone is sex appeal. Sex is one of the most powerful forces in life and to ignore or negate it is to deny life itself. No photographer of women can afford to do this, since pictures of beautiful girls that do not express sex appeal are failures.

Although any definition of sex appeal is as subjective as a definition of beauty or art, one thing seems clear to me: sex appeal has nothing to do with nudity. A photograph of a female nude can be deadly dull and boring; it can be as chaste and pure and beautiful as a classic statue; it can be vulgar and lewd; or it can vibrate with sex appeal. Sex appeal can be caught in a photograph only if the subject appears *alive*. To my mind, Marilyn Monroe's enormous sex appeal derived—in addition, of course, to her physical endowments—primarily from this quality of aliveness. Other actresses may have better figures, bigger bosoms, narrower waists, longer legs, or may be more scantily dressed; but, lacking Marilyn's vitality, they can never hope to become the popular sex-symbol that she was. The surest way to kill the feeling of sex appeal in a photograph is to resort to an arty pose, a deadpan face, a frozen "Hold it!" grin. If a photographer wants to capture this essence of femininity in his photographs, he needs of course a model who has sex appeal. But beyond that, it must be evident that she *enjoys* being a woman.

p. 97 Intangibles can, of course, be evoked not only by people, but also by things. The battle monument previously mentioned as representative of a literary subject, for example, might call forth in a photographer memories of his own past, the thoughts and feelings he experienced as a soldier. Can they possibly be mirrored in a photograph? Perhaps to some extent, but only in symbolic form: if the monument were shown in silhouette, black against a blazing sunset sky, with rays breaking through stormy clouds, a feeling of drama might be created which would signify in the darkness of the clouds the might of battle and in the rays of light the future victory.

As a *Life* photographer, I have covered many assignments wherein success or failure depended primarily upon the degree to which intangibles could be expressed in photographs. I especially recall two picture stories, "The

**100**

Fighting South" (*Life*, July 6, 1942) and "American Legends" (*Life*, February 5, 1945). Both depended entirely upon the symbolization of intangible qualities. In both, glimpses of American history and folklore had to be illustrated photographically, but the objects that were available for this purpose were more or less insignificant in themselves and sometimes had no direct connection with the story at all.

To mention a few examples: in "The Fighting South," one of the captions read: *Jackson came from the soil of the South*. The accompanying photograph showed a primitive southern log cabin on a very low horizon silhouetted against a sultry, thunderous sky with rays of light shooting through breaks in somber clouds, lining their edges with silver.

Another caption read: *At Franklin, the South lost seven generals*. The accompanying photograph shows a view along the back gallery of the mansion where five Confederate generals were laid out after the battle. The deliberately dark key of the picture which was shot shortly after sunset created the mournful mood which was desired.

A third photograph had to illustrate the splendid enlistment record of the little southern hamlet of D'Lo. Its caption read: *The young men of D'Lo have gone to fight*. The picture shows the entrance to the D'Lo post office seen from within, looking out toward the street. The only people in the picture are two boys in their early teens, standing beside a bicycle just outside the door idly gossiping. A sign, POST OFFICE, D'LO, MISS., hanging from the roof of the gallery, is visible above their heads and identifies the picture.

For the essay "American Legends," symbolic pictures had to provide suggestive backgrounds for legendary figures—Blackbeard, Davy Crockett, Paul Bunyan, Judge Roy Bean, and others. The picture that was used in connection with Blackbeard was a photograph of a desolate beach near Ocracoke Inlet, N. C., where the pirate had one of his hideouts. A piece of wreckage from the hull of an old sailing ship—heavy timbers half buried in the sand rotting under a blazing sun, the white line of the surf in the background—is the subject of the picture.

The photograph which was chosen to symbolize the story of Joe Hill, the "Wobbly," was a picture of the Utah State Prison in Salt Lake City where he was executed. Looking down through a barred window into the prison yard, it was taken from inside one of the watch towers, an armed guard sitting in the foreground, guns standing ready in a rack by the side of the window through which one sees the prison wall against which Hill was shot.

The life and legend of Davy Crockett, the crack shot, was symbolized by a close-up of an old Kentucky rifle standing against the corner of an old shack somewhere in the Tennessee mountains.

In the examples described above, the objective of each picture was to create in the observer a receptive mood for the legend. In each, the actual subject of the picture was in itself more or less insignificant. The effect of the photograph resulted rather from the mood created by the symbolized rendition of intangibles: the desolation of the lonely beach and the significance of the wrecked ship; the grimness of the prison yard and the menace of the riot guns; the readiness of the old Kentucky rifle leaning against the wall of the shack, as if Crockett had put it there himself only a few moments ago, expecting to return and grab it momentarily.

Any photograph that merits the term *creative* illustrates in symbolic form something that cannot be rendered directly. This can range from the obvious to the most subtle—from the pleasure of travel suggested by the gay railroad and airline posters to the portrayal of deeply felt emotions.

Photographers are constantly confronted with the need to suggest intangibles in their pictures. Any good advertising photograph, for example, is not only a record shot of some product or appliance, but also a symbolization of intangibles—like dependability, perfection, durability, safety, power, strength, beauty, or any other desirable quality which may induce a prospective customer to buy the product which it depicts. The degree to which a photographer is able to suggest such intangibles in his pictures is a good measure of his sensitivity, artistic ability, imagination, and technical skill.

# DYNAMIC SUBJECTS

Subjects and fields of photography representative of this category are:

People, including candid portraits
Action photography, including people at work and play
War photography
Animals, including wild life photography

The main characteristics of dynamic subjects are motion and action. Action implies change and, like the pattern in a kaleidoscope, the pattern of events is never precisely repeated. Whether the subject is an automobile race, city traffic, a flock of sheep grazing, a boxing match, a football game, a group of children at play, or simply two people conversing, no two moments will ever be exactly alike as far as subject pattern is concerned. Arrangement, juxtaposition, overlapping of forms will differ. In animal and wild life photography, for example, hours, days, and even weeks of laborious preparation, stalking, or patient waiting may afford only one single moment when location, range, light, background, and pose are just right. Unless the photographer gets the picture at that moment, all preparation is wasted, for he may never have another such opportunity.

Photographers can expect to get dramatic pictures of dynamic subjects only if two conditions are fulfilled:

1. The decisive moment must be recognized. In order to capture this all-important instant, the photographer's undivided attention must be focused upon the action or event which is the subject of his picture. This presupposes perceptiveness, alertness, and in certain cases—for example, in photographing athletic events or animals—familiarity with the rules of the game or the habits of the animal.

The more rapid, the more animated a conversation becomes (for instance, during an interview), the more dramatic the moment (spectators at a game or in a courtroom), the tenser the situation (athletes during a competition or a defendant in court), the greater the range of reactions reflected in faces

(Text continued on p. 113.)    **103**

The following insert contains seven photographs of "The City" by Andreas Feininger. Normally, pictures of city scenes and life are among the most common of all photographs; they also are among the dullest. Why? Because the photographer—carried away by the stimuli of bustling life and activity, traffic, skyscrapers, advertising signs, and noise—completely loses his head, indiscriminately shooting everything that excites him and failing to distinguish between the common (or unfamiliar) and the significant.

The following photographs were carefully chosen to illustrate specific means by which a photographer might heighten the significance of his pictures. For example, he might photograph a skyscraper with its top in the clouds, literally "scraping the sky," or indicate that a neighborhood is predominantly Jewish by including in the picture advertising signs written in Hebrew. In this way, by keeping his eyes open, observing his subjects carefully, and including in his pictures visual clues to otherwise intangible qualities, a photographer can considerably strengthen the impact of his city photographs.

The R.C.A. Building, Rockefeller Center, New York. Its upper stories veiled by low-hanging clouds, its top scraping the sky, the structure appears even taller than it does in sunshine. With nothing to indicate its actual height, the observer is free to imagine story upon story in never-ending tiers.

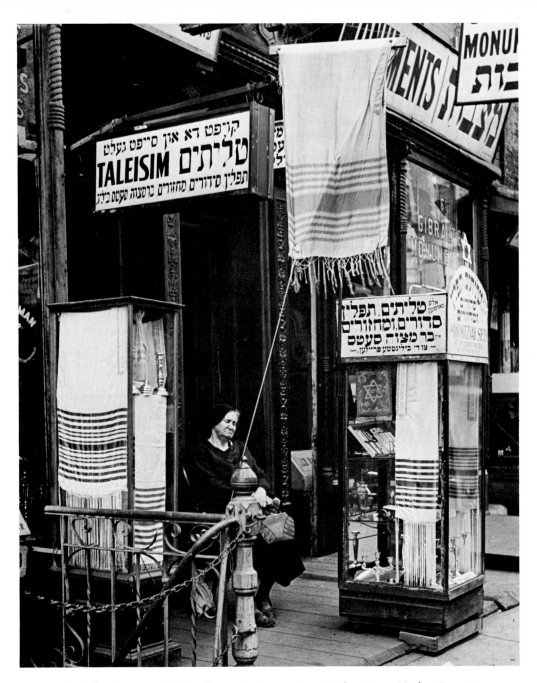

Jewish store on Orchard Street, Lower East Side, New York. Despite rapid deterioration into a slum, this neighborhood still preserves a refreshingly individualistic character. This photograph attempts to translate into picture form intangibles like serenity, the spirit of private enterprise on the smallest scale, old-worldness, conservatism, and faith.

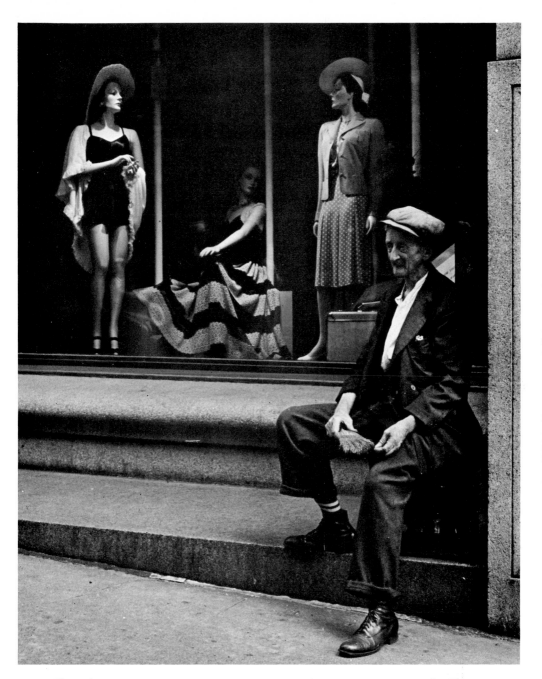

Shoe-shine man waiting for customers, Fifth Avenue, New York. The contrast between the supercilious mannequins in Altman's window and the poor old man watching life go by is symbolic of any big city where wealth and deprivation exist side by side. It is up to the photographer to recognize these moments of contact and to capture them effectively.

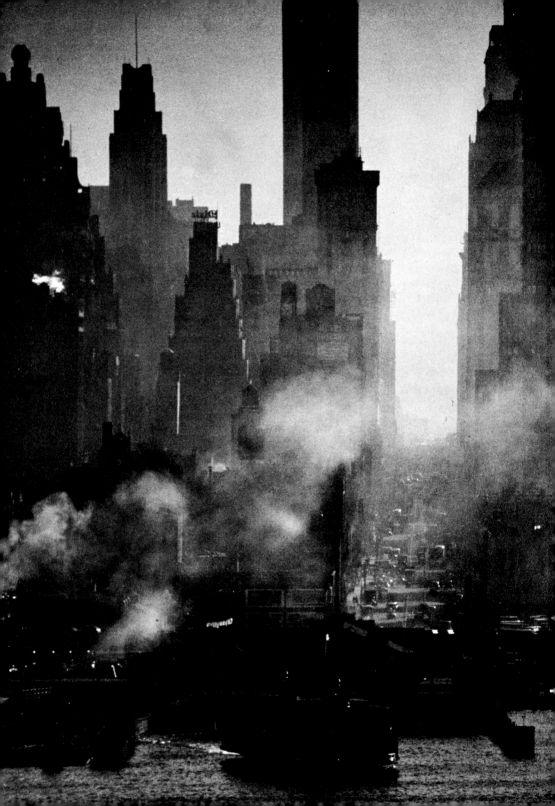

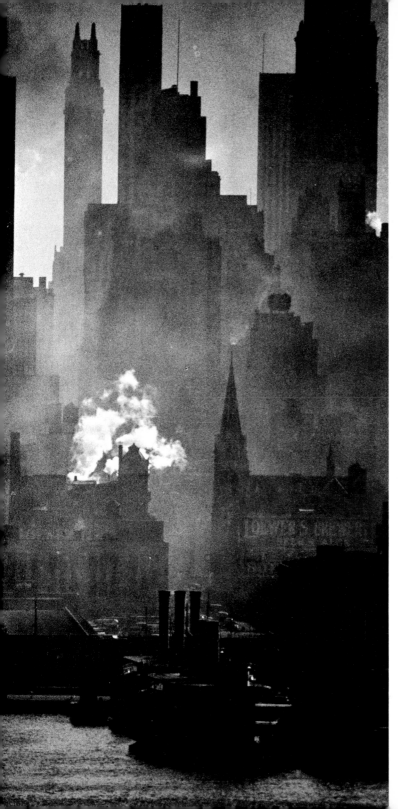

Midtown Manhattan, New York, seen from New Jersey. As nearly free from diminution as practicable, this view shows the components of the city—the buildings, automobiles, and ships—in almost true proportion to one another, regardless of their distance from the observer. This photograph, technical details of which were discussed on p. 55, was taken from approximately two miles away with a super-telephoto lens. Had it been made from a nearer camera position with a lens of shorter focal length, the ships would have been rendered unproportionally large in relation to the much bigger but more distant buildings.

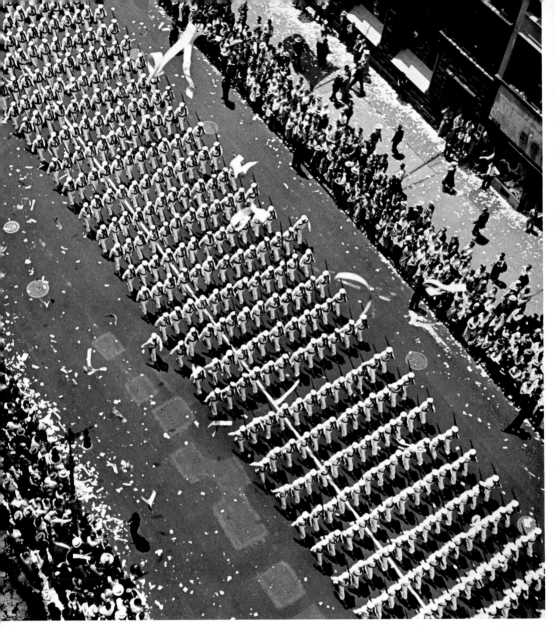

Victory parade, Fifth Avenue, New York. By taking this shot from a high vantage point instead of street level and composing the picture diagonally, the photographer was able to include the greatest number of men and create the strongest feeling of motion—of marching in review to the tune of the band.

Cities Service Building, New York. Aerial perspective (p. 244) creates illusions of depth. Utilization of the typical silhouettes of the "Elevated" trestle and the fire escape, and contrast between old and new (the slummy foreground and the soaring tower in back), enhance the picture's documentary value.

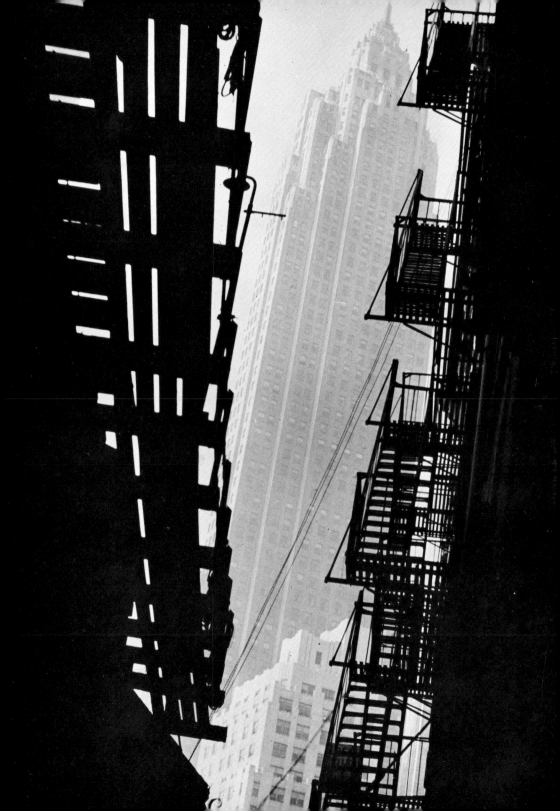

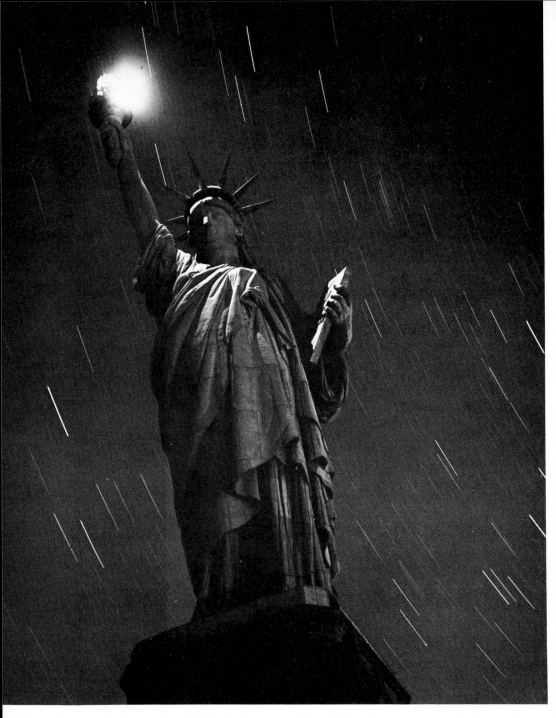

Statue of Liberty, New York. To show an old and familiar, not to say hackneyed, subject in a new light, the photographer took the shot at night instead of during the day. The fifteen-minute time exposure clearly shows a segment of the tracks of the wheeling stars, adding cosmic overtones to our symbol of freedom.

and gestures and the faster it changes. If a photographer wishes to create pictures which make an observer feel as if he were participating in a particular event or seeing a certain emotion, he must capture this precisely.

2. His camera must permit the photographer to shoot pictures lightning fast. For this reason, it must be light, small, easy to operate. It should also be inconspicuous (have as little chromium as possible) and equipped with a fast lens, a shutter capable of very short exposures, and a capacious film magazine. These requirements are best met by 35-mm. cameras. Operation of these cameras is so simple that it soon becomes more or less automatic, leaving the photographer's attention free to be focused undividedly upon the subject.

The secret of making successful pictures of dynamic subjects is *preparedness*. The photographer must anticipate the climactic moment so that he will be ready to capture it when it occurs. Many exciting action pictures which are generally accorded to luck are actually the result of clever anticipation on the part of the photographer who, basing his guess upon previous experience and a preparatory survey of the scene of the expected event, had correctly anticipated the spot or moment of the climax. Most action photographers eventually develop such a sixth sense. In addition, they preset their camera controls (aperture, shutter speed, and focus) in advance and are thus ready when the decisive moment arrives.

## STATIC SUBJECTS

Subjects representative of this category are:

Landscapes, trees, gardens, flowers
Buildings and interiors
Manmade objects, from art to industry
Formal portraits and posed fashion shots
Still lifes and reproductions

The common characteristic of subjects belonging to this group is immobility; they hold still. As a result, the photographer can take his time photographing them and devote more attention to phototechnical problems than he can when depicting dynamic subjects. This additional time factor has several advantages. Among others, it permits a photographer to work with large-size cameras (which are relatively slow in operation), the comparatively large negatives of which need proportionally less enlargement and hence produce sharper and more precisely defined prints with tone values superior to those produced by 35-mm. cameras. Furthermore, use of a tripod is normally feasible, enabling a photographer to work with smaller diaphragm stops and thus increase both depth of field and sharpness of definition in his pictures, since in photographing immobile subjects the resulting increase in exposure time is normally of no consequence. And finally, swing-equipped view cameras which permit extensive perspective control can be used, enabling a photographer to control distortion, render vertical lines parallel in his pictures, and, under certain conditions, extend sharpness in depth from foreground to infinity without resorting to prohibitively small diaphragm stops.

A static subject can of course also be photographed with a 35-mm. (or any other) camera. However, no matter how much manufacturers of 35-mm. cameras stress the universal adaptability and scope of their respective products, they cannot get around one fact: To make an 11x14 inch enlargement, a 35-mm. negative must be enlarged more than ten times linear, a 4x5 inch negative less than three. Since there is no difference in resolving power and grain between 35-mm. and large-size films of equal "speed," and very little difference between lenses made for 35-mm. and large-size cameras, prints of a given size are potentially sharper and better defined, the less the negative has to be enlarged to produce the respective size. And since it is no more difficult to photograph static subjects with a large than with a small camera, the larger camera is naturally preferable since, as far as photo technique is concerned, it makes it possible to produce better results.

114

Whereas *preparedness* is the key to successful photography of dynamic subjects, the key to success where static subjects are concerned is *contemplation*. Since this type of subject holds still, one may as well take advantage of this fact and carefully study one's subject from different points of view—literally as well as figuratively speaking—before one finally fixes it on film. In contrast to the photographer of dynamic subjects who has little or no control over such important factors as illumination, location, background, and composition, photographers of static subjects usually have every possible opportunity to present their subjects in the pictorially most effective form. For example, as far as outdoor subjects are concerned, if the light or the weather is not suitable they can simply wait, or return later, and take their picture when they are satisfied that conditions are right for the best possible subject presentation; they have time to study their subjects from different angles and to select the most effective point of view; they can leisurely consider the most suitable type of lens and filter and ways to bring out texture and significant detail. In my opinion, to shoot static subjects with a 35-mm. camera and by this to produce prints of inferior graphic quality is a sign of either ignorance or laziness on the part of the photographer.

## PHOTOGENIC AND UNPHOTOGENIC SUBJECTS

Although, of course, wide variations of degree exist in each group, photographic subjects can be divided into two categories in accordance with their suitability for rendition through typically photographic means: *photogenic subjects,* those subjects which have qualities which make them well suited to photographic rendition; and *unphotogenic* subjects which are deficient or lacking in such qualities. As far as possible, experienced photographers give preference to the first type and avoid the second, since they know that nothing lowers their batting average as much as photographing subjects which disappoint in picture form.

## Photogenic subject qualities

In general, subjects that are alive, unusual, or surprising because they have certain unexpected qualities, are more likely to make interesting pictures than subjects that are inanimate, common, or have been shown too frequently in photographs. In addition, subjects that can be photographed as close-ups are preferable to those that are so distant that the photographer cannot show them in this especially effective form of rendition.

Specifically, below are listed what I consider the ten most important photogenic qualities. The more of these qualities a subject possesses, the more suitable it is to rendition in photographic form.

> **Simplicity,** order, clarity
> **Contrast** which is strong, but not excessive
> **Detail** that is sharply defined
> **Texture** that gives a surface life
> **Form** that is simple and bold
> **Outline** that is suggestive and crisp
> **Pattern,** rhythm, repetition of related forms
> **Depth** in the form of receding lines or objects
> **Motion** that indicates aliveness or action
> **Spontaneity** if the subject is animate

In addition, these are what I consider *the three most photogenic techniques of subject rendition:*

**Close-ups** almost without exception make more interesting pictures than medium-long or long shots of the same subject, for reasons stated on p. 70.

**Telephoto lenses** produce a more effective type of space rendition than either standard or wide-angle lenses, for the reasons stated on p. 66.

**Backlight** (p. 214) is the most interesting type of illumination, unsurpassed for the creation of stark and dramatic effects.

## Unphotogenic subject qualities

As a rule, subjects that are static or inanimate are less likely to make good pictures than subjects that are dynamic or alive. Subjects that are too frequently seen in the form of photographs should be avoided as repetitious and hence unlikely to attract attention, no matter how photogenic they may be in themselves.

In considering the unphotogenic subject qualities listed hereafter, it must always be remembered that subjects having such normally undesirable qualities may still, under exceptional conditions, make interesting pictures. For instance: as a rule, flat, shadowless light is the least effective type of illumination. However, for certain purposes, especially if used by an imaginative photographer in color photography this normally undesirable type of illumination can produce particularly arresting effects. Although the author is aware of such exceptions, he suggests that beginners avoid subjects possessing the unphotogenic qualities listed below.

**Complexity and disorder.** The fact that the camera records everything within the view of the lens can be both a blessing and a curse. To produce good photographs, a certain amount of organization of the picture elements is necessary since, as mentioned, two of the basic requirements for effective graphic presentation are order and simplicity. Therefore, if the subject itself is too complex and chaotic, fulfillment of these elementary demands may not be possible, and the picture may not be worth taking.

**Lack of contrast.** In black-and-white photography, differentiation of form is based upon contrast between light and dark. In reality, however, differentiation of form is usually the result of differences in color. Thus, if different picture elements either have more or less identical colors or have different colors which are more or less equal in brightness (as a green meadow under a blue sky), then differentiation is lost when such subjects are rendered in the form of a black-and-white photograph. This is so because colors different in hue but equal in brightness are translated into equal

shades of gray. As a result, objects blend into one another, differentiation is lost, and the picture fails due to lack of contrast. For this reason, such subjects are basically unphotogenic. Common examples of this type of unphotogenic subject are green fields and forests, lawns and gardens —particularly in conjunction with a clear blue sky. Although pleasant to the eye, such subjects make some of the dullest and most disappointing black-and-white photographs.

To a lesser extent, lack of contrast can also be caused by a contrastless illumination. Such will be the case either if the light strikes the subject from the direction of the camera (front light), or if the light is evenly diffused as, for example, daylight from an overcast sky. In the first case, few or no shadows are visible from the camera position since they would fall behind the subject and be hidden by it. In the second case, pronounced shadows don't exist. In either case, absence of shadows reduces the contrast between the lightest and darkest areas of the picture. In consequence, the graphic effect of the rendition is weak, and if the subject itself is low in contrast, this additional flattening of contrast may ruin the picture.

**Strong coloration.** Although they are particularly well suited to rendition in color, subjects of which the most outstanding quality is vivid color generally make disappointing black-and-white photographs. Even in cases in which coloration is such that the photographer, with the aid of color filters, can satisfactorily separate adjacent colors when translating them into shades of gray (for example, blue and yellow, red and green), loss of color will nevertheless be felt so strongly in the black-and-white rendition that the result will be disappointing. Typical examples of this kind of subject—which should be photographed only on color film—are: colorful flowers and fruit, autumn leaves, colorful fashions, birds, insects, certain tropical fish, city streets with neon advertising signs at night, and flaming sunset skies.

**Overall views.** The fact that a subject is appealing to the eye does not guarantee that it will also look well in a photograph. This is true not only of very colorful subjects (this applies particularly to black-and-white photog-

raphy), but also of most of the views which we enjoy from high vantage points (this applies to photography both in color and in black-and-white). For one thing, the contrast range of such views is usually very limited, so the picture appears flat. But even more serious is the fact that such photographs are always overloaded with detail and this detail is rendered so small that it becomes ineffective. Furthermore, such overall views usually lack scale (see p. 245), as a result of which even the most magnificent landscape becomes so diminished that it appears toylike, insignificant, and dull. If a photographer feels that he must shoot such open views, he should at least increase overall contrast through use of a dark yellow or red filter. In addition, he should try to include part of some nearby object in the picture in order to suggest a feeling of depth through contrast between near and far and create graphic impact through contrast between light (the distant view) and dark (the nearby object). But even so, he should be prepared to be disappointed because, as a rule, the result will differ markedly from the feeling evoked by the actual view.

**Unsuitable background.** The very word *background* seems to suggest something subordinate, something which does not really matter. Actually, the background is one of the most important picture elements; it is the foil for the subject. Most photographers undoubtedly have heard the story of the potted flower that stood unnoticed in back of the beautiful model, but which in the picture seemed to sprout from her lovely head. This is no joke. It has happened—with variations—innumerable times, accounting for a high percentage of disappointing photographs which otherwise might have been good. pp. 127–129

A background can be unsuitable for two reasons: because its tone value is too similar to that of the subject or because it is too confused, aggressive, or filled with disturbing detail. In the first case, contrast between subject and background is lost—the one merges into the other, and the photograph goes flat. In the second, the background detracts attention from the subject proper of the picture. In both cases, the unlucky photographer, without being aware of it, successfully applied the principle of camouflage to the effect of spoiling his picture.

p. 97 **Literary subjects.** In essence, literary subjects have important qualities which can be expressed only in the form of words. They are basically unphotogenic because they are incomplete when rendered in the form of pictures. Typical examples are monuments, relics, historical sites, birth-places of the great, the "on-this-spot" sort of thing.

If a literary subject must be depicted in photographic form, the photog-rapher should strive as far as possible to symbolize those subject qualities pp. 98–102 which cannot be photographed directly (see also chapter on intangible subjects), and necessary information which cannot be expressed through graphic means must be supplemented by the writer's caption which accom-panies the picture.

## Unphotogenic techniques

**Posing.** More often than in any other way, photographs of people, and particularly of women, are spoiled quite unnecessarily by the typical commands: "Hold it!," "Smile, please!" or "Say cheese!" People can *behave* naturally only if they *feel* natural and comfortable, and to put them at ease is one of the most important tasks of any photographer of people. After all, to what avail is his technical knowledge and skill if his pictures turn out to be stilted and stiff?

No one can feel at ease if posed by a photographer, particularly if a rather ridiculous pose is topped by the command to "Hold it!" and "Say cheese!" If a photographer is so insensitive that he has no feeling for the natural dignity, poise, grace, or beauty of his subject it would be better for him—and his public—if he applied his "talents" to subjects such as still lifes which "hold still."

**Faking.** Thanks to advances in photo technique, faking has become quite a habit with many photographers, although few may see it in that light. Faking, according to my definition, includes any artificial interference with the authenticity of a subject or event. For example, any "outdoor" picture

which is arranged, posed, and shot in the studio is a fake, no matter how seemingly natural the result. To the trained eye, the deception is always apparent in the way in which light strikes the subject from several directions, by the overtransparency of filled-in shadows, and by the sleekness of the models and the unbelievable orderliness of the setup. In *real* outdoor life, sunlight strikes from only *one* direction, shadows are harsh, people are wind-blown, and perfection does not exist. Faking also includes the use of professional models in industrial photographs—recognizable by the too beautiful face, the too sophisticated makeup, the hairdo that is too perfect, the hands too well manicured. Even the use of daylight fill-in flash to lighten shadows that otherwise would appear too dark can make a picture look like a fake since it negates the nature of bright sunlight which one always associates with deep shadows. Of course, by this I do not mean that the use of any fill-in illumination is tantamount to faking. As long as its effect is not obvious and the quality of naturalness not destroyed, it is a perfectly legitimate means for producing natural-appearing photographs. What I object to is the overdoing, exemplified by the type of picture commonly seen in advertisements (and even technical manuals!) which illustrates the use of fill-in flash. Such overlighted shadows are too transparent and detailed, and the overall contrast of the picture is so low that an impression of unnaturalness results. It obviously looks like—and is—a fake.

In my opinion, the use of any auxiliary illumination that destroys the effect of the available light is faking because it falsifies one of the subject's most important qualities—its mood. I know that available light is often so poor that it is impossible to get technically perfect pictures. However, if this is the case, the actual effect created by the diminished light must have produced a particular mood, and to preserve this mood seems more important to me than to produce a well-detailed negative. If a choice exists between the two, I unhesitatingly prefer the grainy, less sharp picture that symbolizes the mood of a place to any technically slick rendition which destroys it.

**Shooting from too far away.** Probably the most common nontechnical mistake of the average photographer, particularly the beginner, is staying

too far away from his subject. He seems to be out to get as much as possible on every film he shoots. Outdoors, he takes shots of the whole landscape. If he photographs his sweetheart, he poses her against a tree, then backs up twenty feet to make sure he includes all of her—and the tree—in his picture. And if he buys a second lens, nine times out of ten it is not a telephoto but a wide-angle, "Because that way I can get more in my picture than with a standard lens."

The result of this misguided approach can be described in five words: too much and too small. Too many different things crowded into too little space vie for the observer's attention, and each is rendered too small to be effective. The result, of course, is an insipid picture.

The remedy is simple: go closer; or, use a telephoto lens. Decide what is the most important aspect of your subject, then concentrate on it. Show it close at hand, big, and effective. It is not always necessary or even desirable to render a specific subject in full. Often, by cropping off a part of it the effect is strengthened—the close-up of a face is generally more effective than a full-length shot.

## "SO-WHAT" SUBJECTS AND CLICHÉS

It may sound paradoxical, but some subjects are unsuitable for the production of interesting photographs precisely because they are photogenic. Why? Because *too many* photographers, having discovered that certain common subjects have highly photogenic qualities, have photographed them so often that everybody has tired of seeing them in picture form. That is, everybody except certain other photographers who, seeing how successful such pictures have been, go out with their cameras, shoot more of the same kind, and keep the vicious circle going.

Subjects belonging to this category which might be labeled "photogenic but not recommended" change in popularity with the times. Usually, some

perceptive and imaginatively gifted photographer starts a trend by photographing a certain type of subject in a certain way. If he is successful, it is then only a question of time until others take up his style and exploit it to the limit. Eventually, the originally sound idea is so overworked that people tire of it, and photographers finally abandon it in favor of something new.

Lacking a tradition of their own, the first photographers understandably turned their attention to the classic subjects of the painters of their time, mainly photographing romantic landscapes bathed in softly diffused light and quaint and sentimental subjects of any kind and description.

The first radical break with this gradually established photographic tradition occurred right after World War I. Inspired by the book of the German photographer Albert Renger-Patsch, *Die Welt ist schön* (*The World Is Beautiful*), for the first time photographers began consciously to explore the camera's potentialities. Whereas previously photographs had to be soft and diffused, they now had to be sharp and precise. Every picture had to have *texture*. Angle shots—both upward and downward—became the fashion of the day, so much so that at the height of their popularity no one except a few diehards would have thought of shooting any subject with the camera held level. Photographers began to discover the inherent beauty of natural and technical forms and took close-ups of plants and seashells, clock movements, phonograph records, and the driving wheels and connecting rods of locomotives.

However, eventually this search for significant form and structure degenerated into curiosity for curiosity's sake, the "guess what this is?" type of picture became increasingly popular (exemplified by highly magnified close-ups of everyday objects such as the heads of matches, the crown of a wristwatch, the teeth of a file), and the whole idea of the *Neue Sachlichkeit* (*New Objectivity*) became a fad.

When the Depression set in, another radical change occurred as photographers switched their interests from objects to people. Sparked by the Farm Security Administration program under Roy Stryker, the documen-

tary photograph evolved. Suddenly, every photograph had to have social significance or it was not worth looking at twice. Despite very impressive results, this idea also degenerated. As time went on, fewer and fewer photographers noticed anything except human misery, hardly ever turned their cameras on the positive sides of life, and finally discredited the whole movement by permitting it to become a tool of political interests. Eventually it became known as the "ashcan school of photography" and is practiced today to the exclusion of all else only by a small group of the "New Left."

Similar to these larger movements which periodically swept the country, although on a smaller scale, a number of different "schools" have influenced the development of aspiring photographers. Such schools generally develop around the personality of a prominent photographer—sometimes with, at other times without, his active participation—and consist of small but often fanatical groups of admiring disciples and imitators. Best known are the so-called "Group f/64" inspired by the work of Edward Weston which made sharpness a fetish and resurrected the 8" x 10" view camera, the Mortensen-inspired group of pictorialists (which saw the ultimate in photographic beauty in such control processes as the paper negative, the abrasion technique, and the Bromoil print) and the *Aperture* Group under the leadership of Minor White (whose members look for significance in the insignificant). Still other photographers who set new styles were Richard Avedon and Erwin Blumenfeld. The work of Avedon's followers is characterized by high-key softness, diffusion, and blur; the work of the Blumenfeld imitators is typified by the wire chair and the uniformly lighted background which imperceptibly melts into ceiling, walls, and floor. Today's fads are more technologically oriented. Typical examples are the flood of pictures taken through prisms which multiply the same image; shots made with a zoom lens zooming in on the subject during the exposure; and indiscriminate use of the fish-eye lens. In all three cases, a new, potentially valuable photo-technological development which permitted the creation of heretofore impossible effects was used merely for novelty's sake—with the result that these effects were almost universally condemned before they had a chance to prove their worth.

**124**

Although all of the photographers whose work established a trend made definite and valuable contributions to the advance of photography, their followers as a rule did nothing constructive except perhaps to spread the master's fame. Lacking the originator's perception and artistic caliber, with very few exceptions they merely imitated his style and often carried it to such an extent that the means became the end. The results, of course, were meaningless and often "arty" photographs—the type which someone aptly labeled "so-what" pictures.

In photography, as in every other field, two types of people can be found: originators and imitators. The originator is creative, discovering new thoughts, ideas, concepts, and techniques; the imitator exploits these. And although an imitator may become rich and even famous on the strength of his derivations, he can never experience that profound satisfaction which results from creative work—that feeling of having broken new ground, of having made a contribution to knowledge and experience.

Unfortunately, the majority of photographic magazines and books actually encourage photographers to imitate by telling their readers exactly what to do and how to do it. This, of course, is necessary as far as established techniques are concerned, but worthless beyond that, for creativity can only be sought and found in one's self.

In the following, I list some of *the worst photographic clichés* which should be avoided by anyone intent on doing original work.

**Everything quaint.** Bearded bums, "charming" (rundown) little nooks in the Village, Cape Cod fishing wharves, Mexican children begging pennies, sleeping bambinos with flies on their faces.

**Everything phony.** So-called character studies of bewhiskered old men; fake monks draped in burlap pretending to write with fake quills; gnarled old women sunk in simulated prayer; still lifes including open books, candles, spectacles; sentimental "studies" of slums, cowboys riding into the sunset smoking cigarettes, and so on.

**Everything cute.** From babies to babes, including cute pictures of cats and dogs.

**"So-what" subjects** which are basically photogenic but not worth recording because they don't mean anything. For example: stacks of lobster pots and rows of empty chairs with "interesting" shadows (I cannot understand why the picture of a collection of dull objects is considered to be better than the shot of only one); a coil of heavy rope; still lifes consisting of chinaware or spun aluminum plates and vases—in fact, the majority of still lifes and table-top setups; sentimental "symbolic" nudes, oiled or plain; texture studies for texture's sake; pattern compositions for pattern's sake.

**The photographic clichés.** The foreground branch that frames the distant view—and its variation, the birch trees that frame the white church in the valley; cats and ashcans; crosslighted portraits with the face in half-shade and highlighted hair and ears; snow-laden little evergreens that look like dwarfs; the sweater girl that adds "human interest" to the boring landscape; the little brook—snow-rimmed, ice-encrusted—that sinuously winds its way toward the depth of the picture; the country road that composes along a perfect S-curve that guides the eye toward no center of interest; bathing beauties posing stiffly on the beach in stilted attitudes with or without ridiculous props such as guitars, conch shells, large mirrors half buried in the sand, and "amusing" rubber animals.

## THE SECONDARY SUBJECTS

In addition to the subject proper of the picture, most photographs contain elements which can be grouped under the heading *secondary subjects*. Typical of these are the *background*, the *foreground*, the *sky*, the *horizon*, and what are commonly called *props*. Most photographers pay relatively little attention to these particular picture elements, disregarding their importance. They don't realize that secondary subjects can be utilized for

the creation of effects which can strengthen the impression of the subject proper of the picture and that ways and means exist to control the form in which they will appear. In this respect, the following should be considered:

### The background

As previously mentioned, the background is the foil for the subject. As such, **p. 119** it must normally be subordinate to the subject proper both in tone value and design. At the same time, it should make the subject stand out and show it to best advantage.

**In black-and-white photography,** as a rule, if the subject is dark, the background should be light; if the subject is light, the background should be dark; and if the subject is of an intermediate shade, the background should be either lighter or darker than the subject. This may seem elementary, but it is frequently overlooked by photographers who become confused by the fact that in reality differentiation between subject and background is usually a matter of difference in color, but that colors, although different in hue, may photograph as more or less identical shades of gray. If this is the case, differentiation between subject and background in a black-and-white rendition can usually be produced through the use of an appropriate filter which renders one of the two colors as a darker shade of gray. The principles according to which such filters must be selected are discussed in *Successful Photography* by this author.

If artificial illumination can be used, differentiation between subject and background is most easily produced through the use of light. By directing the illumination toward either the subject or the background, the photographer can at will make one appear lighter or darker than the other. This method offers such complete control over the respective tone values of subject and background that it is possible to make a black statuette placed in front of a white background appear light and the background dark by strongly illuminating the statuette and keeping the background in the shade. Thus, merely through appropriate use of light, a complete reversal

**127**

of actual tone values can be accomplished. This indicates the high degree of control which is possible.

**In color photography,** differentiation between subject and background should normally be based upon difference in color, *not,* as in black-and-white photography, upon contrast of light and dark. Of course, this does not mean that the background color must be complementary to the principal color of the subject or should be a strongly saturated color, as many photographers seem to believe. Violating the basic rule that the background should be subordinate to the subject, strong color makes a background appear as important in the picture as the subject itself, thus competing with the subject for the observer's attention and muddling the composition. Most common examples of this are color portraits and nudes photographed against a bright red background, in which the raw background color completely overpowers the delicate shades of the skin. Actually, in color photography, if conditions permit their use, some of the best background colors are white and the lighter shades of beige and gray.

**Unsharpness and blur** are effective devices for separating subject and background in both color and black-and-white photography. Both produce a heightened impression of three-dimensionality and depth. Normally, the subject should be rendered sharp and the background unsharp or blurred. This is easily accomplished by using a relatively large diaphragm stop in photographing the subject which causes the background to be rendered out of focus and hence unsharp. In the case of subjects in motion, the subject can furthermore be rendered sharp and the background blurred if the photographer uses his camera as a hunter uses a shotgun on a flying bird: center the subject in the finder, keep it there by following through with the camera, and expose while swinging (this technique is called panning). Occasionally, it can be of advantage to reverse these effects to make the subject unsharp or blurred and the background sharp. For example, to create an impression of extreme nearness, render the subject unsharp and the background sharp by focusing the camera on the background, thereby throwing the subject out of focus. And to express motion, render a moving subject blurred and

the background sharp by holding the camera still when making the exposure and using a shutter speed that is too slow to freeze the image in motion. In each of these possibilities, the contrast between sharpness and unsharpness or blur effectively separates subject and background. In addition, it suggests in symbolic form qualities which cannot be rendered directly in a photograph, like motion and depth.

**A completely neutral background,** as mentioned, is one of the most effective, graphic means that can be used both in color and in black-and-white to depict certain subjects to best advantage. For subjects such as fashion models or furniture, such a background—one which imperceptibly merges into floor, walls, and ceiling—can be produced by constructing a *light-tent* made of white background paper (which comes in large rolls for shop window display purposes) and flooding the subject with completely diffused light as described on p. 69. For smaller subjects, and in particular objects made of glass, a large sheet of flash opal glass illuminated from the back makes a very effective background.

**For outdoor subjects** of almost any kind—people, portraits, trees, flowers, cars—a background that is always effective is the unobstructed sky.

**Unsuitable backgrounds** which should be avoided have already been discussed on p. 119.

### The foreground

In my opinion, a large percentage of photographs are ineffective because they include too much unwarranted foreground. Either the photographer stayed too far away from his subject, or he made the shot with a wide-angle lens. In either case, the result is inclusion in the picture of abnormally-much foreground matter. This can easily be avoided either by decreasing the distance between subject and camera, or by making the shot with a lens of longer focal length. And many already existing pictures can be improved considerably by enlarging only a section of the negative, cropping off meaningless foreground in the print.

The foreground, being the part of the subject or its surrounding which is closest to the camera, symbolizes nearness. Consequently, the more extensive this area in the picture, the more pronounced the feeling of nearness. The strongest impression of nearness can be created if a wide-angle lens is used which by its very nature emphasizes the foreground and minimizes distant objects. The resulting type of wide-angle perspective—normally considered distortion—if deliberately and skillfully used to symbolize extreme nearness, is capable of producing extraordinarily striking pictures.

A typical characteristic of wide-angle perspective is a pronounced impression of depth. As customarily used, wide-angle lenses render near objects proportionally larger and distant objects smaller than they appear to the eye. As a result, differences in scale between near and far objects seem exaggerated, producing the sensation of abnormally great depth. The opposite effect is produced by telephoto lenses which minimize differences in scale between near and far objects, "compress" space, and produce impressions of flatness. These characteristics of different types of lenses and the ways they can be utilized to create specific predetermined effects will be

**pp. 210, 240** discussed later.

A good way to create an illusion of depth in a photograph is to contrast near and far objects, foreground matter playing the role of the near object. Application of this principle is illustrated by pictures taken through arches or doorways or views framed by the nearby branches of a tree. Although photographs of this kind are often highly stereotyped, the idea of suggesting depth through juxtaposition of near and distant objects is basically sound and can be expressed in many different ways. The effect will be particularly strong if contrast of near and far is heightened by contrast of light and dark. Used for this purpose, the foreground object takes on the function of a symbol in that it permits the photographer to suggest the third dimension, which cannot be rendered directly in a photograph. In such a case, the nature of the foreground object is immaterial as long as its outline is expressive and its tone dark. Best results are often achieved if the depth-suggesting foreground object is silhouetted in solid black.

**130**

## The sky

Although the sky comprises an important element of most outdoor views, photographers, as a rule, pay little attention to its appearance and are satisfied as long as they get clouds in their pictures. Few are consciously aware of the fact that the endless variety of different aspects and moods which the sky can assume reflects upon the character and mood of their pictures.

The appearance of the sky is determined by atmospheric conditions in conjunction with the position of the sun and the time of day. In a photograph, the sky can suggest an enormous diversity of moods—from drama to monotony. It can appear in any of the colors of the spectrum except green, although at sunset parts of the sky may be turquoise or aquamarine. The influence of such factors upon the character of a photograph should be obvious to any sensitive photographer.

Despite the fact that in reality a clear blue sky with a few white clouds is always pleasant to see, in photographs—both in color and in black-and-white—it has become a cliché. For this reason, it should be used with discrimination by anyone trying for interesting pictures.

The appearance of the sky in a photograph can be controlled in two ways: the photographer can wait until the sky assumes the character which he needs to supplement the character of his subject, or he can render a given sky in different ways with the aid of filters or a polarizer. How this can be done in black-and-white photographs is explained in *Successful Photography* and in color photographs in *The Color Photo Book*, both by this author.

## The horizon

If the horizon appears in the photograph, it acts as one of the most important picture elements because it divides the scene into two parts —earth and sky—the relative proportions of which are of major importance to the overall impression of the picture. Predominance of sky— a low

horizon—suggests space, airiness, and spiritual qualities; predominance of ground—a high horizon—emphasizes nearness and suggests earthiness and material qualities.

These impressions will be most pronounced if the horizon is completely eliminated. For example, the photograph of a soaring bird of prey silhouetted against the sky can have a compelling quality of airiness. And the picture of a village at the foot of a mountain, the mountain filling the entire background, can convincingly suggest the earth-bound isolation of life in a remote valley.

The line of the horizon can be straight (ocean, plains), undulating (hills), or jagged (craggy mountains); it can be uninterrupted or broken by objects crossing it; it can be horizontal or tilted. Each of these manifestations evokes different impressions and associations in the mind of the observer —from the tranquillity or monotony suggested by a flat and straight horizon to the nervous excitement induced by the jagged graph of a mountain range. Needless to say, creative photographers are sensitive to such factors and deliberately use them as far as possible to express specific moods.

Compositionally speaking, the horizon divides a photograph into two parts which stand in a definite relationship to one another: The greater the difference in proportion between sky and ground, the tenser the composition; and vice versa. If both parts are equal—the horizon dividing the picture in halves—tension is lost and the composition becomes static and monotonous. However, although normally such a composition is not recommended, it can on occasion serve to emphasize the dullness of a monotonous subject and thus be desirable from the artist's point of view.

### Props

Props are auxiliary devices whose use, in my opinion, too easily results in arty photographs. Typical examples are telephone receivers, rubber balloons, mirrors, veils, and the guitars so commonly seen in photographs of

pinup girls and nudes. They make the picture appear tasteless and the model cheap. Photographers who use props apparently believe that such devices heighten the sex appeal of their pictures—or they simply don't know how to handle their subjects.

Few subjects can be as graceful and enjoyable as the body of a beautiful young woman. In a photograph, anything added only detracts. It is a theme complete in itself. It should be treated photographically as a living sculpture, with the feeling and respect with which one approaches a work of art. Of course it should have sex appeal. But healthy sex appeal can never be expressed with the aid of fatuous props. It is an inherent quality of the living female body, and if a photographer does not know how to express it without the crutch of vulgar trappings, he should not photograph the nude.

## Subject Selection

By now it should be obvious that subject selection is one of the most important and consequential stages in the making of a photograph. Unfortunately, not being particularly interested in any specific type of subject, too many photographers expend their efforts on subjects that are meaningless, trite, or have been done by others ad nauseam. Sometimes, of course, meaning is hidden and needs to be discovered. I remember the revelation I experienced during the showing of Robert Flaherty's movie, *St. Matthew's Passion*. This movie is composed entirely of close-ups of medieval religious paintings, selected to illustrate the life of Christ as conceived by medieval artists. Previously, I had considered religious paintings *art*—in the sense of something apart from, and almost opposed to, *life*. How wrong I had been! Revealed in Flaherty's masterly edited close-ups presented in logical sequence, these paintings, expressively realistic, at once moving and shocking, suddenly came to life and assumed a terrific meaning: a documentation

**133**

of the lives of people. The gestures and expressions, the viciousness and cruelty of the mob, as well as the serenity and passion, love, pity, and despair mirrored in these faces! There was significance in every brush stroke, in every detail, in each color, and suddenly, though I had seen many of these paintings before, I began for the first time to really see.

Such moments are precious in life. All at once it is as if a curtain lifts, a horizon widens, and one feels then a different person, somehow enriched.

In essence, then, subject selection becomes a matter of seeing—not only seeing with the eye, but even more so with the mind. It is creative, imaginative seeing—seeing in a subject something worthy to be photographed, a thing which no one had seen in this light before: a new meaning, a new concept, a new point of view, discovered through the power of the imagination.

Imagination is the ability of the mind to create. It is the force which enables the novelist to invent his characters and events and to weave the fabric of his story. In photography, imagination enables the photographer to see differently and to produce pictures that are original in concept. A parallel between the blank sheet of paper in the typewriter and the blank sheet of film in the camera suggests itself. In both cases, a subjective interpretation of a theme must be created and transferred to an empty surface so that the reader or observer may participate, to the extent of his understanding and sensitivity, in the work created and share the experience of the artist.

The extent and inclination of the imaginative faculties of a photographer are invariably reflected in his pictures. Lack of imagination reveals itself in the form of run-of-the-mill photographs dealing with trite and obvious subjects. On the other hand, discrimination in the selection of subject matter, originality of approach, taste, and daring in treatment and presentation distinguish the work of the imaginative photographer.

Imagination and personality are closely related. No two people are capable of achieving through imagination completely identical results. Imagination is not always of an artistic nature. It often manifests itself in the

**134**

form of inventiveness in a technological field. This dualism is very much in evidence in photography, a medium based partly on art and partly on technique. Richard Avedon, the late Erwin Blumenfeld, Cartier-Bresson, and Ernst Haas are, in my opinion, predominantly artistically imaginative photographers; whereas others, like Gjon Mili, Roman Vishniac, or Lennart Nilsson, are representative of those photographers whose imagination manifests itself primarily in the form of technical ingenuity. Naturally, such a classification is of necessity crude, signifying only that these photographers are predominantly imaginative in either an artistic or a technical field. It does *not* mean that their gifts and accomplishments are limited exclusively to one of these spheres.

It is only natural that this duality in the realm of imagination should also manifest itself in photography—in which it particularly affects subject selection and the various means and methods of expression. Emotionally stirring subjects and simple and direct methods of rendition will attract mainly photographers with artistic imagination. Technically ingenious devices and techniques, such as speedlights, specialized lenses, high-speed photography, photomicrography, infrared-sensitized films, or the potentialities of polarized light will be utilized mostly by technically imaginative photographers. Such classification is not meant to reflect upon the merit of the photographer or his methods. Neither group is superior to the other in any respect; the work of both is equally important. They are merely different. The value of a photograph is always found in its effect upon the viewer, the particular means used to achieve it being of no concern to him unless he has a specialized interest.

Photographers either are assigned specific subjects to photograph or are free to select the subjects of their pictures. In the first case, either the possibilities for subject selection are limited (if a choice exists between several subjects with suitable qualifications), or there is no choice at all. Under such circumstances, the photographer must do the best he can, realizing that the result may never be particularly interesting. His only consolation is that responsibility for the outcome of the picture is shared, at

**135**

least in part, by the editor or client who gave him the assignment.

Those photographers who are free to choose both the subject and the final form of presentation are, of course, solely responsible for their work. As far as subject selection is concerned, these photographers may be divided into two groups: those who are interested in specific subjects and know what they want to photograph (although often they may not know at first *how* to photograph it), and those who wish to make photographs but are uncertain about the kind of subject they should take. The following guidelines are intended to help this last group to make a suitable selection.

Basically, in reference to such selection, the potentialities of the photographic medium are twofold:

*The camera can be used as a scientific instrument* for objective exploration, recording and documentation of the world in which we live.

*The camera can be used as an artist's tool* for the expression of subjective commentary upon, and interpretation of, the surroundings of the photographer.

Depending upon whether a photographer is predominantly technically or artistically inclined, he generally will do best if he uses the camera in accordance with only one of these approaches.

### The camera as a scientific instrument

The all-important question is: In what subject is the photographer interested? Fundamentally, he can choose from three different categories: people, subjects of nature, the work and world of man. The following brief survey—of necessity very sketchy and incomplete—lists in telegraphic style some of the most important subjects and fields which belong to each group.

**People.** Anthropology and ethnology—the study of present-day mankind, its races, cultures, and social customs and institutions. Religious ceremonies—from witchcraft to Christianity. Costumes, folklore, dances, festivals.

**Subjects of nature.** Zoology—the world of animals. Mammals, birds, reptiles, amphibians, fish. Insects and spiders—a fabulous world of their own, weird and beautiful forms, fascinating behaviors that surpass the imagination. The structural beauty of seashells. The unbelievable variety of the lower forms of life. The wondrous world disclosed by the microscope.

Botany—the world of plants. The color and shape of flowers and fruit. The means which plants employ to protect themselves against enemies, heat, drought, and storm. The fabulous devices by which plants spread their kind. The structural beauty of plants and seeds.

Geology—the study of the earth and its rocks. Mountains and plains, rivers, lakes, the sea. Weathering and erosion. The geometrical precision of crystalline forms.

Ecology—the interrelationship and interdependence of everything in nature. The environmental problems created by man: his explosive population growth, his aggressive technology and its influence upon the soil, the water, the air, the animals and plants.

The sciences—astronomy, physics, chemistry, biology, oceanography, meteorology. The realm of the researcher, the discoverer, the pioneer, the shaper of tomorrow's world.

**The work and world of man.** Archaeology, the study of the cultures of the past. Technology and art. Manufacturing and production. Smelters, steel mills, shipyards, factories of all kinds. The complex organism of the city—traffic, commerce, airports, harbors, railroad terminals; airplanes, automobiles, ships, and trains. Roads and bridges, houses and homes. The manmade landscapes—plowed and seeded fields, harvesting; power dams, open pit and strip mines, oil fields. Farms, villages, and towns.

### The camera as an artist's tool

Again the first question ought to be: In what type of subject is the photographer interested? In this field, the choice is between three fundamentally different subject groups:

*People.*

*The interpretation of feelings and moods.*

*The creation of photographs which reflect the artist's concept of beauty, harmony, spatial relationships, the interplay of light and form, and the kind of pictures which are known as experimental photographs. Again, the following list of subjects is of necessity brief and incomplete.*

**People.** Portraiture. Interpretation of man's emotional world in peace and war. The things people do in the daily course of their lives. People at work and at play. The joys and tragedies of life.

pp. 98–102

**Interpretations of feelings and moods.** This is the realm of the symbolic photograph. A few examples were previously discussed. The subject itself is only the vehicle which enables the photographer to suggest in visual form intangibles which cannot be depicted directly: beauty, love, hate, violence, fear, despair. Specific moods: loneliness, sadness, contentment; the magic of dusk and the mystery of night. The power of the elements, the immensity of the universe, the insignificance and the glory of man.

**Artistic concepts and experimental photographs.** This is the field of the creative artist, as well as that of the experimenter in new means and techniques of graphic expression. The nature of the subject itself is immaterial as long as it permits the photographer to realize his concepts of the spatial relationship between various objects and his compositions of light and dark, line, volume, and form. Photographs of this kind are very different from the average type of picture, usually stimulating, often controversial, and frequently ridiculed by more conservative photographers—although many of the means and techniques developed by creative photographers are ultimately accepted and used as a matter of course by these same conservatives. Some of the means and techniques developed in the creation of this kind of expressionistic photograph are: the stark and graphic contrast of pure black-and-white; controlled blur; controlled unsharpness; controlled graininess; the processes of bas-relief, controlled reticulation, and solarization; multiple exposures and multiple printing; and cameraless photograms.

**138**

## SUMMING UP AND CONCLUSIONS

In view of the immense number of worthy photographic subjects, diversified enough to fit the interests of anyone, it is hard to understand why so many amateur photographers waste their time and effort on meaningless subjects. That this is a fact is obvious to anyone who looks through the pictorial sections of photographic magazines or visits the exhibits of photo clubs. An often heard excuse is that amateurs have neither the special equipment of the professional nor his opportunities for shooting interesting subject matter. This is not true. As far as equipment is concerned, many amateurs own the same kinds of cameras as many of our most successful photojournalists. Even in many of the more specialized branches of photography, essentially the same type of equipment is used by amateurs and professionals. Only in certain highly specialized cases, which are always the exception even with professionals, are amateurs handicapped because they do not have access to suitable equipment.

Furthermore, some of the most beautiful and moving photographs made by professionals depict people and events from daily life—subjects which are within the scope of the average amateur. On the other hand, many pictures of subjects accessible only to professionals—public figures, celebrities, and even movie stars—are notoriously boring: the handshake, the professional smile, the stereotyped pose.

Some people's pursuits in photography may be likened to some people's pursuits in reading: some are satisfied to read the gossip columns and the comics, whereas others read because they are intellectually alive, aware of their surroundings, and curious to know what is going on in the world. In photography, some people are satisfied to play with the tabletop arrangements, whereas others take their cameras out into the world.

# Black-and-White or Color?

It is always possible to shoot a given subject either in color or in black-and-white, provided of course that the photographer has the necessary equipment and skill. Neither medium is *ipso facto* superior or preferable to the other. The only question to be considered is this: When should a subject be photographed in color and when in black-and-white?

To make the right decision should be as important to photographers as to photo editors and clients who assign photographers. The use of one medium or the other depends upon these considerations:

> Since color is more expensive than black-and-white, can one afford it?
>
> Even if cost is no problem, can color photographs be used?
>
> Which will give the better result, color or black-and-white?

To properly answer these questions, two aspects must be considered—one practical, the other artistic.

## Practical considerations

Attention must be given to two factors: cost and purpose. All along the way, from the price of the film to the printing (whether in the form of color prints or photomechanical reproduction) color is many times more expensive than black-and-white. Photographers who shoot color solely for direct viewing or projection—either for their own use or for use as slides to illustrate lectures—don't have to worry about reproduction cost. Although color film is more expensive than black-and-white material, if it is used for

purposes of direct viewing or projection, part of this extra cost can be written off since no prints are necessary. In this respect, unlike a black-and-white negative, a positive color transparency is a finished product.

Consideration of the cost factor is important to anyone who intends to sell his photographs or wishes to use them to illustrate his own articles or books. For what good is the finest color transparency if it cannot be used because it costs too much to reproduce?

Finally, the purpose for which the picture is intended may decide the question of whether to shoot a subject in color or in black-and-white. For example, if a picture is to be used for newspaper reproduction, for inclusion in the illustration of a book or brochure printed only in black-and-white, or for transmission by wirephoto, obviously only black-and-white will do. It is, of course, always possible to make a black-and-white print (via a copy negative) from a color transparency, but the quality of such a print is generally somewhat lower than that of a print made directly from a good black-and-white negative.

## Artistic considerations

In essence, the choice between black-and-white and color is a choice between a more abstract and a more naturalistic form of rendition. Neither is preferable *per se*, and to critically compare the two is pointless unless done with the aim of determining which of the two media under a given set of circumstances is more suitable for the rendition of a specific subject.

Any such comparison must take into consideration the following three interrelated points:

**1. How important is color to the characterization of the subject?**
Conditioned by over a hundred years of black-and-white photography, we are so accustomed to gray tone renditions that absence of color in a

photograph does not normally make the subject any less recognizable in a picture. As a matter of fact, the opposite can occasionally be the case. For example, in portraiture, a good rendition in black-and-white actually appears more natural and will be more readily accepted than one in color in which the skin tones are off-color. And the stark and graphic black-and-white photograph of a landscape frequently makes a stronger impression than a color photograph of the same view which, although more naturalistic, may for this very reason be insipid.

However, no black-and-white picture of colorful flowers, butterflies, birds, autumn foliage, or flaming sunset skies can ever rival a good color photograph of these subjects. As far as these and other subjects are concerned whose most outstanding characteristic is color, color is too important a quality to be excluded without seriously impairing the effect of the picture. If color is one of the most outstanding subject qualities, then of course rendition would be less meaningful, less significant, and less complete if the subject were photographed in black-and-white. In such cases, the use of color is not only justified, but becomes a necessity in order to create the most effective form of presentation. On the other hand, if color is more or less incidental, if the subject might just as well have had another color, or if outline and form are more essential for the characterization of the subject than its color, then rendition in black-and-white may produce the stronger impression because its more abstract nature permits the photographer to create more artistically powerful effects.

**2. Naturalistic color or abstract black-and-white?** The number of subjects that appear effective only if shot in color is relatively small in comparison to the vast number of subjects which lend themselves to rendition in both color and black-and-white. To decide whether to shoot such subjects in color or in black-and-white, the photographer must make up his mind whether he wishes to produce pictures that are primarily naturalistic or abstract. This, again, depends upon two factors: the purpose of the picture and the nature of the subject which it depicts.

**142**

The purpose of a photograph can be either illustrative or interpretive. If illustrative, the main function of the picture is to depict the subject with all its different qualities—including, of course, its color—as accurately as is technically possible. Obviously, in such a case, a color photograph is preferable to one in black-and-white.

On the other hand, if interpretation is more important than illustration, a black-and-white photograph is often preferable to a color shot because it offers the photographer greater freedom for creative symbolization of some of those subject qualities which have to be interpreted because they cannot be depicted directly: strength, power, sadness, tragedy—qualities which can be suggested best with the aid of stark and graphic black-and-white, contrast, and darkness.

As previously mentioned, the subject of a photograph can be either concrete or intangible. In the first case, the character of the picture should be basically realistic, whereas in the latter case it must be essentially abstract. Consequently—apart from all other considerations—as a rule (there are many exceptions), the first kind of subject is more suitable to rendition in color, and the latter for treatment in black-and-white. Occasionally, the same subject can be conceived in either way, each way necessitating a different treatment. For example, the photograph of a particular landscape can be conceived as a portrait of this landscape, in which case a naturalistic treatment is indicated. Or, the landscape can be merely the vehicle which permits the photographer to express in symbolic form such intangibles as the vastness of the plains or the mellow mood of a summer evening, in which case the more abstract black-and-white photograph is likely to produce the more expressive result.

**3. Is color likely to be technically good or bad?** Even if the results of the two foregoing considerations point to color as the more suitable medium of rendition for a given subject, a black-and-white treatment may still be advisable because of certain shortcomings of color film. As explained in *The Color Photo Book* by this author, color films produce satisfactory results

**143**

only under specific conditions. If these conditions are not fulfilled, color rendition appears more or less distorted, and a photograph in distorted color is normally inferior to a good black-and-white photograph.

Color distortion is most likely to occur under the following conditions:

> If the spectral composition of the ambient light differs from that for which the color film is balanced.

> If subject contrast is excessively high.

> If subject coloration is desaturated—i.e., if pale colors and pastel shades prevail.

Whenever one or several of these conditions occur, it is advisable, in addition to photographing the subject in color, to photograph it also in black-and-white as a safety measure in case the color shot turns out unsatisfactorily. When the outcome is questionable, making the right decision often becomes easier if the nature of the subject is considered: if it is manmade, a fairly high degree of color distortion in the photograph will probably go undetected by the observer of the picture since manmade objects can conceivably have any kind of color. Similarly, if the subject is of a kind which is unfamiliar to the average observer (for example, a rare tropical bird), color distortion in the photograph is also likely to pass unnoticed since the observer has no standard for comparison.

On the other hand, if the represented subject is one that is familiar to the observer, even slight deviations from natural color will probably be detected and cause the picture to be rejected as unnatural. Most critical in this respect are renditions of people, particularly portraits, since even the slightest color deviations from normal skin tones appear objectionable. Other such subjects are: green foliage, fields, and meadows; clear blue skies; and subjects having the colors gray and white. If such subjects must be shot in color, the photographer should take extra care to insure a color rendition which appears natural, and if conditions make good color rendition doubtful, he should also take a shot in black-and-white if possible.

**144**

# Reflections on the Accidental

Although a photographer has a high degree of control over the final appearance of his pictures—from the selecting and directing of the subjects to the choice of means and techniques for execution and presentation—the more experienced he becomes, the more clearly he realizes how often it is luck which accidentally presents him with an outstanding picture.

Personally, I could cite any number of examples to prove this, but shall mention only a few to illustrate my point. One morning, while I was walking up Fifth Avenue on my way to the *Life* office, a brilliant reflection accidentally caught my eye. Glancing up, I noticed that one of the windows near the top of the RCA Building strongly reflected the sun, producing a veritable burst of light. Luckily I had a camera with me and recorded this beautiful sight which was later used on the jacket of my book *New York* (Ziff-Davis, 1945). Several strictly accidental events brought about this picture which I regard as one of my best: it was a clear morning; I happened to pass by at just the right moment, for the sun moves fast and its reflection in the window lasted only a few minutes before it was gone; I happened to walk right through the beam of light cast by the reflection—three feet away in either direction and I wouldn't have seen it; and I happened to carry a camera. This accidental combination gave me a cover.

Another time, I had to make an overall shot of a steel mill in McKeesport, Pa. I had found a suitable vantage point on a bluff above the Youghiogheny River overlooking the plant, the river, and the surrounding countryside with the town and the workers' houses scattered in the background. Horizon and sky were outside the picture area. Everything was satisfactory except that the scene lacked a focal point since there was no single outstanding mass and too much gray-in-gray. I waited for a long time for something to happen—I don't know what—but nothing did. Since I couldn't think of any way to improve my picture—the weather and the light were perfect and the mill was going full blast—I finally made my exposure, using a red filter to

improve contrast. And then, just as I was ready to pack up and leave, it happened: a switching locomotive in a compositionally excellent spot blew off a cloud of steam. I had time to take only a single picture before the steam disappeared and the scene was gray-in-gray again. But this unexpected sudden burst of steam, *this lucky accident,* by giving me contrast and a focal point for my picture, made this photograph better than four pictures of other steel mills with which it had to compete for space in the magazine, and eventually it made a double spread in *Life.*

One of my best skyline pictures of New York I owe to a lucky accident. Driving home on assignment, on a secondary road near Paterson, N. J., I happened to glance to the right, and there, like a miniature floating on the horizon, was the most beautiful view of the skyline of midtown Manhattan I had ever seen. That I noticed it at all was due to an almost incredible combination of lucky accidents. It happened to be late in the day, the only time at which the sun strikes the distant buildings head-on, making them stand out brilliantly against the darkening sky; at any other time they would have merged with the haze. The atmosphere was exceptionally clear; I later learned that, due to a distance of fourteen miles, New York is visible from this spot only on a very few days each year. I had lost my way and was driving along a road which I would normally not have taken. I happened to turn my head and look up at just the right moment, for there is only a single short stretch of road from which the skyline can be seen. Eventually, I went back with suitable telephoto equipment to photograph this magic view —going three times before conditions were again right—and got a picture which made a double spread in *Life* (November 10, 1941).

I mention these examples because they show how often photographers owe good pictures to luck. Such luck involves having the right equipment at the right place at the right time. No one can always anticipate the right place or the right moment. I know of photographers who were delayed through no fault of their own, who got very angry, but who got an outstanding picture precisely because they were late. Had they been on time, they would have missed it.

**146**

Actually, of course, nothing is accidental. There is a reason and an explanation for everything. For instance, coming back to my first example, any astronomer would have known that at a certain time of a certain day, if the sky was clear, the sun would reflect from a certain window in a certain building, and that this reflection would be visible from a certain spot on the street. Such seemingly accidental phenomena pervade our whole physical world. For example, take a handful of pebbles and try to arrange them in a natural way on a sheet of paper. Most likely you will experiment for a long time, and yet the arrangement will look unnatural. Then, take the pebbles and drop them casually on the paper, letting them fall and roll as they will, and the chances are that the arrangement will look natural. We may call such an arrangement accidental, but actually it is not. On the contrary: the artificial arrangement was "accidental"—the pebbles were composed according to our own subjective concepts of beauty (or whatever one may choose to call it). On the other hand, the pebbles that were just dropped arranged themselves in accordance with certain unalterable laws of nature—the laws of mechanics, gravity, inertia, friction, least resistance —and the resulting pattern was *not* accidental but could, at least in theory, have been predicted according to the mathematical formulas governing these laws. The same applies to the "accidental" patterns formed by cracks in a broken pane of glass, by the branches of a tree, by wild geese flying in formation, by ice feathers on a window pane, or by the reticulation of a negative emulsion. However, photographers attempting to compose objects "artistically" often violate these natural laws, and the result is that their arbitrary solutions turn out to be stiff and unnatural. Control in photography should never go that far.

Another controversial subject belonging in part to the category of the accidental is the question of whether or not, in being photographed, people should look directly at the lens. Studying old photographs, we usually find that people looked at the camera. According to most modern views, except for certain types of portraits, such "mugging" spoils a picture.

In my opinion, the direction in which the model should look depends upon

the purpose of the picture. In bygone days, when cameras were large and conspicuous and photographers a curiosity, taking a candid picture was virtually impossible. Naturally, people watched what was going on with interest, looking straight at the camera. This established a relationship between subject and observer which does not exist in most candid photographs. When you look at old photographs, people appear to look right into your eyes, compelling you to look back at them. And somehow these people seem to speak to you. The expressions in their eyes, the lines in their faces, still speak of pride and happiness, or of persecution and privation —like the people shown in Jacob Riis' and Lewis Hine's memorable photographs. This direct emotional contact is missing in most modern candid pictures in which faces are averted and eyes hidden. Relying on the smallness of their cameras to escape detection, modern photographers sneak up on their victims and take them unaware, preferably catching them at a moment when they are engaged in some more or less private activity.

As Ansel Adams once put it, this is a peephole or keyhole point of view. Such pictures never let us meet the subject eye to eye. Often, I feel personally embarrassed for photographers who must intrude upon some bereaved mother or a despairing accident victim and shoot those pictures which we subsequently see slapped across the pages of the tabloids. I know how I would feel if I were subjected to such an attack upon my most private emotions. But then, of course, I am not a news photographer.

In shooting posed pictures, today's photographers often instruct their models not to look at the camera but to act naturally. This reminds me of the previously mentioned attempts to arrange objects naturally—results are in both cases bound to be forced and unnatural. How can they be otherwise? The only successful way to get unposed photographs of people is to photograph them when their attention is focused upon some interest other than the photographer (people at work, children at play). Only under such conditions can photographers get genuinely candid shots. And if they pose people, they may as well let them look directly at the lens so that the viewer of the picture can meet them eye to eye.

# 3

---

# The Photographer

## How to Become a Photographer

I am constantly asked by young people how one becomes a professional photographer. Unfortunately, there is no single answer. But since I believe that my own experience is rather typical, I shall outline it briefly. As long as I can remember, I have been interested in structure and construction, from the construction of a feather and a bird's wing to that of an automobile engine or a bridge. I am fascinated by the ways in which things function and one of my great interests is the interrelation of function and form. So it was no surprise to anyone when, at the age of fifteen, I left school and began to learn the trade of a cabinetmaker. Three years later, I finished my apprenticeship, became a journeyman, and immediately afterward began to study architecture. At the end of four years, I got my diploma and went to work as an architect, first in Germany, then in France, and later in Sweden. However, it did not take me very long to realize that, in order to be a successful architect, two qualities are necessary which I did not possess: to stay in the same place long enough to get acquainted with the people for whom one hopes to build; and, to be a diplomat, able to get along with anyone whether one likes the person or not. Unfortunately for me, I love to travel and dislike staying too long in one place—and I never was, and probably will never become, a diplomatic person. This, in conjunction with the Depression of the early Thirties, which almost completely halted building activities all over Europe (where I then lived), induced me to switch professions: I became an architectural photographer.

Ever since I left school, without being particularly interested in photography, I had used the camera as the most convenient means for obtaining records of objects which interested me. Taking photographs took less time and produced more accurate results than sketching. Since I was thus familiar with the rudiments of photo technique, had a passion for constructions of any kind, and knew a large number of architects, it was only natural that I should combine these assets and become an architectural photographer. For six years, I made my living photographing for most of the leading architects and architectural publications of Sweden.

When the war broke out in 1939, I moved to the United States and settled in New York. Here, no one knew me, no one had ever heard of me or my work, and I had to start all over again. I signed a one-year contract with a well-known New York picture agency and began to work as an all-around photographer. Every day I learned something new, working harder than I had ever worked before, six days a week, fifty-two weeks a year, for a minimum guarantee of twenty dollars a week (this was in 1940). But although I got my share for every picture story which the agency sold for me (unfortunately, most of my agency-assigned picture stories were done on speculation and did not sell too well), I had to pay all the expenses for photo material and processing, and since the owners of the agency believed in constantly underselling the competition, by the end of the year, I had earned no more than the minimum guarantee advanced to me each week. When my contract came up for renewal, I refused to sign up again.

In the meantime, the agency had introduced me to *Life* Magazine. Fortunately, Wilson Hicks, then picture editor of *Life*, liked my work, and gave me assignments regularly. When I left the agency, he signed me up as a contract photographer and guaranteed me a monthly retainer. Eventually, in 1943, I joined the photographic staff of *Life*, a position which I held for the next twenty years.

Looking back on my own career as a photographer, I find several aspects and observations which, I believe, can be of practical value to future photographers. They are briefly discussed in the following pages.

I never went to any photo school or took any kind of course in photography. I exposed and developed my first negatives (they were glass plates then) by carefully following the instructions that accompanied the plates and the developer. From then on, I learned as I worked, profiting from every mistake I made by tracing it back to its cause. And I found that, once I had discovered the cause, I never had to make the same mistake again. Speaking from experience, I know that modern photo technique is so simple that anyone can produce technically satisfactory photographs of average subjects merely by following the instructions that accompany every new piece of photographic equipment and package of material.

## Approach to photography

As previously pointed out, I believe that it is mainly a photographer's attitude toward photography that determines whether or not he will succeed. Unless he realizes that *the picture is the end,* that *the subject is the reason why he takes the picture,* and that *the camera is only the means,* he will never become a good photographer. I became a photographer from necessity because I had an intense interest in certain types of subjects —structures, constructions, buildings of any kind, and architecture and city planning in general—and needed visual records of them for study and future reference. Sketching was too slow and too inaccurate, so I taught myself the use of the camera.

An analogy from the days of my apprenticeship as a cabinetmaker comes to mind. When the handsaw was too slow, we naturally used a powersaw, a more suitable tool. But although I enjoyed working with a powersaw, my interest was centered not upon it but upon the piece of furniture which I was building.

This attitude of mine has never changed. I still consider the mechanics of making a photograph subordinate to the subject and my interest in it. Since I am a photographer, this may sound incongruous; but I firmly believe that whatever success I have had in my chosen field results from this attitude which always makes me place the subject of the picture first.

**151**

## Interest and specialization

As I have explained, it was my interest in architecture, *not* in photography, that first brought me into contact with the camera. And so it was with many of *Life*'s best photographers. Alfred Eisenstaedt, for example, was a button manufacturer; Ansel Adams, a musician; Fritz Goro, a sculptor and magazine editor; Dmitri Kessel, a fur merchant; George Karger, a banker; Gjon Mili, an engineer; Wallace Kirkland, a social worker; and Eric Schaal sold ladies' undergarments. With all of them it was interest in some specific subject or field—people, sociological problems, industry, nature—which first made them reach for the camera. This seems significant to me; if one's interest is wholly absorbed by one specific subject, one simply does not have the time nor the interest to pay *more* attention to the business of making pictures than is necessary to achieve a specific goal. This attitude guarantees that interest will be concentrated where it belongs—on the subject.

This concentration of one's interest upon subjects of a specific nature can have a consequence which, depending on one's point of view, may or may not be desirable: it tends to make the photographer a specialist in a more or less limited field. This is advantageous insofar as it eventually makes the photographer an expert in his chosen field, knowing more about a certain type of subject and how to photograph it than a more versatile photographer. Such a specialist, of course, has a greater chance to reach the top of his profession than the average all-around photographer who faces much greater competition. This is proven by the phenomenal success of photographers such as Eugene W. Smith, who specializes in photographing people; Fritz Goro, specialist in scientific photography; Roman Vishniac, outstanding pioneer in photomicroscopy; Richard Avedon and Hiro, both of whom specialize in fashion photography; and Philippe Halsman and Yousuf Karsh, the portraitists. Each of these photographers is a specialist who rarely if ever photographs subjects outside of his chosen field, and each not only stands at the top in his particular field, but also is one of the great photographers of his time.

On the other hand, the more versatile all-around photographer has a

choice of a larger number of assignments and is generally more useful to assignment editors and the average users of photography.

Because of this, some specialist photographers deliberately try to broaden their sphere of activity by branching out into related fields in order to widen their experience and increase their usefulness to assignment editors. And some all-around photographers specialize on the side in fields which particularly interest them. Needless to say, both departures are likely to be of benefit to the development of each type of photographer.

## Amateur vs. professional

According to popular opinion, photographers are divided into two groups: amateurs and professionals. Amateurs lose, and professionals make, money on photography. Amateurs are dilettantes and dabblers in photography, whereas professionals are serious men and women who know what they are doing. . . . Needless to say, this is completely untrue.

Two very different types of professional photographers exist: The strictly commercially minded types who see in photography merely one way to earn a living, and who approach the taking of a picture with no more emotional expenditure than a butcher approaching a salami he is about to slice. And those to whom photography is a way of life, who would photograph at any cost, and who consider themselves lucky because they earn their living by doing something which they would do anyway since they cannot live happily without doing it. It is this second group to which most of our best photographers and photo journalists belong. And it is primarily to photographers belonging to this group that the author addresses this book.

Photographers who belong to the latter group often became professionals because this enabled them to broaden the scope of their hobby which thus became their livelihood. The obvious advantages are manifold: instead of having to pay for it, a professional photographer gets paid for doing precisely the kind of work he loves to do. He gets an opportunity to travel and to visit places which otherwise he could not afford to see, the client or

magazine taking care of his expenses. He meets interesting and unusual people whom, without the influence and prestige of his employer behind him, he would never have a chance to meet. For the same reason, he is able to get into places which otherwise would be closed to him. Being a professional photographer, and particularly a photojournalist working for a big magazine, enables one "to see the world, to witness great events," as the editors of *Life* put it. It can be a whole education in itself, so interesting and immense in scope that it cannot be duplicated in any other way.

## Hard work and a touch of luck

Any aspiring photographer who wishes to become a professional, because he imagines that this would give him a chance to associate with beautiful models and to handle beautiful equipment, is in for the worst disappointment of his life. Very soon he will find that photographing even the most beautiful models is strictly business—hard and serious work—and that cameras and lenses are tools to be used, not to be polished and admired. Any photographer who is so much in love with his camera that he can not bear seeing it wetted by rain, scratched by desert sand or cinders in a steel mill, and generally treated in the same businesslike way that a mechanic treats his tools, should never consider a professional career. Although professional photographers try to keep their equipment in top shape and to protect it as much as possible from needless wear, they regard it as expendable inasmuch as the picture always comes first.

Professional photography and photojournalism in particular are intensely competitive professions. Too many young photographers dream of the big money they are going to earn and the strange places which they will see in the course of their work. But, while many dream of success, only a few will have a chance to succeed, and then only if they are prepared to work harder than they ever worked before. Any number of people work hard from nine to five, but a photographer on assignment must be willing to work not eight, but ten, twelve, fifteen, or twenty hours a day, until his work is done. He must be prepared to face boredom and almost intolerable

**154**

hardships: living for weeks in the vermin- and fungus-infested jungle of the tropical rain forest as Eisenstaedt did when he photographed his part of the *Life* series "The World We Live In"; flying to the North Pole on a few hours' notice as *Life*'s Albert Fenn did; or camping out in the arctic tundra on a gale-swept plain at forty degrees below zero.

But even if he is willing and able to endure such hardships and capable of producing the story material required, he still needs a chance to prove what he can do. This requires luck. Understandably, assignment editors are extremely reluctant to trust untrained photographers with important jobs. This means starting at the bottom—and never mind the fact that nobody can produce very stimulating or impressive pictures from the kind of assignments which applicant photographers are most likely to get. I still remember some of my first assignments from *Life*. Among others, I did stories on can openers, slip covers (my first story in color), and matchbook covers—not exactly subjects suitable to bring out whatever latent talent I may have possessed. And yet these enabled me to break into the field of magazine photography. I didn't realize till much later *how lucky* I had been to get started so soon, after only one year of agency work. And if Wilson Hicks had not liked my way of handling can openers and matchbooks it might have taken years more before I would have reached my goal.

## Breaking into the field

Basically, there are two different ways to break into the profession: either the photographer can try to sell himself to a client, or he can let a picture agency do the selling. Despite my own rough time with such an agency, I still believe that the latter is preferable—unless the aspiring photographer is unusually talented or lucky. Although any agency takes in the form of a commission a sizable slice from the photographer's earnings, this seems money well spent in exchange for the following services. The agency advises the inexperienced photographer on all professional matters—technical, practical, ethical. The agency employs people who daily make the rounds of the various users of pictures and show the work of the young photog-

raphers to those most likely to buy it; this saves the photographer hours and hours of running from office to office and waiting for interviews which sometimes don't even materialize, time which he can spend more profitably on taking pictures. At the most opportune moment, the agency introduces the photographer to interested picture editors and clients, many of whom he could not personally contact because they are too busy to make appointments with unknown applicants. Finally, the agency gets assignments for the photographer, thus saving him from wasting time shooting unsalable pictures on speculation. This happens surprisingly often to unaided beginners, partly because they do not know that pictures similar to their own have previously been published, and partly because they lack the necessary editorial judgment.

Photographers who prefer to sell themselves must show editors samples of their work—on the strength of which they hope to get assignments. Samples can be in the form of either a scrapbook of clippings of their published photographs, or a portfolio of original prints. Two factors are important: selection and presentation. Needless to say, the kind of work submitted must be selected with the needs of the particular publication in mind. Advertising agencies are concerned mainly with single photographs, whereas magazine editors are interested almost exclusively in coherent picture stories. This is where so many applicants to magazines make a mistake: their portfolios contain only single unconnected photographs—no picture stories because they have none to show. They don't know, as magazine editors do, that a photographer may be able to produce beautiful pictures and still be incapable of producing coherent picture stories. It is comparatively easy to pick the high point of an event and turn it into a smashing photograph. It is considerably more difficult to depict the whole event in the form of an interesting picture story, and this is exactly what magazine editors demand. To prove that they are able to do this type of work, applicant photographers should do picture stories on their own, with the aim of learning from practical experience how to produce coherent stories and accumulating samples of the type of work which magazines

need. Without such material, their interviews very likely will be in vain, for no proof of their competence is evident. And once a photographer has been turned down by an editor, it is almost impossible for him to make contact again.

Even before a prospective employer looks at an aspirant's work in detail, he forms a general opinion about his visitor's character and qualifications based upon the way in which the samples are presented. He will be favorably impressed if the presentation is neat but unpretentious; he will be prejudiced if it is either sloppy or ostentatious. To make a good impression, a collection of sample photographs should consist of a moderate number of color transparencies or slides. Prints should be on double-weight paper not smaller than 5x7 and not larger than 11x14 inches, unmounted, spotlessly clean, and evenly trimmed *without* a white border. All too often, young photographers seeking my advice on how to break into the magazine or advertising field have shown me collections of sample prints which looked as if they had been through the war—in a duffel bag; corners scuffed from too much handling; some prints spotty, some scratched, some kinked; fer-rotyped prints mixed with prints on mat paper; sizes too small and too large; prints mounted on heavy boards alternating with buckled prints on single-weight paper. Or else they were presented in a much too preten-tious manner, mounted under bevel-edged mats, signed as if they were works of art. Needless to say, neither the sloppy nor the ostentatious type of aspirant has much chance of landing a job.

In assembling his collection, the photographer must not include too many pictures. Editors don't need to see large numbers to make up their minds and resent wasting their time. As a result, a collection of about a dozen prints or color shots carefully selected from a photographer's best work will *always* make a better impression than a big stack of pictures of no more than ordinary interest. Furthermore, in making their selection, most photog-raphers would do well to ask the advice of friends whose taste they trust. Photographers only too often have trouble objectively judging the quality of their work. Frequently, they prize pictures highly merely because they

were difficult to take or because they are of personal interest, although nobody else sees anything remarkable in them. Needless to say, submitting such pictures to a prospective client is a waste of time.

## The changing photographic market

When I started my photographic career, the big thing was photo-journalism—every young photographer's dream was to join the staff of *Life*. Today, the big picture magazines are gone, and the chances of landing a permanent job in photography are relatively small. *National Geographic* still maintains its own staff of photographers, and there still is a demand for permanently employed photographers in industry. But generally speaking, the time of job security is a thing of the past. The present belongs to the individual photographer who works on his own. If he is diligent, resourceful, imaginative, and aggressive, he still can make a very good living—and derive a lot of satisfaction from doing it—in one of the following fields.

**Advertising.** This is a constantly expanding field in which originality and daring can reap the highest rewards. Competition, however, is murderous because the high prices paid for top commercial work attract the best photographers. To break into advertising photography usually requires a touch of luck or the proper connections; to stay in it for any length of time calls for iron nerves, the constitution of a horse, the skin of a rhino, and a stomach that scoffs at ulcers. It also may require the maintenance of a sumptuous studio with accompanying large overhead. Billings can run into six figures.

**Fashion photography.** A highly specialized field demanding a highly special talent. But to the man or woman with a flair for fashion, taste, love of elegance and luxury, and an understanding of the feminine mystique, fashion photography can be an extraordinarily rewarding experience.

**Architectural photography.** Another highly specialized field open only to those who have the necessary qualifications: interest in structures and

spatial relationships; an eye for color, outline, and form; and understanding of the purpose and functions of the different kinds of buildings and their relationship to the city, society, and the environment. Clients for architectural photographers are primarily architects—architectural magazines usually don't like to pay for pictures which architects are eager to furnish for free.

**Magazine photography.** A large number of often small, relatively specialized magazines are still flourishing which to a very high extent depend on individual photographers to satisfy their constant need for pictures. Working for these special-interest magazines, a photographer with a special interest of his own can combine his hobby with his profession—not a bad way of making a living. Subjects from which to choose are animals and pets, agriculture, boating, skiing, girls, food, automobiles, photography, travel, homes and gardens, flower growing, nature and conservation—you name it. . . . Interested photographers should go to a large newsstand and study the display, get copies of the magazines they may want to work for, and contact the respective picture editors.

**Picture books,** from the coffee-table variety to illustrated manuals and paperbacks, are still going strong. Distinguish between two kinds: those which are made up of pictures by many contributors and those which are produced in their entirety by only one photographer. Readers interested in this field of photography should go to a large book store and study their display of picture books, examine the ones that deal with subjects in which they themselves are interested, note the names and addresses of the publishers, and then get in touch with an editor as soon as they have developed an idea for a picture book of their own. (Editors of the various publishers are usually listed in *Literary Market Place*.)

**Book jackets and record album covers** offer rewarding possibilities for graphically talented photographers with a flair for design. To get this kind of work, a photographer should make up some designs of his own and then contact the respective publisher or PR director and show him the samples.

**Portraiture** is a field of extremes: on one hand, we find innumerable small portrait studios of a highly commercial nature run more or less as picture factories; on the other hand, we see a few famous portrait photographers of highest artistic caliber, the best known of which are Philippe Halsman and Yousuf Karsh. In my opinion, the first kind of portrait studio is strictly a business which has very little to do with photography in the sense of this book, whereas the second kind of portraiture can be extremely rewarding to any photographer who is seriously interested in people, physiognomy, and psychology.

**Commercial photography** is generally nothing but bread-and-butter photography, a business run strictly for profit which leaves very little room for artistic considerations. This is the field of product and catalog photography, brides and babies, and so on. I very much doubt that the reader would be interested in these fields of professional photography. The one exception might be photographic reproductions of works of art—especially sculpture—which, however, should be of practical interest only to photographers living in or very near large cities where they can work for artists, museums, galleries, and collectors. I have done this kind of work repeatedly myself and always enjoyed it immensely. Indispensible prerequisites for success are taste and a genuine interest in and understanding of the works one has to photograph. The pay, however, is often minimal—artists and museums having very little cash to spend on photography, and many galleries and collectors having too high a regard for money to "waste" it on what they consider unprofitable trivia.

### The problem of equipment

Three factors are of paramount importance:

> **Suitability**
> **Quality**
> **Simplicity**

**Suitability.** The equipment and especially the camera must be chosen in accordance with the temperament of the photographer and the type of work he wants to do. As mentioned, dynamic subjects, particularly unposed p. 103 pictures of people, demand the use of a fast, light, inconspicuous, easy-handling camera; on the other hand, photographs of static subjects p. 113 —objects, landscapes, buildings—are best taken with a larger, swing-equipped camera. Photographers who wish to be prepared to handle both types of subject should own at least one camera of each type.

In selecting a camera, many beginners make the mistake of buying the same type and brand of camera which is used by some photographer whose work they admire, regardless of whether or not such a camera fits their own needs. I know; I made the same mistake myself. Although, as a photographer, I am interested almost exclusively in objects—objects of nature and objects made by man—and furthermore am a slow and careful worker who likes to take his time and do things thoroughly and carefully, I of all people chose a world-famous brand of 35-mm. camera at the beginning of my photographic career. Naturally the inevitable happened: despite the fact that this camera was supposed to do everything, I never got good pictures with it. It fitted neither my temperament nor my type of work.

The buying of unsuitable equipment has two inevitable consequences: the photographer will never be able to take good pictures with it, a fact which can take all the pleasure out of photography; and sooner or later he will trade it in for something more suitable, a transaction which always involves a certain financial loss.

All the different aspects which should be considered in selecting a camera are discussed in detail in *Successful Photography* and *The Color Photo Book* by this author.

**Quality.** No craftsman can do good work with tools of inferior quality, and a photographer is no exception. Many may feel that acquisition of a fine, precision camera is beyond their means. However, any model of any type

of camera is available secondhand at greatly reduced cost. If purchased at a reputable photo store, such a camera is for all practical purposes just as good as a new one. Furthermore, it is guaranteed by the store and can be bought on the installment plan. Under average conditions, the life of a fine camera is at least eight years, at the end of which time it still has a certain value. Consider it in this way: A fine precision camera in like-new condition which would cost about $700 new might sell secondhand for perhaps $400. Bought on the installment plan, payments come to about $35 a month for one year. Five years later, you trade it in for a new camera and get an allowance of $70. In that case, the camera has cost you only $70 per year or $5.80 per month. Does that seem too much?

No serious photographer can afford *not* to afford a good camera. For this reason, I cannot urge him strongly enough to buy only a quality instrument. But he must not make the mistake of confusing quality and suitability. An expensive camera is not *ipso facto* a better camera than a less expensive type *as far as a particular photographer is concerned*. For example, it would be a great mistake for an architectural photographer able to afford the best to buy a fine 35-mm. camera with an f/1.4 lens in the belief that, because it is the most expensive camera in the shop, it is also the best for *his* purposes. On the contrary, not even a $15 box camera could be less suitable to architectural photography. Actually, what *he* needs is a swing-equipped, 4x5 inch view camera with a *slow* sharp lens, an instrument which can be had for less than half the price of the 35-mm. camera.

**Simplicity.** One of the most valuable practical lessons I learned in my work for *Life* was that it is advantageous to keep one's equipment down to a minimum—for several reasons: the less equipment I had to carry, the more independent I became of porters, taxicabs, and help in general; the more ground I could cover in a given time; and the less tired I got. Furthermore, the simpler the equipment, the simpler its use; and the less attention the technical aspects of picture-making demand, the more attention can be given to the subject. All these factors reflect favorably on the quality of one's work.

I also made the discovery that many pieces of equipment (which I had seen other magazine photographers carry and which I subsequently dutifully acquired myself) *were not necessary at all to my particular type of work*. This taught me *not* to pay undue attention to the equipment of others whose work is often very different from my own, but instead to find out for myself what I *really* needed. As a result, I discovered that *only two cameras*—a 35-mm. and a swing-equipped, 4x5 inch view camera, both equipped with several suitable types of lenses—are all that is necessary to successfully photograph almost any kind of subject under any imaginable conditions except those extremely rare instances in which special equipment is needed (aerial and rapid-sequence photography). Also that *one type of black-and-white film* (I use Kodak Tri-X) can do everything, regardless of the size of the camera or the nature of the subject, since professional photographers shoot pictures primarily for reproduction, and the screen of the half-tone engravings makes grainless enlargements illusory. That *a few simple adapters* make it possible—within the limits of focusing arrangements, shutter requirements, and covering power—to use certain lenses interchangeably on several different cameras. That with the aid of simple adapters, *a single set of filters* can be used in conjunction with many lenses. That *photography in available light* not only produces the most natural appearing pictures, but also eliminates the need for cumbersome and expensive lighting equipment. That, in cases in which auxiliary illumination is absolutely required, clamp reflectors cut down the number of light stands. That "miracle developers" exist only in the imagination of their manufacturers and a few gullible amateurs (if such developers were possible, reputable manufacturers such as Kodak or Ansco would have been the first to produce and market them). And that the contrast-rendition characteristic of a film can be modified to a very high degree and adapted to specific subject conditions through suitable modification of exposure and development (as explained in *Successful Photography* by this author). As a result, I used to travel with only one moderate size case of equipment. Often people, seeing how little this *Life* photographer carried, exclaimed in surprise, "Is that all?"

**163**

# The Qualifications of a Photographer

Unfortunately, today, the concept of success is synonymous with financial success; a wealthy person is obviously "successful." Another can be truly great as far as achievement in his chosen field is concerned, but unless he has amassed a fortune from it, he is considered "unsuccessful"—a failure.

It is easy to list the qualities which a photographer must possess in order to have a chance to become successful in accordance with the popular definition given above. First of all, he must have a winning personality. He must be diplomatic in his relationships with clients and know when to give in. He must be authoritative yet polite in dealing with people on a job. In addition, a good front—neat appearance, good address, impressive office and studio—is a definite asset. It also helps if he knows his business, although lack of photo-technical knowledge or imagination can usually be overcome by employing the right kind of help.

However, important as it is in our kind of society, this sort of success is not what I have in mind when I discuss the following qualities which, in my opinion, are prerequisites for success as a photographer. Many of these qualities are intangible and as such are difficult to define.

## The drive to create

One of the most mysterious forces in man is the drive to create, the urge to accomplish things which are beyond the basic needs of life. The highest animals show no evidence of this force; but we find it already manifested in prehistoric man who, some thirty thousand years ago, painted the murals in the caves of Altamira and Lascaux. It is this force which created our culture. It is this compulsion to create which is the one essential factor without which no one can become a truly great photographer.

I have seen this force at work in others, I have felt it in myself. It defies analysis and reason. It is simply there, as elementary as the drives of sex and hunger, and it demands release.

**164**

It is this urge to create which forces the artist to paint, to try again and again for something that always seems to elude his grasp, to persist—no matter how painful the struggle, how terrible the frustration when the hand is unable to give form to what the mind so clearly sees. It drove Gauguin from family and home; it drove Van Gogh into insanity; it created the great masterpieces of art.

Although the degree may differ, it is this compulsion to create which makes great photographers. It explains why they work like slaves and sometimes, like Robert Capa, Werner Bischof, Larry Burrows, and others, literally die in an attempt to accomplish something which no one essentially cares about. Why do we do it, and for what? Consider the magazine photographer's case: for days, weeks, sometimes months, he works, often under conditions of indescribable hardship—in steaming jungles, in the arctic cold, beneath the surface of the sea, in the unimaginable loneliness of the stratosphere, or risking his life in war—for what? Not for money. He could stay at home and earn much more in advertising. Not for fame. A magazine copy's life is almost as short as that of a newspaper; few save it for future reference, although it documents the history of our time. No, we do this work and lead this kind of life because we have to. We could not function otherwise because we are possessed by the compulsion to create.

We do our work in the only way which we can do it—the right way, the perfectionist's way, the hard way—because creative man is compelled to drive forward, contributing his share to the slow progress of the race, forever searching, hoping, and believing, consciously or subconsciously, that tomorrow will bring a better day.

To give is more satisfying than to take; no one realizes this more and lives up to it more than the creative artist. His whole life is devoted to constructive thought, to *giving*. Yet he seldom reaps the reward of his labor and is often ridiculed or persecuted as a "radical." Van Gogh was spat upon, nearly starved to death, never sold a painting in his life—yet today his work is valued at millions of dollars. Gauguin died a forgotten man in a South Pacific jungle—but his paintings live!

**165**

This drive to create is not limited to artistic spheres, but is also manifest in materialistic fields. Americans, for example, are on the average highly creative in organizing, planning, and producing material things. Each modern business, factory, advertising campaign—functioning smoothly and efficiently—testifies to this. But on a larger scale, planning is still frowned upon. Strong resentment exists against what is commonly called "government control and interference." Creative thought is not as yet applied on a larger scale. The frightening results are evident everywhere: in the inefficient planning of our cities; the impossible traffic conditions; the inadequacy of soil conservation and erosion control programs and appropriations; the pollution of water and air; the greed of vested interests which leads to wholesale waste of some of our national resources; the constant threat of war. Why? Because the creative drive is focused, with almost complete neglect of spiritual and cultural values, upon the creation of material things—a one-way road that in the past has inevitably led to the downfall of the so afflicted civilization.

Nature is wasteful on a gigantic scale because it can afford it: an immense number of lives are sacrificed for every one that survives to fulfill its destiny. But man cannot follow such a course if he expects to survive. No one will ever know the number of talents crushed before they had a chance to develop, to mature, to *give* to all of us—victims of a system devoted almost exclusively to the creation of material goods. How many potential Beethovens and Van Goghs have been lost to humanity because their aspirations were submerged in the struggle for bodily survival? How much longer can we afford to waste our resources in this way?

Anyone who in himself feels the spark of creative power is duty-bound to keep it alive, to feed it, to develop it until in time he can *give*, adding his contribution—be it ever so small—to the cultural heritage of man.

## The drive to work hard

Everyone realizes that in order to succeed in this world one has to work hard. This applies whether one intends to become a cabinetmaker or a

**166**

photographer. However, there are differences of degree. Sooner or later, if he works hard enough, the cabinetmaker will become an accomplished artisan, will reach the point where he literally knows everything that a craftsman in his profession must know. But no matter how long a photographer may work and how accomplished he is as a photo technician, as long as he lives he can never reach an end in his learning as an artist —because there is neither end nor perfection in art.

An artist is always at work. Even when he seems to be doing nothing, his mind is still concerned with his work, observing, searching, sifting facts and impressions. Similarly, a creative photographer works not only when taking pictures, but all the time he is awake. He constantly sees new images, conceives new ideas and ways of visual expression, thinks of new experiments. Consciously or unconsciously, his mind is always active, creating in terms of images and photographs.

Some photographers, however, are dreamers who never get around to realizing their dreams. Somehow, something always seems to get in the way: practical matters that cannot be delayed, business, clients, obligations, appointments, the chores of daily life. Tomorrow is another day, tomorrow they'll find the time to do their revolutionary work, tomorrow they will show the world! But this tomorrow never comes. And, gradually worn down by inertia and frustration, the creativity dies, the contribution remains unmade; routine has claimed another victim.

Important as routine work is to material success, in creative photography one must go beyond routine. Any competent photographer is expected to be able to do the job assigned to him, and to do it well. *It is the work done above and beyond the call of duty, the extra effort, the overtime neither paid nor asked for, willingly put in for the sake of a better picture, which gets a photographer to the top.*

There are any number of hard-working photographers, competent nine-to-fivers who are perfectly capable of doing routine jobs. Art directors and picture editors have no trouble finding as many as they need. But what is always in demand, because it is so rare, is *the photographer who gives more*

**167**

*than is expected of him*. This is the magic formula for success: put *plus-values* into your work. If necessary, work longer and harder than you were asked to work; do more than is expected of you; contribute something of yourself—personality, ideas, style, that indefinable something which states that a certain picture could have been made only by you.

## Ability to think in terms of pictures

As previously mentioned, a subject can be *interesting and beautiful, yet not be photogenic*. But the photojournalist often finds that he must depict such unphotogenic subjects because they are journalistically important as news. The more trained he is to think in terms of pictures, the better he will be able to handle such difficult subjects.

For example: Some years ago, I had to do a story on two new types of plastic which had unusual properties. One type was "photosensitive," i.e., the liquid plastic solidified upon exposure to light but stayed liquid indefinitely if kept in the dark; the other simply was stronger than any previously known type of plastic. Photosensitivity and extraordinary tensile strength; how could one possibly depict these qualities in the form of interesting photographs, particularly since the two plastics—both being transparent and colorless—were singularly unphotogenic?

The obvious way to present the photosensitive plastic would have been to do a story in the form of a step-by-step sequence: the components of the plastic—a beaker containing the liquid plastic—irradiation of the liquid plastic with light—the process of polymerization (hardening) under the influence of light—the final solidified plastic. However, few types of pictures are more boring than step-by-step sequences of hands holding laboratory beakers and stirring colorless liquids. In the form of a short movie, such a sequence might conceivably be interesting and informative. In stills, it would not. There were many reasons: the liquid plastic looked like water; the irradiated plastic looked like water illuminated by a beam of light; the process of polymerization itself was practically unnoticeable and would not show in a picture because no visible difference existed between

**168**

the plastic in its liquid and in its solid state. Since pictures of such a transformation could easily be faked, they could never convincingly prove that the plastic actually hardened under the influence of light instead of becoming set by drying like ordinary cement.

This is a typical example of a subject that is at once interesting and unphotogenic. The researcher, unused to thinking in terms of pictures, had scripted the story in the form of a step-by-step picture sequence which, for the reasons given, was obviously unacceptable. The problem had to be attacked differently. These are the conclusions and solutions at which I finally arrived:

One of the main premises in photo journalism is that every picture must mean or prove something. This automatically eliminated the first of the proposed pictures which was to show the dry components of the new plastic. In powder form most chemicals look alike, and we might just as well have photographed small mounds of sugar or flour, for the effect of the picture and its informative value would have been no different. If this information on the components of the plastic was necessary to the story, its place was in the caption since as a literary subject it was unsuitable to rendition in picture form.

p. 97

Next, I decided to cut down the remaining proposed pictures from four to two—the shorter a sequence, the simpler and less tiresome—for simplicity is one of the basic photogenic qualities.

*The first picture.* A Petri dish (a shallow, circular, flat-bottomed container of thin glass), placed on a laboratory ring stand, contained the liquid (waterlike) plastic. A small slide projector, placed in front of the ring stand, projected (via a small mirror placed beneath the Petri dish at an angle of 45°) the image of a Maltese cross through the glass bottom of the Petri dish. In this way, the horizontal beam of the projector was deflected upward so that the image of the Maltese cross penetrated the liquid plastic. The whole setup was then photographed in a darkened room, the main light being that of the beam of the projector.

*The second picture.* The setup is essentially the same. However, under the influence of the light projected through it, the irradiated plastic in the Petri dish had hardened in the form of the projected image, a Maltese cross, whereas the unirradiated plastic surrounding the cross had remained liquid. The picture was taken as two hands, gripping the Petri dish, slowly poured out the unaffected liquid plastic from the tilted dish while the solidified part, adhering to the bottom of the dish, emerged in the form of a Maltese cross.

Together, these two pictures *proved* what the originally proposed sequence of five could never have: *The fact that this particular kind of plastic hardened under the influence of light,* because, conceived as it was, this setup could not have been faked.

Incidentally, although the solution to such a problem may seem simple on paper, complications usually arise during the process of practical execution. In this case, two unforeseen difficulties had to be overcome. One resulted from the fact that in the photograph the beam thrown by the projector had to be visible to explain how the Maltese cross was produced (cigarette smoke was blown into the path of the projector's beam to make it visible). The other difficulty derived from the fact that an image projected into a clear liquid such as the unpolymerized plastic is as invisible as an image projected into air. However, the value of the first picture depended entirely upon the visibility of the projected image of the cross. This image within the liquid plastic was made visible by adding to the fluid a small amount of fluorescent powder which began to glow under the influence of the light, revealing within the liquid plastic the three-dimensional shape of the projected Maltese cross.

The second assignment required that the superior strength of the other type of plastic be demonstrated in picture form. The obvious way to do this would have been to suspend a heavy weight from a narrow strip of this plastic. But no picture could possibly be duller or prove less. Nothing would be simpler to fake by making a giant-size weight of balsa wood or papier-mâché and painting it with aluminum paint.

**170**

With the cooperation of the manufacturer of the plastic, we solved our problem by enveloping a full-size automobile in an enormous bag made of this paper-thin, perfectly transparent plastic, and suspending it from a crane. A gag, corny perhaps, but extremely effective. Photographed against the sun, this plastic bag—containing at the bottom the heavy, silhouetted car—was all but invisible except for some glittering reflections, producing the sensation of an automobile suspended in midair and demonstrating in the most convincing way the fabulous strength of the new material.

In another case, the imperviousness to acid of a new fabric made of a synthetic fiber had to be demonstrated in photographic form. The script called for two photographs, each showing a laboratory beaker filled with acid. The first picture was to show a sample of ordinary fabric partially submerged in the acid and being dissolved. The second picture was to show the same setup, with the difference that the new material remained unaffected. A short talk with the editor, in which I pointed out that such pictures would prove nothing since there was no way of showing that the second beaker did not contain water instead of acid, resulted in the cancellation of the whole idea.

A few years ago, the newspapers carried pictures of a Navy helicopter equipped with lights at the tips of its rotor which, it was hoped, would facilitate night rescue work at sea. The picture which came to the attention of one of Life's editors showed a time exposure at night of the helicopter making short vertical ascents superimposed upon one another, its rotor lights tracing luminous designs against the black sky. Since the motion of the helicopter was more or less straight up and down, the image was blurred and confusing. But the picture indicated certain possibilities which made the editor send me out to try and get some better shots. The problem, as I saw it, was that in one picture two different things should be accomplished: the helicopter itself should be shown clearly instead of blurred; and the effect of the rotor lights should be brought out in a graphically effective form. To produce such a picture, it was necessary to use a double exposure. The first

exposure showed the floodlight-illuminated helicopter at night standing still at the end of the field. The second, a superimposed time exposure of the ascending helicopter flying toward the camera, over it, and out of the picture, showed to full advantage the beautiful design of the spiral traced against the sky by the lights at the tips of the whirling rotor blades.

I believe these examples suffice to explain what I mean when I speak of the ability to think in terms of pictures. It really is quite simple and can be summed up as follows: An idea itself obviously cannot be photographed, but it can be conveyed to others through photographs—*provided it has been properly translated into visual form*. If properly translated, it loses none of its meaning. If improperly translated, its meaning is distorted or lost. To be able to translate an idea into tangible visual form, a photographer must be able not only to visualize images *before* he actually produces them on film and sensitized paper, but also to evaluate such hypothetical images in regard to their observer effect and meaning: Will the original idea be clearly conveyed or could it be misunderstood? Does the picture *mean* anything? Does it *prove* anything? If the answer is yes, take it; if no, forget it.

**Ability to report and interpret**

A photographer combines two functions: that of a *collector* and that of a *disseminator* of information. As a collector, he meets interesting personalities whom other people only read about; gets into places that are closed to others; travels to remote parts of the world known to most people solely through description; and in the form of photographs supplies the information he was sent out to collect. Reproduced in magazines or Sunday supplements or projected on movie and television screens, his pictures may be seen by millions of less privileged people, informing them and often influencing their thinking. Since these are *his* photographs which are sent all over the world, he is justified in regarding himself as the disseminator of the information which they contain.

172

Since to a rather high degree it is up to the photographer to determine *what* he photographs and *how* he photographs it, his power to influence those who see his pictures can be immense. It can be immensely destructive if not matched by an equally developed sense of responsibility. Consequently, a photographer's first duty is to report, to collect facts. Yet it is often impossible to collect *all* the facts if there are many. Hence, a photographer must be able to evaluate facts in regard to their importance to the story so that he can select his subjects accordingly—as long as they are representative, regardless of whether their implications are good or bad. To do this he needs judgment, the ability to see things in their proper proportion and in their true relationship to other facts. Few things in life are entirely good or entirely evil; but to detect the evil in something seemingly good or the good in something apparently evil is often difficult.

For example, a photographer is sent out to report on a foreign country. The editor who assigned him is far away, and the photographer is on his own. Choice of subject is his and his alone. Merely by *not* photographing certain kinds of subjects he can give his picture story a specific slant. If, for some reason, he does not like the country or regime he was assigned to document, there is nothing to prevent him from stressing whatever evils may exist and more or less ignoring the good aspects, though these may actually outnumber those which are undesirable. Back home, his pictures, seen by millions, may influence public opinion in a way detrimental to the true interests of both countries.

Lack of judgment is particularly often found in photographers who prefer to be guided by the heart rather than the mind. Typical examples are, as already mentioned, those documentary photographers who concentrate on **p. 78** depicting the unfortunate aspects of society to the exclusion of all else. Lacking a sense of proportion, blind to the fact that the good far outweighs the admitted evils, and devoid of constructive ideas, they focus on a particular situation and make it representative of the whole. They seem to believe that destruction of this form of society is a better way to eliminate its evils than improvement in a constructive way of already existing institutions.

**173**

To those photographers I want to say: Don't be so negative! In your pursuit of the seamy side of life, don't overlook its other sides. Be constructive. Document the good achievements, the positive spirit. Instead of solely photographing dirty children playing among the rubbish of abandoned city lots, show in contrast the new playgrounds. Perhaps some people, inspired by your commentary, will work for the necessary changes. If your photographs arouse people to do something good—whatever it may be—this good is partly due to *you,* is *your contribution* to make a better world. It is easy to tear down and destroy. But pessimism and defeatism help no one, nor do they contribute to progress. On the contrary, such attitudes have paralyzing effects. Only in a positive and constructive spirit can new things be created or obsolete things replaced with better ones.

Since photojournalists have human failings, their judgment understandably is sometimes clouded by personal opinion. Once more I want to repeat that I believe in anyone's right to a personal opinion. However, *in their work,* photojournalists should attempt to keep their pictures free from bias. Regardless of how they feel about a certain subject, they should stick to factual reporting because this is the only way in which they can present the public with pictures—documents—which permit each viewer to form his own opinion. However stimulating the subjective approach may be in certain other fields of photography, the picture report of the photojournalist must be objective, realistic, true to fact. Because it forms the basis in accordance with which people, who otherwise cannot get certain facts, draw their own conclusions. In short, a photojournalist states facts so that others can form opinions.

If photographs reflect the personal opinions of a photographer, they cannot be classified as photojournalism. The photographer is no longer a photojournalist, but an interpreter of the subject which he depicts. If pictures of this kind are recognizable or designated as *subjective* photographs—as personal commentaries or impressions—they can have effects as refreshing and stimulating as those of works of art. If they are misrepresented as *factual,* they are *propaganda*.

**174**

## Ability to work with people

A working photographer often finds himself in situations which can be rather embarrassing: he must ask people for something without being able to give anything in return. He must intrude upon people, invade their privacy, take their time, ask their cooperation either as models for his pictures or as helpers in one capacity or another. The more diplomatic he is in such dealings, the easier his job is, and consequently the better his pictures will be.

A professional photographer represents his client. Further than that, to most of the people with whom he comes in contact on a job, he becomes representative of *all* professional photographers. This places a responsibility upon him to observe certain standards of courtesy and professional ethics.

In the course of my work as a magazine photographer I have talked to many people who had previously had experience with other photojournalists; and whereas they had nothing but praise for some, they complained bitterly about others. As a matter of fact, in some cases I had the greatest difficulty in getting any cooperation at all from people who had previously had bad experiences with inconsiderate photographers who, judging from what I was told, behaved more like rowdies than civilized people. In particular, complaints were made against three different types of photographer:

**The dictator.** He is the arrogant type who believes in short, authoritative commands, who orders people about, rearranges furniture without asking permission, and confuses a dictatorial manner with efficiency. Being the representative of a big magazine or advertising agency obviously goes to his head. He antagonizes everyone on the job and creates more ill will against himself, his client, and working photographers in general than can be eradicated by half a dozen courteous photographers who come after him—provided they are admitted at all.

**The pig.** This is the messy type who, when he is through with a job, leaves the place a shambles. Film wrappers and flashbulbs lie where they fell,

(Text continued on p. 185.)    **175**

The following insert contains eight photographs, each of which is in its own way "different" from ordinary pictures. These differences range all the way from very small (like the close-up of a face against a background of infinity) to rather large (like multiple-printing and solarization). As explained elsewhere in this book, photographs that are "different" have two advantages over ordinary pictures: they attract attention (which means they are not so easily lost in the mass of undistinguished photographs), and they are stimulating because they enrich the viewer's mind, be it ever so slightly, by showing him something which he had not seen or known or thought of before in this particular form.

None of these pictorial "differences" is the outcome of elaborate techniques or of unusual or expensive equipment. On the contrary, each photograph could have been made with any one of hundreds of ordinary cameras. This fact should make these pictures of more than ordinary interest to any photographer who wants to break with tradition and has the guts to be himself.

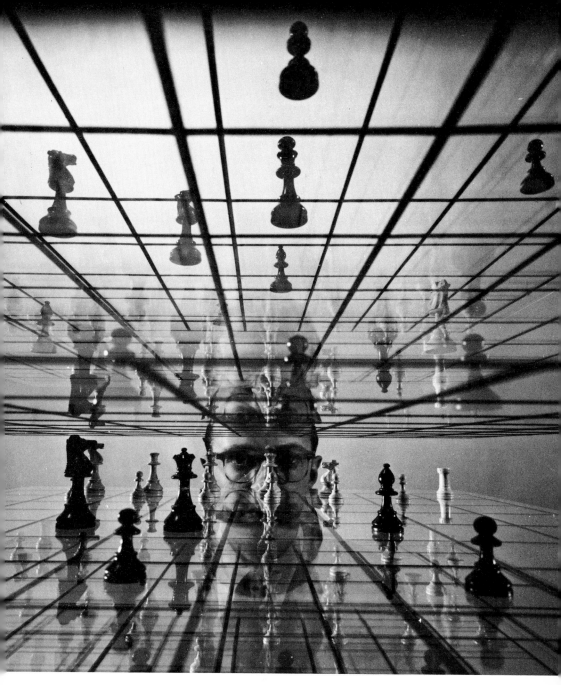

Three-dimensional chess, photographed by Yale Joel. By putting his camera in the position of the second player (instead of passively looking at the game from the outside like a spectator), the photographer gets the viewer of the picture involved in the play. This is bound to generate added interest, besides resulting in a more informative picture.

Hands reading Braille, by Dick Wolters. Multiple exposure convincingly conveys the idea of motion, of sensitive fingertips "reading" the dots of Braille. Low-skimming sidelight accentuates the slightly elevated dots, a good example of an application of texture lighting (see pp. 214, 225).

Shock, by Clyde Childress. A pictorial interpretation of electroshock therapy. An X-ray negative of a head (donated by a physician) was printed slightly out of register with a lighter mask from the same negative. A solarized time exposure of fireworks was printed in.

Harlequin, by Zoltan Glass. A superbly composed picture based on contrast between black and white. An excellent example for proving the truth of the rule that it is not *what* a photographer photographs, but *how* he photographs it—because the subject of this shot is rather dull.

Quartet, by Gjon Mili. Superfluous detail is eliminated through darkness. Essentials—the expressions of the players, the instruments, the score—are emphasized by means of light. As in the picture on the opposite page, the keynote of the shot is contrast between black and white.

Girl in a plane, by Fritz Henle. By go-
ing close-in with his camera, the photog-
rapher created a mood of intimacy. A
beautiful study of a charming flight
companion which was not, but could
have been, made with a simple box
camera. It is not the tool that makes a
picture, but the photographer's use of it.

New York Waterfront, by Fritz Henle.
Superimposed upon the saloon interior
in the form of a reflection, the water-
front street with its trucks and cranes
and masts of moored ships becomes an
integral part of a whole—a one-shot pic-
ture story complete with subject mat-
ter, background, and atmosphere.

An expert simultaneously juggling 14 hula hoops, photographed by Joe Clark. A tiny flashlight attached to each hoop traces its path in the form of a fine white line. At the height of the action, a couple of electronic flash lamps were fired to superimpose the image of the boy upon the time exposure.

cigarette ashes and butts are everywhere except in the ashtray. He never bothers to clean up anything or move back the furniture which he has rearranged. He breezes in, goes through the job like a cyclone, and often departs in such a hurry that he forgets to say "Thank you" and "Goodbye."

**The promiser.** He works under false pretenses, inducing people to cooperate with him by promising to send them photographs later—which of course he never does. He also paints glowing pictures of how much they will benefit from getting into the magazine, but fails to mention the fact that there is no guarantee that the story will ever run. When no results are forthcoming —no courtesy prints arrive, no story appears in the magazine (and they buy copy after copy in the expectation that it surely will)—it is understandable that, feeling cheated, they subsequently refuse to cooperate with other photographers.

**The responsible photographer.** Always courteous and considerate, he makes no promises which he cannot keep. After he is finished with the job, he leaves the place exactly as he found it. Regardless of how tired or how much in a hurry he may be, he always finds time to express his gratitude for the help and cooperation received in the course of his assignment. If such help is considerable in extent, he may invite the people for dinner at a restaurant or give them a year's subscription to his magazine, both of which he charges on his expense account. No responsible editor who knows the value of these small courtesies will object to such expenses. At other times, he may also take a few pictures of the people or their children and *send them prints* and a note of thanks and appreciation. He knows that there may be a time when it might be necessary to photograph the same people again—or their friends or neighbors, or others who in the meantime had heard of him. Instead of being turned down, he then will be welcomed. And in the course of time he may thus acquire new friends.

## Ability to see imaginatively

In accordance with the laws of supply and demand, the unusual is always more sought after than the common. This also applies to photography:

unusual photographs have a better chance of being used by art directors and picture editors than ordinary pictures. Unfortunately, the subjects of photographs are usually more or less the same: people, objects, landscapes, scenes from daily life. Hence, whatever unusual qualities a picture may have must be the result of an unusual quality existing in the photographer rather than the subject. This unusual and desirable quality is *imagination*.

It is his imaginative faculties which make a photographer capable of going beyond whatever he may have learned from others and creating something new in his own work: a new idea, a new approach, a new point of view, a new effect, *a personal style*. An unimaginative person may read all the right books on photography, attend lecture after lecture, go to a photoschool—and still be unable to do more than copy what he has seen. Photo-technical knowledge and skill in its use can be acquired; even the principles of composition can be mastered in time; but no one can acquire imagination. One either does or does not possess this priceless quality. However, many people have latent imaginative qualities, and such unrecognized talents can be brought out and developed.

A good way to train one's imaginative faculties is through mental exercises: try to imagine *different ways* of doing the same thing, different ways of rendering the same subject, different applications of photographic means and techniques. When confronted with a photographic problem, try to visualize how the subject would appear from a different point of view —from higher up; from lower down; from the side; from the rear. How would it appear if taken from farther away with a telephoto lens? Would the subsequent reduction of perspective distortion contribute to a better characterization of the subject? What would happen if a wide-angle lens were used? Would a certain amount of perspective distortion aid in rendering more clearly typical features of the subject—in the manner of a caricature which often is more characteristic of the subject it depicts than an objective rendition? What about a different type of illumination? Backlight,

**186**

for example, instead of the more ordinary sidelight. A silhouette instead of a detailed rendition? Stark graphic black-and-white?

By investigating systematically every controllable factor which contributes to the appearance of a picture; by patiently searching for *other* ways than the obvious one for solving a specific problem; by critically analyzing the results of his investigations; by making clever use of the possibilities inherent in his subject, the inventive photographer creates the kind of picture which makes less gifted or less patient photographers jealously exclaim: Why didn't *I* think of that! How could I overlook such possibilities!

This method is, of course, nothing but imaginative seeing in reverse. Instead of trying to visualize the effects of different means and techniques upon the appearance of his subject, the truly imaginative photographer, encountering a subject to which he responds, immediately forms images in his mind: skyscrapers tower over the horizon like giant megalithic tombstones; a pianist seems to become an extension of his instrument; a woman's lovely face smiles out of darkness, with eyes closed floats into the light, nearer and nearer until it fills the universe—unborn images, waiting to be delivered from the fertile mind, to take shape and form on film and sensitized paper.

First, the mental image, the concept, the idea. Then, selection of the means necessary for their realization. This is how the imaginative mind functions.

Another way to train one's latent imaginative faculties is to study and analyze the work of other more imaginative photographers, much as the student artist learns by studying the work of the masters. I believe that there is no artist who, in one way or another, has not been influenced in his work by the thought and work of others. Such influences are necessary catalysts to the artistic growth and development of any creative personality. This must not be confused with imitation. Influence, in the best sense of the word, is synonymous with inspiration—provided, of course, that the influencing factors are evaluated and assimilated by one whose personality is strong enough to resist the temptation to imitate.

Inspiration derived from someone else's work can lead to the production of

entirely original photographs, so different from the pictures to which they indirectly owe their existence that no one could guess the connection. Inspiration wakens the mind to creativity of its own, bringing impressions to cluster around the things seen, to form a concept or idea independent and original which, realized in tangible form, becomes a creative product of one's own. On the other hand the imitator, too restricted or unimaginative to respond to another's work in such a way, literally copies what he sees and likes, thieving in the realm of ideas.

Unfortunately, this kind of plagiarism is, at least to some extent, encouraged by amateur photo magazines. In the form of technical data readers are told exactly how other photographers produced the pictures shown, thus unduly emphasizing the means used instead of the underlying ideas upon which the photographs were based. Inspiration can spring from anything in another photographer's work to which one responds. It may be the precision of Edward Weston's photographs which suddenly impresses a student photographer with the effects which fine definition can have upon the impact of a picture. It may be the sophisticated softness of unsharpness and blur, so effectively employed by Avedon and Haas to symbolize specific moods, which will make a photographer realize *that intangibles can be suggested in pictures*. Or it may be the boldness of composition in photographs by Arnold Newman or Irving Penn which will make him want to try to use bold, graphic black-and-white himself. But no matter what it is that inspires him, as long as he adapts it to his own type of work, any influence of this kind is bound to be constructive and to further his artistic growth.

The artistic development of any creative person follows a definite pattern which is based upon his character, temperament, interests, sensitivity, and taste. To find one's own pattern is the first step in becoming a creative, original photographer. One must realize that originality is the sum total of one's traits. These traits must be consciously recognized, accepted, and utilized to best advantage. They cannot be changed, although they can be suppressed. One must try to make the best of his abilities. This is *not*

achieved by joining movements or subscribing to specific schools of thought. Exchange of ideas and opinions with others is vital for anybody's intellectual and artistic growth. Photographers who identify with a specific group consisting of people who agree with one another in every important point don't get the stimulating interchange which they need; instead, they forfeit their right to individual thought. Without exception, anyone who has ever achieved anything of lasting importance was an individualist—one who worked in his own way, unafraid to fight for his convictions. Photographers who are not willing, if necessary, to fight for their right to say in their pictures what they want to say in the way they want to say it, lose their freedom as artists. This fight is the silent fight of the mind against the corroding influences of public opinion ("What will other photographers say? What will my editor think?"); vanity ("I wish I were like such-and-such a person."); inertia ("Why try so hard? No one will appreciate the difference."); the temptation to gain quick recognition by copying the successful work of others ("After all, they all steal ideas from one another."). Only those who win this fight become personalities in their own right. And only through personal integrity can one ever acquire a personal style of one's own, for a style is the reflection of oneself.

A personal style distinguishes a photographer from the anonymous mass of photographers whose pictures look more or less alike. Quite a few photographers have gradually acquired such a personal style. Just as an art expert can recognize a painting by Renoir or a sculpture by Rodin without looking at the signature, so any experienced photo editor, without looking at the stamp on the back, can recognize a *typical* photograph by Ansel Adams, Avedon, Karsh, Mili, Newman, or Penn, to name only a few that immediately come to mind. I say *typical* because only pictures which a photographer made in accordance with his own ideas can carry this seal of personality; those made to order according to specifications set by a client may not typify as clearly the style of their maker as those which originated entirely from himself.

To a certain extent, development of a personal style seems to go parallel

with specialization. Each of the photographers mentioned above is a specialist in a more or less sharply defined field. Any creative mind is preoccupied with certain specific subjects. And any creative photographer will preponderantly photograph those subjects in which he is particularly interested. This, of course, leads to specialization. At the same time, however, precisely because he is imaginatively gifted, a creative photographer will gradually develop a style of his own. This style will evolve from the kind of work he mainly does. In this way, specialization and the acquisition of a personal style evolve along parallel lines.

An imaginative photographer maintains his sense of wonder—imagination and curiosity always going hand in hand. Unlike the unimaginative photographer who eventually becomes bored with his work, feeling that everything is repetitious and has been done before, the imaginative mind constantly discovers new sources of wonder. It is the imagination which makes one see marvels and beauty in things in which the less sensitive would see little or nothing at all. It is the imaginative photographer who finds new and interesting pictures in subjects which others would bypass, discovering meaning and beauty in unexpected places. And it is he who, through his pictures, conveys to others the beauty and excitement of the world.

**Ability to observe**

What a photographer must realize is that his eye and his camera see things differently. Guided by the brain, the eye is selective, whereas the camera records everything within its range. To prove this, make a simple experiment: Ask two friends, a man and a woman, to walk along a street with you. Ask them to take a look at a pretty girl approaching while you take a candid photograph of her. Then ask them to describe her.

Most likely, the man noticed the shape of her legs and figure, the way she moves her hips, and the color of her hair. The woman more likely paid attention to the way in which she was dressed, the color and material of her clothes, her hairdo, and her makeup. And whereas the man may call her attractive, the woman may describe her as overdressed and not particularly

attractive. Paradoxical as it may seem, both will probably be perfectly sincere in their descriptions which reflect the difference in their respective interests in the girl, the result of the selectivity of brain and eye. To realize the degree to which such descriptions are selective, i.e., *subjective*, check them against the photograph you took. It will tell you objectively how the girl actually appeared. Perhaps all three of you will be surprised.

A photographer should train himself to see *objectively*, otherwise he may miss important subject features merely because they are not within his sphere of interest, with the result that his photo report—his picture story—may be incomplete.

A good way to train one's power of observation is to take a quick look at a photograph—any photograph—then describe it as completely as possible. One will be surprised at how many features one overlooks. However, if in repeating this procedure one looks at many different photographs of different kinds of subjects, the power of observation will gradually sharpen until finally one will scarcely miss a detail of the rendition. This training can be furthered by substituting actual subjects in place of photographs. Look at things for a few seconds, then turn away and describe from memory what you saw. Check to find out what you failed to notice.

Ability to observe accurately is an important prerequisite for any photographer for the following reasons:

1. A photographer can take only a limited number of pictures in any given situation. Within this number, he must cover every important aspect of his subject. To be able to do this, he must make a wise selection from the subject material which confronts him. The basis for such selection is observation —observation of *all* the different facts, phases, and features of his theme. Only if he is sure that he has missed nothing of importance can a photographer decide what is essential and what is superfluous, what to photograph and what to omit, and expect to come back with a valid picture report.

2. As previously mentioned, it is unavoidable for a photographer to

approach an assignment with certain preconceived ideas. Whether or not these ideas conform to fact can only be determined on location by critical observation of the subject or event which is the theme of his story. Without such objective observation, a photographer might easily return with a more or less prejudiced and distorted report.

3. Photographers cannot always know in advance *exactly* what they may have to photograph. For example, a vacationer traveling in a foreign country must decide on the spot what is typical. In such a case, success or failure of the pictures he brings home will largely depend upon his ability for accurate observation. Picture possibilities can be found almost anywhere; the problem lies in recognizing them. For some, this is difficult because the subject does not always appear at its best when first seen. It may be important enough to warrant recording, but the angle of view, the light, the weather, or the time of day may be unsuitable for the most effective rendition. Such unfortunate conditions may prevent an unobservant photographer from recognizing an important subject—or a subject which under different conditions would make a striking picture. Observant photographers, however, trained to see the latent possibilities in a subject—its underlying basic qualities—easily recognize unsuitable conditions for what they are: temporary inconveniences which can be overcome one way or another—if necessary, by waiting (or later returning) and photographing the subject when conditions are right.

4. A photographer must know *exactly* when to release the shutter. This is perhaps the most important moment in the making of a photograph inasmuch as it is so uncompromisingly final. Before this decisive instant, the initiative belongs to the photographer: the power to decide, select, reject, arrange, and change. But with the click of the shutter the image is irrevocably fixed within the emulsion of the film. Afterward, during developing and printing, only minor changes and improvements can be made.

Consequently, *before* he takes this final step, a photographer should critically survey his subject to be sure that nothing has been overlooked. Specifically, he should pay attention to details of seemingly minor impor-

tance which might have been obscured by the more important aspects of the subject. Such last-minute checks serve to insure that the background is pp. 127–129 suitable and distant objects do not endanger the clarity of the rendition; that perspective is not unduly distorted (converging verticals in buildings, objects too close to the lens); that colors in translation into shades of gray will not blend one into another, making subject and background merge in the picture (if necessary, separation can usually be accomplished with the aid of filters); and so on. Many photographs, which otherwise would have been successful, have been ruined because photographers overlooked such seemingly unimportant details as a result of insufficient observation.

5. Even after he has arranged all the stationary details of a setup to his satisfaction, a photographer must observe everything that moves or changes within the range of his lens. A setup rarely consists entirely of static objects. Even when taking posed pictures, the photographer must still observe people's expressions if he wants to capture the moment when they appear natural instead of posed and stiff. Outdoors, if the wind is strong enough to move branches and foliage or vibrate a camera mounted on a tripod, this should be taken into account and the shutter released during a quiet spell or a sufficiently high shutter speed used, unless the photographer wishes to record motion in the form of blur. Clouds moving across the sky and cloud shadows moving across a landscape cause constant changes in the pattern of a picture, and have to be observed carefully so that the photographer does not miss the moment when they best fit his composition. Similar considerations also apply to photographing people on the street and traffic which constantly form different patterns.

Only if such changes in pattern are carefully observed and the instant of exposure timed correctly, can setups containing motion appear effective in photographs.

6. A photographer can exert a high degree of control over the graphic appearance of his pictures. (The different forms of control, form, and contrast, as well as translation of color into shades of gray, will be discussed later on pp. 207–259.) The aim of such control is to bring out

characteristic qualities of the subject in the most effective form. However, to be able to select the pictorially most suitable graphic treatment, a photographer through observation must study his subject in regard to outline and form, depth, coloration, contrast, illumination, and motion.

**Ability to experiment**

Some photographers put their faith in instructions and believe in sticking to the rules; others, more adventurous or rebellious, strike out on their own, disregard the rules, and experiment. The first attitude is safe, avoids disappointment, and guarantees production of usable although not necessarily exciting photographs. The latter approach can lead to the creation of new effects and new styles and generally contributes to the artistic growth of the experimenter.

Photographers experiment for two reasons: to familiarize themselves with their tools, materials, and techniques; to find new forms of graphic expression.

The correct use of photographic equipment and materials can be learned from the instructions which accompany them. Unfortunately, these instructions seldom tell the whole story. Sometimes, one is led to expect too much: "The system-camera that does everything"; "The most versatile camera"; "Prize-winning cameras." More often, because such instructions are addressed to the *average* photographer, they fail to contain certain information which the *expert* needs. As a result, photographers who want to further their own work must get such information themselves—through experimentation.

To give an example from my own experience: In 1936, I did a picture book on Stockholm. This city is such that some of its most typical views can only be taken across wide stretches of water. My camera, equipped with a standard lens, produced images in a scale which I considered too small. Because of this I decided to work with telephoto lenses. Since I had never used a telephoto lens before, I made mistake after mistake; all my negatives were

unsharp. So I had to experiment systematically to find the reason for these failures before I could take acceptable pictures. At the beginning of these experiments, I knew nothing about telephotography; when I was finished, I knew everything I needed to know. I found that if certain atmospheric conditions exist, it is impossible to get sharp telephotographs, no matter how sharp the lens. That heat waves rising from chimneys, steamer smoke-stacks, railroad tracks, and roofs, which sometimes are not even within the picture area, can cause blur in the negative. That practically unnotice-able vibrations of the camera (wind) or the ground on which the tripod stands (passing trucks) cause blur in direct proportion to the magnification of the lens. That a camera equipped with an extreme telephoto lens must be supported at *both* front and back. That certain types of filters may give acceptable results in conjunction with a lens of standard focal length but produce fuzzy images if used in conjunction with long-focus lenses. And that decreasing the aperture of a lens increases sharpness of the rendition, but only to a certain point beyond which definition begins to deteriorate rapidly, although extension of the depth of field continues to increase. I also learned how to construct telecameras with focal lengths up to sixty inches from simple materials and for very little money—by making the camera body in the form of telescoping wooden boxes and using for a telelens the front element of old-fashioned, slow, but exceedingly sharp, rapid rec-tilinear lenses which I picked up in pawnshops for the equivalent of a few dollars. And I designed a new type of collapsible tripod with five legs which touched the ground in only three points and which, because of its girder-type construction, even on windy days supported without vibration my biggest telecameras. Since I knew no one who could have told me these facts which I needed for the continuation of my work, and since I didn't find them in the books and periodicals which I consulted, I had to learn them the hard way—the best way—through practical experiments and tests.

Whereas the first reason for experimenting is *necessity*, the second reason for experimenting is, in a sense, *curiosity*, the curiosity inherent in any creative person, the wish to learn how far one can go in certain directions in the pursuit of his work.

Again, an example from my own experience may serve to explain what I mean. At one time, I was interested in photographing the human figure. Trying to depersonalize my photographs of the nude and to bring out sculptural qualities, I printed my negatives on paper of hard gradation in an effort to get graphic effects in pure black-and-white. It was late, and I was very tired. I had finished printing and had just transferred the last print from the developer to the rinse tray when, absentmindedly, I turned on the white light. Almost immediately I realized what I had done and switched the light off, hoping that it had not spoiled my print. However, before I could transfer the paper to the hypo, I saw it darken and knew that the print was lost. I left it where it was and started to clean up the room when, accidentally glancing at it, I noticed that it had not turned evenly black (as I expected), but showed the figure of my model distinctly traced in the form of a thin white line on black. Immediately I put the print in the hypo to fix the image, then looked at it in wonder, seeing the delicate effect. At that time, I had never heard of solarization, nor did I know anything of the work of Man Ray and his experiments with this process. But I realized that I had accidentally discovered something which might be useful in my attempts at abstraction. I could hardly wait until I could start experimenting systematically with this new method. And in time, I learned to control it and to produce the effects which I wanted.

Despite the fact that experiments in new methods of expression do not, as a rule, produce immediate *practical* results, their influence upon the artistic development of a photographer can hardly be overemphasized. If such experiments are successful, one learns something new and stimulating which, directly or indirectly, is bound to reflect favorably upon his daily work. On the other hand, if unsuccessful, they provide a challenge to find the reason for failure, and in the process of determining it one is bound to learn something new. In one way or another, the result is beneficial and a welcome relief from the routine of regular work.

Photographers who never experiment with new forms of expression are in danger of becoming stale. They get into a rut, their work tends to become

stereotyped, and they are eventually overshadowed or displaced by new talent. Creative photographers constantly experiment—and prove it by their work. If all photographers were to stick to the rules, photography as a medium of expression would cease to develop.

Only a century and a half have passed since the invention of photography. But during this time, man has moved from the age of steam through the age of electricity into the age of atomic energy. He has invented radio and television. He has learned to fly faster than the speed of sound. He has probed the universe and found that space is four-dimensional and curved, that mass and energy are the same, and that nothing is what it appears to be. It is no wonder that such a complete change in our materialistic and intellectual climate is reflected in photography and that modern photographs—expressing our time—are different from those made by Hill, Brady, and Atget. Today, photographers seek new ways to express feelings, concepts, and ideas—intangibles which cannot be expressed through straight photography. They experiment with new processes—solarization, reticulation, bas-relief printing, multiple exposures and multiple printing, direct projection, negative prints, and photograms—*not* because they intend to replace straight photography with new techniques, but because additional techniques are needed to broaden the scope of photography and bring it up to date.

## Photo-technical requirements

Although, according to popular belief, photo-technical knowledge and skill are first among the qualifications of a good photographer, in my opinion they rank last. I say this because I have met too many photographers who literally knew all the answers in the book, were experts in photo-technical matters, owned the finest equipment, and never made a worthwhile photograph. On the other hand, I know for a fact that several of our most successful photojournalists have only the sketchiest ideas about photo technique—and that the laboratory technicians assigned to do their work suffer whenever they have to print their films. But these photographers *know*

*how to make good pictures*. They know how to *see*, they *feel* for and with their subjects, and they know how to *express* their feelings in photographic form. Any competent photo technician can make acceptable prints from technically poor negatives; but if feeling and sensitivity are lacking, then, obviously, there is no remedy.

This should not be interpreted to mean that I condone bad technique. I don't. But if I had to choose between the two—a meaningful picture that is technically poor, and a meaningless picture that is photo-technically unassailable—I unhesitatingly would choose the first. However, in this age of foolproof cameras, lens-coupled range finders, internally synchronized shutters, photoelectric exposure meters, electronically controlled speed-lights, and time-and-temperature methods of development, there is really no excuse for bad photo technique. Technique can be mastered by anyone who cares to make the effort. And once mastered, it should be taken for granted and *not* used as a measure of the value of a photograph—or a photographer.

## The Theory of Making a Photograph

Except for those surprise shots upon which a photographer stumbles accidentally, *creation of any good photograph starts with an idea followed by a plan.* A photographer has certain objectives: to report, to inform or educate, to entertain or amuse, to convey a feeling or mood, to share an experience with others, to inspire. In order not to lose sight of his goal, he must keep in mind the purpose of the picture—what it should say, which subject qualities must be captured and expressed, how they can best be recorded on film, what an observer will get out of the photograph, and how he is likely to react.

Creation of a photograph presents a problem that must be solved in two respects: in terms of the camera (photo-technically) and in terms of the

picture (editorially). To be able to do this, a photographer must have certain qualities and fulfill certain requirements. He must be discriminating (subject selection); sensitive (receptive to feelings and moods); observant and alert (subject characteristics); intelligent and understanding (subject evaluation); objective when necessary (factual reporting); subjective when necessary (artistic interpretation); imaginative (subject presentation). If he possesses these qualities and is able to use them to solve his photographic problems, he can produce photographs which—because of good subject selection and characterization from the editorial point of view and captivating form of presentation from the pictorial point of view—can appear more significant, interesting, and meaningful than the subject itself at the moment of exposure.

The practical aspects of making a photograph can be grouped to form a series consisting of four stages (see also pp. 18–27). Although few may consciously be aware of them, each time a photographer takes a picture, he goes through these stages. When on assignment, most photographers rely on experience gained from assignments of a similar nature. But if a photographer would prepare for specific assignments by analyzing the problems which he must face, his chances of solving them effectively would be greater than if he merely relied on luck and intuition to carry him through. The following presents such a step-by-step analysis of the process of making a photograph.

**The first stage:** *the conception of the picture*. From the many possibilities which every photographic venture offers, the photographer selects those aspects which he thinks best suited to his particular purpose, paying special attention to the presence of photogenic qualities.

**The second stage:** *rough shaping of the picture*. Having made his choice, the photographer then studies the typical characteristics of his subject so that he can give them proper attention and treatment. He concentrates upon the effective rendition of essential qualities and, as far as possible, subordinates or eliminates disturbing influences, by selecting an appropriate point of view, suitable illumination, effective composition, and so on.

**The third stage:** *terms of nature into terms of photography*. Since several of a subject's most important qualities—such as three-dimensionality, color (except in color photography), motion, radiant light—cannot be transferred directly into a photograph, the photographer must find means which in symbolic, descriptive form can convey the impression of these qualities which otherwise would be lost.

**The fourth stage:** *technical execution*. Having arrived at a definite conception of his picture and decided upon his approach to the subject and its form of presentation, the photographer finally is prepared to execute the photograph. He sees in the photo technique only a means to an end and attributes no more importance to the final steps of taking the picture, developing the negative, and making the print than the novelist attributes to the act of writing down a story he has already finished in mind.

Reduced to its simplest terms, this step-by-step analysis can be expressed as follows:

<div align="center">

**Discrimination** and **selection**
**Condensation** and **elimination**
**Symbolization** and **dramatization**
**Execution** and **presentation**

</div>

## SUMMING UP AND CONCLUSIONS

The born photographer—the artist—takes his pictures intuitively, subconsciously doing the right thing at the right time. Because he has no need for it, this book is not addressed to him. However, a glance through it may stimulate him and make him come to some conclusions that can be profitable to his work.

The artistically less gifted photographer must substitute intelligence and energy for intuition. The greater his knowledge of things photographic, the better his chances for success.

The following diagram presents an attempt to correlate in graphic form the essence of the preceding chapters.

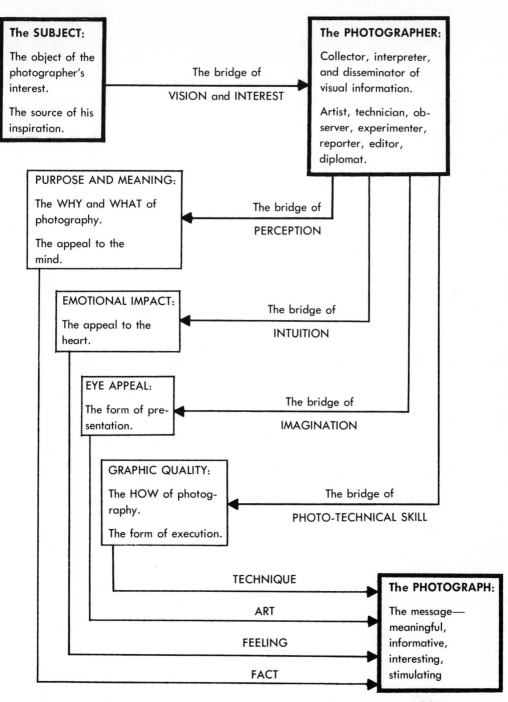

**The SUBJECT:**

The object of the photographer's interest.

The source of his inspiration.

The bridge of
VISION and INTEREST

**The PHOTOGRAPHER:**

Collector, interpreter, and disseminator of visual information.

Artist, technician, observer, experimenter, reporter, editor, diplomat.

PURPOSE AND MEANING:

The WHY and WHAT of photography.

The appeal to the mind.

The bridge of
PERCEPTION

EMOTIONAL IMPACT:

The appeal to the heart.

The bridge of
INTUITION

EYE APPEAL:

The form of presentation.

The bridge of
IMAGINATION

GRAPHIC QUALITY:

The HOW of photography.

The form of execution.

The bridge of
PHOTO-TECHNICAL SKILL

TECHNIQUE

ART

FEELING

FACT

**The PHOTOGRAPH:**

The message—meaningful, informative, interesting, stimulating

**201**

# 4

## The Picture

Until now, we have been concerned mainly with the *content* of a photograph, the purpose and meaning of the picture. However, unless the content is presented in such a way that it is clearly understandable, eye-catching, and attention-holding, a photograph is wasted. To avoid this, the subject must be rendered in a form that is both interesting and effective. How this can be done will be discussed in the following chapters.

## The Need for Photographic Control

Taking a snap is easy. Any box camera owner can take snapshots and get recognizable pictures. Since this is a fact, people often wonder why anyone should read a book on photography. They may admit that a treatise on the *technical* aspects of photography can have its uses, but books that go beyond this level are often considered unnecessary even by those who spend considerable time and care on the making and finishing of their pictures. This opinion results directly from the idea that photography is no more than a rigid mechanical process of rendition which can be controlled only in regard to certain photo-technical aspects: a *good*, i.e., properly controlled, picture is one that is sharp and correctly exposed, whereas a *bad* picture is one that is fuzzy and under- or overexposed. Hence, the degree of technical excellence becomes in common practice the basis on which a photograph is judged.

However, if this were correct, how does one explain the fact that some technically unassailable photographs are dull, whereas others are interesting and even exciting? Even in those cases in which the subject of both is the same? And even if this subject is not particularly interesting in itself?

Obviously, all other factors being equal, this difference in effect can only be the result of the particular way in which the subject is rendered, the way in which the photographer made use of the technical means at his disposal, his choice and effective use of certain controls.

The difference between a recognizable and an effective photograph, then, is largely a matter of degree. Technical excellence should always be taken for granted; it will always lead to the production of recognizable pictures. But this alone is not enough. The picture must also be effective and stimulating from a graphic point of view, must characterize the subject and be esthetically pleasing. To accomplish this, the photographer must exercise control: from the various techniques and means of representation at his disposal he must choose those most likely to produce the effects which he intends to create. If this is accomplished, the picture is not only a recognizable rendition of the subject, but also an *effective photograph*.

Unfortunately, when applied to photo-technical processes, the word *control* has acquired a meaning that implies either falsification through retouching or similar manual interferences with the accuracy of the rendition, or certain arty control processes such as the abrasion technique or the Bromoil print. Needless to say, I have neither of these nor similar things in mind. When I speak of control, I literally mean what the word actually implies: power and ability to choose from those available the means and techniques of rendition most suitable to perform a given task.

This form of control is in no way different from that which other artists or craftsmen exercise in their work. Any sculptor has dozens of chisels, any painter dozens of brushes, any mechanic dozens of wrenches, from which he chooses the one most suitable to achieve a certain result. Of course, a different chisel or brush or wrench would probably do the job, too, *but not*

**204**

*quite so well*. In other words, they use *control*—which is merely a shorter way of saying that they do their work in the best and most workmanlike way.

Similarly, in photography any lens will project an image on the film. But since there are many different types of lenses with widely different characteristics, some lenses will do a specific job better than others, and often only one type of lens will do it to perfection. The photographer who realizes this and selects the best qualified lens uses control.

That a definite need exists in photography for control is proven by every picture that "didn't come off"—because perspective appeared distorted, illumination seemed harsh and unnatural, gray shades blended one into another, contrast was lacking or too high. Although, according to popular belief, "the camera does not lie," such unsuccessful pictures prove unquestionably that the camera is eminently capable of lying. Actually, most uncontrolled photographs "lie" insofar as they do not truthfully represent the subject in all its physical aspects or because they fail to indicate certain intangible qualities which are important for its characterization.

For example: A photographer wishes to take a black-and-white picture of red roses among green leaves. Taken by a purist who disdains control, the colors red and green would appear in the print as two more or less identical shades of gray, differentiation between the flowers and the leaves would be lost, and the picture would be a contrastless confusion of gray-in-gray. On the other hand, a photographer who knows his controls would take such a picture through an orange filter. As a result, the flowers would appear as light and the leaves as dark shades of gray, differentiation would be excellent, and the picture would be as good a representation of the subject as is possible to achieve within the limitations of the medium.

Another example: A photographer has to take a portrait. His only camera is a twin-lens reflex with limited extension. Using a slip-on lens, he takes a close-up from a relatively short distance—and the portrait is distorted to such a degree that the face appears grotesque. On the other hand, a

photographer who knows his controls would have taken the same portrait without the slip-on lens from farther away, would have used a fine-grain film and a fine-grain developer, and would have enlarged only a section of the negative. As a result, he would have produced a portrait not differing in scale from that of the close-up and would have avoided distortion.

Another example: A photographer who believes that the 35-mm. camera can do everything uses it to take a picture of a building. To include its entire height, he tilts his camera slightly upward, as a result of which the vertical lines of the buildings converge, giving the appearance of leaning walls and imminent collapse. Although this is a "straight" or uncontrolled photograph, the effect of such a picture is completely unnatural and a good example of a "camera lie." In contrast, a photographer who knows his controls either uses a swing-equipped view camera to take this type of subject or corrects distortion during the enlarging of the negative, producing a photograph which *appears* natural because its verticals are rendered parallel.

I believe these examples suffice to prove that a straight photograph can appear *less natural* than a picture in which a photographer exercised control. The explanation for this, as mentioned on p. 205, lies in the fact that the eye and the camera "see" differently. For example, in comparison to most lenses, the angle of view of the eye is very narrow. Thus, we can see sharply only a very small section of our surroundings at one time. When you read this line, your eye scans it, taking in a few words at a time because it cannot sharply encompass the whole line, much less the whole page, as any photographic lens can do. Similarly, when we look at buildings in the street, our eyes scan the view, seeing sharply only a very narrow angle of the scene at a time. As a result, because the degree of convergence inherent in any sharply seen zone is too small to be noticed, we are not consciously aware of the apparent converging of verticals as we look up toward the roofs. But the lens, sharply covering a much greater area, "adds up" the minute quanta of convergence inherent in every section of the upward view and presents them all at once in the form of the photograph. From bottom to

**206**

top, the total degree of convergence is enough to become apparent in the picture, although it was *not* in reality consciously noticed by the eye.

The fact that the eye does not notice the apparent converging of verticals when we look up (or look down from a height) is actually quite remarkable, because this phenomenon of vertical perspective is exactly the same as that which makes railroad tracks appear to come together in the distance. We notice this effect of perspective when it occurs in the horizontal plane (railroad tracks) but fail to consciously see it when it occurs in the vertical plane (the walls of a building). So it follows that, recorded objectively by the camera, the phenomenon of perspective seems perfectly natural in one case—and so unnatural in another that it is considered a fault which must be corrected before the rendition is accepted as true. In effect, the photographer must make the camera "lie" in order to produce a true-appearing photograph.

Once one has realized that an objective rendition can appear unnatural and that in certain cases only a deliberate falsification can produce a picture which appears natural, any objection which one might have had to the use of controls should be removed.

## The Principles of Photographic Control

As previously mentioned, the average photograph cannot truthfully be called a reproduction of the subject which it depicts because the following important characteristics cannot be shown directly in picture form:

> **Space** (except in stereophotographs)
> **Color** (except in color photographs)
> **Movement** (except in motion pictures)
> **Radiant light** (except in translumination)

**207**

Whenever we take a black-and-white still photograph of a three-dimensional subject, a colorful subject, a subject in motion, or a source of light, we get a picture in which subject qualities which cannot be rendered directly appear in some new form. Space appears in the form of perspective, i.e., convergence and diminution; color appears in the form of shades of gray; motion can be either frozen in the form of sharpness or appear as blur; and radiant light appears as white surrounded by halation. These forms are the symbols which represent in our pictures those subject qualities which cannot be rendered directly.

Although we may never think about it, symbols are familiar to everyone. Whenever we speak, write, or read, we use symbols. Speech is based upon sound and writing upon letters. Both sound and letters are symbols which stand for something else: words. And words in turn are symbols which stand for specific concepts. However, we are so used to speaking or reading that normally we are not conscious of the fact that we are constantly dealing in abstractions—that, for example, in order to understand the meaning of the symbols G-I-R-L, we first have to translate them into the concept which they represent.

Similarly, when we look at a black-and-white still photograph, it never consciously occurs to us that here we also deal with abstractions—symbols—which first must be translated by the mind before we can *read* the picture and understand its meaning. For example, in looking at a black-and-white photograph, no one will fail to recognize a face or a running horse merely because the picture lacks color or motion. We are so used to this form of abstraction that we automatically compensate for the lack of color and motion, our memory substituting the missing qualities. For this reason it rarely, if ever, occurs to a photographer that he is working with symbols, that he can control these symbols, and that—like a writer who carefully selects the most descriptive word from a number of synonyms—he usually has the choice of several symbols from which to select the best suited to produce a specific effect. Only those photographers who are aware of such symbols are "photographically literate," and only those

who know how to purposefully use them will ever acquire full mastery of their medium.

The principles of translating reality into picture form—the principles of photographic control—are not unlike those of translating from one language into another. Such translations can be done in two different ways. Either the translator makes a *literal translation*, which is always clumsy and often misleading; or he *translates freely*, trying to capture in his translation the meaning and feeling of the original rather than its superficial form. Usually, such a free translation not only matches but on occasion even surpasses the original in clarity and beauty of expression.

Similarly in photography, the literal approach to translating reality into picture form is likely to result in a clumsy or misleading rendition—as, for example, the picture of a bunch of roses mentioned before in which, due to **p. 205** a literal translation of color into corresponding shades of gray, flowers and leaves merged ineffectively into one another. On the other hand, if freely translated with imagination and skill, even subjects which are ordinarily insignificant or dull can be made to appear in a photograph in a form which is new and stimulating, surpassing in effect the impression created in reality at the moment of exposure.

## SUMMING UP AND CONCLUSIONS

Since they lack three-dimensionality, color (if in black-and-white), and motion, still photographs can never be truly realistic; hence, to strive for superficial realism is a waste of time. In photography, reality is expressed through symbols: perspective stands for space, gray shades represent colors, blur signifies movement, halation expresses the radiance of direct light. They are abstractions in the same sense as speech and writing—in which specific sounds, letters, and words symbolize specific concepts. Just as no one can become a good writer until he has acquired a certain mastery of his symbols (the meaning and use of words) so no one can become a good photographer until he

knows how to use the symbols of photography. And since by the very nature of his medium he must utilize some sort of symbolic form anyway, instead of being satisfied with such symbolic forms as accident presents him, he should deliberately choose his symbols in accordance with their suitability for expressing precisely what he wants his pictures to say.

## The Symbols of Photography

The number of basically different symbols which the photographer can use is not as large as that available to the writer, for each word is a symbol. But although the number of photographic symbols is comparatively small, it is *large in effect* since each can be varied to a very high degree. For example: lightness can be used in a photograph to symbolize emotional concepts such as pleasure, optimism, gaiety, and happiness; darkness to symbolize tragedy, drama, suffering, and death. Merely by adjusting the exposure of the paper accordingly when he makes his print, the photographer can make the overall tone of his picture lighter or darker as desired. He thus has at his disposal an infinite number of shades between light and dark and, by correctly applying these, can symbolically express any shade of emotion from boundless joy to abject misery.

Another example: perspective, in the form of convergence and diminution, symbolizes space and depth. The more abruptly parallel lines appear to converge and the greater the difference in apparent size between near and far objects, the more pronounced the illusion of depth in a picture. With the aid of lenses of different focal lengths in conjunction with appropriate distances between subject and camera, the photographer can produce any kind of perspective, from wide-angle distortion with its extremely abrupt transition from near to far, to telephoto perspective in which differences in object size between near and far are very small. The same space or depth

**210**

can thus be made to appear deep or shallow in the picture. And, of course, through appropriate use of lenses of less extreme focal lengths, any intermediary effect can also be produced. Thus, a photographer who knows how to use his symbols has complete control over the rendition of space and depth, with an infinite number of finely graded transitions at his disposal.

But the symbols of photography can not only be varied to any desired degree, they can also be combined with one another to form an unlimited number of combinations. For example, the effects of either lightness or darkness can be combined with the effects of any kind of perspective or with any kind of color translation into shades of gray, and these in turn with any kind of motion symbolization. Thus, in effect, a photographer can express himself in his picture as precisely as the writer with his greater number of word symbols can express himself in his prose.

In the following sections, I will list and discuss briefly the most important subject characteristics together with their symbols and controls. Briefly —because they are treated extensively in my books *The Complete Photographer, The Color Photo Book,* and *Total Picture Control*—to which the interested reader is referred.

## LIGHT

Every art form has its specific medium. That of the photographer is light. It is his most important symbol. Without light, he is as stymied as a sculptor without clay, a painter without colors, a writer without words. It is therefore all the more surprising that most photographers take light for granted, paying attention to only one of its many aspects—brightness. They neglect the fact that light manifests itself in many different forms from which they can choose the one most suitable for their purpose, that these forms can be controlled, and that they can be used to *precisely* symbolize specific subject

qualities, feelings, and moods in photographic form. As far as a photographer is concerned, light has four main qualities:

**Brightness**
**Direction**
**Color**
**Contrast**

In addition, he must differentiate between four main forms of light:

**Direct light**
**Diffused light**
**Reflected light**
**Filtered light**

Practical considerations make it desirable to distinguish between:

**Natural light**
**Artificial light**
**Continuous light**
**Discontinuous light**
**Radiant light**

For the photographer, light has four main functions:

**It illuminates the subject.**
**It symbolizes volume and depth.**
**It sets the mood of the picture.**
**It creates designs in light and dark.**

## Brightness

Brightness is the measure of the strength of the illumination, the intensity of which can vary from light to dark. Brightness determines the exposure which in turn should be determined with the aid of a photoelectric exposure meter (hand-held or built into the camera), since the human eye is a notoriously unreliable instrument for accurately gauging degrees of brightness. Bright light is harsh, crisp, sharply matter-of-fact. Dim light is vague, restful,

suggestive of mood. As a rule, the brighter the light, the more cheerful the mood of a scene, the higher the contrast between light and dark in the subject, the clearer and sharper the picture, the shorter the exposure, and the better the color rendition. Brightness can be controlled with the aid of the diaphragm, the shutter, neutral density filters, and—if artificial light is used—by adjusting the distance between subject and photo-lamps. In this connection, it should be pointed out that the inverse square law of brightness diminishing with distance is applicable only if the light-source is a point (for example, a zirconium lamp); if an area light-source is used (a photoflood lamp in a large reflector in conjunction with a diffuser; fluorescent tubes), light falloff is directly proportional to the distance between subject and lamp—that is, doubling the distance halves the light intensity at the subject plane (whereas, according to the inverse square law, intensity should have been reduced to one-fourth). This is of particular importance in close-up photography by artificial light where relatively short subject-lamp distances are involved.

## Direction

The direction of the ambient light determines the position and extent of the shadows and therefore controls the contrast and the depth effect of the picture. In this respect, photographers must distinguish between light from five different directions:

**Frontlight.** The light strikes the subject more or less from the direction of the camera. This is the least contrasty type of light. Shadows largely fall behind the subject where they are hidden from the lens—with the result that subject contrast is generally very low. Although frontlight is the type of light most suitable for accurate rendition of color, it is the "flattest" type of light and the one least suited to evoke impressions of depth. A completely shadowless form of illumination can be produced either by means of a "light-tent" or a ringlight. In the first case, the shadowless illumination is achieved by surrounding the subject with an enclosure of white panels of paper, shining the light of several photo lamps at them instead of at the

subject, and thereby illuminating the subject from all sides with reflected light. In the second case, the subject is illuminated with the aid of a ring-shaped electronic flash tube which encircles the lens. Although effective use of shadowless light is difficult and not recommended for beginners, in the hands of a master it can lead to graphically outstanding effects.

**Sidelight.** The light source is located more or less to one side of the subject, but always illuminates it more from the front than from the back. This is the most popular type of light and the one most suitable for the creation of photographs in which clarity of rendition coupled with a feeling of three-dimensionality is important. Sidelight is easier to handle than any other type of light and consistently produces good results, but it rarely creates spectacular effects. Low-skimming sidelight is the best form of illumination for bringing out texture and delicate structural detail.

**Backlight.** The light-source is located more or less behind the subject, illuminating it from the rear and throwing its shadows toward the camera. Subject contrast is higher than with any other form of light, a fact which makes backlight difficult to use in color photography. On the other hand, expertly used backlight produces illusions of space and depth unmatched by light from any other direction. Drawbacks of backlight are the danger of flare and halation as a result of direct light shining into the lens, and the possibility of excessive contrast resulting in photographs or transparencies in which overexposure and underexposure occur within the same picture. But if these dangers can be avoided (or turned to creative use), backlight is unsurpassed by any other form of light when it comes to expressing mood, symbolizing luminosity, or creating exceptionally beautiful spatial and graphic effects.

**Toplight.** The light-source is more or less above the subject. This is the typical high-noon-of-summer type of light—and the least photogenic one because vertical surfaces are insufficiently illuminated and shadows too small and poorly placed for good depth symbolization. Experienced photographers avoid it.

**214**

**Light from below.** A form of light normally not occurring in nature but easily produced with photo lamps, it often results in unnatural and theatrical effects and invites misuse: the creation of weird effects that appear forced and gimmicky, novelty for novelty's sake.

## Color

Although of no interest to photographers who work in black-and-white, the color of the ambient light is of paramount importance to anybody intent on producing transparencies in natural-appearing colors. The reason for this is the fact that, unless the color (spectral energy distribution) of the ambient light conforms to that of the type of light for which the color film is balanced, color will appear more or less unnatural in the transparency.

Color photographers who, in regard to the color of the ambient light, distinguish only between daylight and artificial light, are in for a surprise. As far as color film is concerned, daylight is "standard daylight"—a specific form of daylight consisting of a combination of direct sunlight and light reflected from a clear blue sky with a few white clouds when the sun is more than 20° above the horizon. All other forms of daylight are not "standard" as far as daylight color film is concerned. Pictures taken in early morning or late afternoon light, in the open shade, or under an overcast sky would have color casts in yellow, red, blue, or purple tones—that is, unless the photographer was able to recognize in time the deviation in the color of the light from "standard" and correct it with the aid of the appropriate filter.

Similar considerations apply to artificial light which exists in still more colors than daylight, ranging all the way from blue-white arc light and pure white electronic flash to yellowish photo-flood light and the reddish illumination produced by ordinary household bulbs—not to mention red-deficient fluorescent, yellow sodium, and blue-green mercury-vapor illumination. Each of these forms of light would render the same subject in totally different colors, even if each shot were made on color film intended for use with artificial light. (How the problem of natural-appearing color rendition

can be solved under such conditions is explained in *The Color Photo Book* by this author.) On the other hand, by deliberately utilizing unorthodox types of light, creative photographers widen the scope of their work and produce color photographs which, by the newness of their concept, can enrich our visual experience.

## Contrast

The contrast range of light can vary from high to low and manifests itself in the depth and outline of the shadows. A high-contrast illumination casts shadows that are blacker and have sharper outlines than those cast by a low-contrast form of illumination, the shadows of which are lighter in tone and have more or less blurred edges. Whether the contrast of an illumination is high, medium, or low depends on the brightness of the light and the apparent size of the light-source: the brighter the light and the more pointlike the light-source, the higher the contrast and the harsher the character of the illumination; the dimmer the light and the more arealike the light-source, the lower the contrast and the softer the character of the illumination.

Consequently, sunlight and light from a spotlight, both of which are relatively pointlike light-sources in the photographic sense, are contrasty and harsh—whereas light from an overcast sky or from a bank of fluorescent tubes, both of which are arealike light-sources, is contrastless and soft. Light emitted by photo lamps in reflectors or by electronic flash is intermediary in character.

Since the character of a high-contrast illumination and the mood created by it are very different from those associated with a low-contrast form of illumination, discriminating photographers are careful which one they use. They know that they can control the degree of contrast of an illumination to almost any extent by means of auxiliary fill-in light, diffusers, and reflectors (the same photo lamp is a large, satin-finished, shallow reflector casts a softer light than in a small, polished, deep reflector). The following lists a variety of light-forms in decreasing order from very high contrast to

**216**

virtually no contrast at all: zirconium arc lamp, end-on ribbon filament lamp, direct sunlight, spotlight, photo-flood lamp without a reflector, photo-flood in small polished reflector, photoflood in large satin-finished reflector, photoflood in reflector equipped with a diffuser, fluorescent tubes, indirect light reflected from a large panel covered with crinkled aluminum foil, bouncelight.

## Direct light

Direct light is light which has not been reflected, filtered, diffused, scattered, or otherwise altered since emission from its source. As far as the photographer is concerned, this makes it predictable light—light that is uniform, constant, and always the same as far as spectral energy distribution is concerned. As a result, color photographs taken in direct light usually show excellent color rendition—provided, of course, that light and film are compatible or the right kind of filter was used.

As far as the color photographer is concerned, the most important characteristic of direct light is its color temperature because this decides whether or not a correction filter is required in conjunction with a specific type of color film if transparencies in natural-appearing colors are desired. The concept of color temperature, its ramifications, and the practice of filter selection are explained in *The Color Photo Book* by this author.

In comparison to diffused or reflected light, direct light is harsh and precise. This makes it particularly suitable in cases in which documentation, clarity, and factual considerations are more important than the creation of a mood.

## Diffused light

Direct light that passes through a scattering medium becomes diffused, its brightness reduced, its contrast lowered, and often its color altered by the diffuser which in this case acts like a filter. A typical example is light on an overcast day when sunlight is diffused by a layer of clouds. In comparison to direct light, diffused light is always softer and less contrasty and casts

weaker shadows. Having been filtered, it is also unpredictable. Color rendition on an overcast day often turns out unsatisfactory unless proper filtration is used, the color of the sunlight being altered by the layer of clouds which it has to penetrate. Indoors, diffused light can be produced and contrast lowered by placing diffusion screens in front of the photo lamps. In particular, lamps used for shadow fill-in illumination should always be well diffused in order to prevent them from casting secondary shadows—shadows within the shadows produced by the main light—a most disturbing effect and a common mistake of beginners.

### Reflected light

This form of illumination is usually very soft and casts only weak and vaguely defined shadows. Its color is a mixture of the color of the primary light-source and that of the reflecting surface. A typical example outdoors on a sunny day is light in the open shade which is always more or less blue although the color of the prime illuminant, the sun, is white. Another example is bounce-light—flash illumination reflected from a ceiling—which consists of flash light modified by the color of the ceiling. In photography, reflected light is used mainly as shadow fill-in and to reduce contrast.

### Filtered light

This kind of light has lost part of its spectrum—the colors absorbed by the filtering agent. In color photography, unnoticed filtered light is often the cause of "inexplicable" color casts, such as indoor daylight that has been filtered by tinted window glass or daylight in the forest that has been filtered and tinged by green leaves.

On the positive side, filtering provides a photographer with some of his most effective pictorial controls by enabling him to improve both color rendition in color photographs and color translation into shades of gray in black-and-white pictures. The principles by which this can be done and the methods for doing it have been discussed in my books *Successful Photography, The Complete Photographer,* and *The Color Photo Book.*

**218**

## Natural light

In contrast to artificial light, natural light—the different forms of daylight—is unpredictable, constantly changing not only in regard to brightness (which can easily be measured with an exposure meter), but also in regard to color (which is very difficult to gauge correctly): yellowish at sunrise, neutral (white) during the middle of the day, reddish at sunset, blue in the open shade, purplish when the sky is overcast, or greenish in the forest. Color photographers have two choices for coping with this multiplicity of color: they can either bring non-standard daylight back to the norm with the aid of the appropriate correction filter, or they can utilize it for the creation of special effects.

A valuable advantage of daylight over artificial light—evenness of illumination—stems from the fact that the light-source, the sun, is so far away that any subject, no matter how big, is always uniformly lit. If artificial illumination is used, those parts of the subject that are closer to the lamp receive more light than those that are farther away, with the result that the first may be overexposed and the second underexposed. This danger never exists in daylight photography (the lightening effect of haze on distant subject matter is a different story). Nor does the danger of multiple sets of shadows, the curse of the artificial light photographer, exist in daylight photography because there is only one light-source—the sun.

## Artificial light

Unlike daylight, light emitted by photo lamps is predictable and constant in regard to brightness and color, provided that incandescent lamps are operated at the specified voltage and that the voltage is constant. This makes artificial light particularly suitable for color photography in cases in which color fidelity is essential.

Another difference between natural and artificial light is the fact that in daylight photography only a single light-source exists whereas in artificial light any number of photo-lamps can be employed simultaneously—all

different in regard to brightness, contrast, or color, and all producing either continuous (incandescent, fluorescent) or discontinuous (flash) light. As a result, photography by artificial light is both easier and more difficult than photography by natural light. Easier because the photographer's degree of control over the illumination is virtually unlimited; more difficult because he has to deal successfully with a number of possible pitfalls—the most serious of which are overlighting (subject areas close to the lamps), underlighting (especially common in regard to the background), multiplicity of shadows, and the creation of contrived or confusing light effects.

## Continuous light

The sun, spotlights, photo-flood lamps, and fluorescent tubes produce continuous light which, in contrast to discontinuous light (flash), has several advantages: The photographer can see the effect of his illumination in terms of light and shadow; he can measure the contrast range of his subject by taking spot readings with an exposure meter; and he can take an overall light-meter reading and precisely determine the exposure. On the other hand, except for the sun, most sources of continuous light are not bright enough to enable a photographer to "freeze" rapid motion, which is a cinch with flash. Furthermore, incandescent photo lamps emit prodigious amounts of heat. But despite these drawbacks, unless motion must be "stopped," continuous light is usually preferable to discontinuous light for most photographic purposes.

## Discontinuous light

Flashbulbs and electronic flash produce discontinuous illumination, delivering a tremendous burst of light within a fraction of a second, sufficiently bright and fast to "freeze" even the most rapid events. This makes these light-sources ideal for motion and action photography, but unsuitable to most other photographic purposes because of three inherent disadvantages: the photographer cannot see in advance the distribution of light and shadow in his picture; he cannot determine the contrast range of the

illumination by taking spot readings with an exposure meter; he cannot take a light-meter reading and must instead calculate his exposures on the basis of guide numbers furnished by the flash manufacturer unless he is prepared to invest a sizeable amount of money in a special exposure meter suitable for flash. Consequently, while discontinuous light provides the only means by which rapid motion can be photographically "frozen," it is unsuitable in most cases in which motion is not involved.

## Radiant light

Both physically and emotionally, we make a distinction between reflected light and direct light: there is a great difference in the quality of the light that is *reflected* from, say, a sheet of white paper and that emitted by the lamp which illuminates it. In looking at the paper, we see the "color" *white*; in looking at the incandescent bulb, we see blindingly brilliant, direct, *radiant light*. But if we were to photograph the two—the white surface and the radiant bulb—we would in both cases only get a patch of white in our photograph, with nothing to indicate the different nature of these two white shapes.

Whenever it is important to indicate the nature of a source of radiant light shown in the picture (most commonly, the sun, or street lights at night), a photographer must use symbols. Fortunately, he has several at his disposal: halation, flare, the halo, and the four- or many-pointed star. Instructions for the use of these symbols can be found in *The Complete Photographer* and *Total Picture Control* by this author.

## Light illuminates the subject

In the absence of light, we cannot see. Hence, in a deeper sense, light is synonymous with seeing, and seeing is the most important bridge between reality and the mind.

However, there are different degrees of seeing: the casual glance, the interested look, the curious investigation, the search for knowledge and

understanding. Then, there is photographic seeing: seeing in terms of the camera, seeing for most effective photographic rendition, seeing in terms of black-and-white, color translation into shades of gray, perspective and diminution, motion symbolization, sharpness, unsharpness, directional blur. . . . When a photographer spots a subject that interests him, he shouldn't be satisfied giving it only a single look before he shoots it—there may be better ways of "seeing" it. If a subject is worth photographing, it is worth photographing well. It should be studied from different angles and viewpoints, literally as well as figuratively speaking. It should be seen not only with the eyes, but also with the eye of the mind—in regard to its characteristics, its significance, its implications. Light gives a photographer his chance to see reality; it is up to him to make the viewer of his picture see, to provide him with an "illuminating" experience.

## Light symbolizes volume and depth

Any draftsman knows that "shading" gives "depth" to his drawing. The same is true in photography: illuminated by more or less shadowless frontlight, any subject appears flat. But if we turn it relative to the sun or reposition the photo lamps so that they cast expressive shadows, the feeling of flatness disappears and is replaced by a sense of three-dimensionality: the subject suddenly acquires "depth." Hit by floods of uncontrolled light, even a veritable Brunhilde appears as flat as a paper doll. On the other hand, effectively modelled by light and shadow, even a shallow bas-relief acquires depth. In photography, interplay between light and shadow is the most powerful symbol of depth.

Indoors, to separate a subject from its background, he can use an "accent light" which edge-lights the subject and makes its outline appear light against the darkness of the background. A variation of this method is Gjon Mili's famous edge-lighting technique which shows a subject dark against a dark background, separation being accomplished by highlighting all the edges of the subject with sharp, well-masked light from both sides. Outdoors, a somewhat similar effect can sometimes be produced with the aid of

222

pure backlight, the source of the light (the sun, a street light, the headlights of a car) being hidden by the subject itself which will then appear silhouetted, its edges lined with light.

## Light sets the mood of the picture

If we analyze a mood—a feeling, an intangible—we often find that it is evoked by light. As an example, consider two church interiors: the white-washed interior of a typical New England church, bright sunlight streaming through large, clear-glass windows, puts us into an entirely different mood from that evoked by a dark, medieval cathedral where mysterious light dimly filters through deeply colored stained glass. The difference in mood between a nightclub, where pools of orange light from many little lamps fight darkness, and a brilliantly lit restaurant is also due primarily to differences in the nature of the light.

Photographers who are aware of the importance which feeling, "atmosphere," and mood have upon the impact of their work pay great attention to the character of the light that illuminates their subjects. They know that often the specific mood in which a subject is seen is more important than the subject itself. For example, lighting a nightclub with banks of photofloods to bring out every little detail would, by destroying its characteristic mood, produce a technically perfect negative and a useless picture.

I still remember a night at Madison Square Garden when, side by side, Gjon Mili and I were shooting pictures of the Louis-Wolcott fight for *Life*. Mili used two view cameras synchronized for strobe and about a thousand pounds of strobe equipment. I used a Rolleiflex and shot candidly. The reason for our strange contest was to find out in exactly what respects candid shots differ from pictures taken with auxiliary lights and whether one technique has decisive advantages over the other.

In this particular case, the strobe won. Mili, with his lightning-fast speed-lights, caught the historic moment when Joe Louis went down for a fraction of a second. This fact alone would have made such a picture sensational,

regardless of whether it was fuzzy or sharp. Mili's picture was sharp, and, thanks to the inimitable Mili technique of backlighting, it was excellent and fully deserved the double spread it had in *Life*. However, the particular atmosphere of the Garden—the smoky air crisscrossed by the cones of spotlight beams—was absent in the strobe-lighted pictures but showed effectively in the candid shots. On the other hand, the action of the boxing was generally too fast to be caught by the candid camera under the existing light conditions. (This was before the time of Tri-X pan film.) The net result of the contest was that the strobe-synchronized camera caught the action, while the candid camera using available light captured the atmosphere and the mood. Conclusion: If action is more important than mood, auxiliary illumination is often necessary—but if possible should be used in such a way that the mood of the scene is preserved. If mood is more important than action, nothing can beat available-light photography.

## Light creates designs in light and dark

In black-and-white photography (and, to a lesser extent, in color), brightly illuminated subject areas appear relatively light or white, while areas in the shade appear relatively dark or black. Between these extremes lies the range of intermediary tones. Regarded and evaluated as an abstract design, this overall pattern produced by light is almost as important to the effect of a photograph as the space- and mood-suggesting qualities of light.

Analyzing the emotional effect of light and dark, we find that white is dominant and aggressive, black receding and passive. Taking advantage of these psychological effects, a photographer can therefore emphasize certain areas of the picture and draw attention to them simply by arranging his illumination accordingly. By using dark foreground matter in the form of a frame, he can compellingly draw the viewer's eye toward the lighter center of the picture where the focal point of interest will normally lie. For the same reason, he will avoid placing bits of small, white subject matter near the borders of the photograph where they might make the image appear to "leak out" of the frame of the picture.

**224**

Photographically speaking, shadow is a form of light—negative light —which, in a photograph, can manifest itself in three different ways and fulfill three different functions:

## Shadow as symbol of three-dimensionality

If a surface illuminated by sidelight appears uniform in tone— shadowless—it must be flat (two-dimensional and plane). If, on the other hand, it is enlivened by shadows, it cannot be plane but must have elevations or curvature. Therefore, shadow is graphic proof of three-dimensionality.

Like the aforementioned draftsman who knows that "shading adds depth to his drawing," most photographers know that a shadowless picture is a flat picture and, conversely, that the more pronounced the shadows, the greater the illusion of depth. This is particularly apparent in photographs in which texture rendition is important: low-skimming, shadow-producing sidelight brings out the texture of the material; shadowless frontlight destroys it. Even the direction in which the shadows fall is important, as proven by the following experiment: illuminate a coin with low-skimming sidelight coming from the upper left; then take a second picture in the same kind of light coming from the lower right. Compare the prints. In the first case, the coin will appear natural, in the second case, reversed insofar as what actually was an elevation will now appear as a depression, and what originally was a depression will now stand out in high relief. A similar effect can be found in aerial photographs of mountains shot from directly above. Such photographs, of course, have neither "top" nor "bottom." If such a picture is held in vertical position and turned so that the shadows point toward the lower right, the effect will be true to reality. But if the picture is held so that the shadows point toward the upper left, the landscape will seem to be "turned inside out": mountains will appear as valleys, and depressions will appear as heights.

Incidentally, in landscape photography in mountainous terrain, the shadow of a passing cloud can often be used to make the scene stand out in bold relief. By waiting until the position of the cloud shadow is just right—the foreground dark and the background bathed in light—the photographer can increase the depth effect of the picture.

## Shadow as darkness

In this case, the value of the shadow lies in its depth of tone. Graphically speaking, the darker the shadow, the lighter, more luminous, or more colorful the adjacent illuminated picture elements. White never appears more brilliant nor color more luminous than when contrasted with darkness or black (in this case, shadow). Consequently, black shadows can be used advantageously to enhance the luminosity of color or heighten the brilliance of white. Only in academic photographic circles is a black and undetailed shadow a pictorial disaster. Creative photographers, knowing better, regard such shadows as valuable graphic elements which can give their pictures added strength.

## Shadow as independent form

Although shadows with forms significant enough to contribute appreciably to the impact of a photograph are relatively rare, creative photographers always pay attention to the more important shadows within the frame of their pictures. They know that grotesquely distorted shadows, imaginatively used in the sense of a caricature can, by merit of exaggeration, emphasize a subject and characterize it in a highly expressive form. While beginners and dilettantes photograph outdoors mostly during the middle of the day when shadows are relatively short, experienced photographers are most active in the early morning or the late afternoon hours when the sun is low and long, slanting shadows assume a strange life of their own. Bird's-eye views have been taken of people hurrying along the street in which the weirdly distorted shadows, fantastically stretched by a low-riding sun, express in frightfully convincing form the heedless rush and hectic ways

of modern city life. I still remember certain aerial photographs of bombed-out cities—taken vertically from a low altitude in the late afternoon—in which the shadows of the roofless shells of burned-out, empty-windowed houses formed in harsh and graphic black-and-white a macabre pattern of hollow squares which, in the form of a city of shadows, symbolized unforgettably the horror and senseless destruction of war.

## REFLECTIONS

Reflections, like shadows, are also secondary images of objects or (in the form of highlights) of light sources. To the imaginative photographer they provide effective means for introducing elements of surprise, shock, grotesqueness, or unexpected beauty into a photograph. Used in this sense, reflections can become valuable means for providing a picture with stopping power.

As far as the photographer is concerned, reflections manifest themselves in four different forms.

**Highlights.** All shiny objects reflect, in the form of highlights, the source of light by which they are illuminated. Proper placing of such highlights aids considerably in producing a clear and easily understandable rendition of the shiny object. The most common error in photographing shiny objects is the inclusion of an overabundance of highlights which destroy rather than clarify the form. The best remedy for this fault is careful arrangement of the illumination and, if necessary, reduction of the number of lights employed—with proper attention given to the placement of the resulting highlights.

In portraiture, each eye should normally be accentuated by one (but no more than two) highlights. They should appear near the center of the eye but must not obscure the circle of the pupil.

Outdoors, highlights are reflections of the sun, the most brilliant of all light sources. To express this brilliance graphically it may even be desirable to have a halo surround these highlights—which in such a case is not a fault, for it symbolizes the radiance of direct light. (See discussions on radiant light, p. 221.) In rendition, sun-glittering water can be made to appear positively radiant if each highlight is surrounded by a halo. This effect is produced by using a diffuser in front of the lens. Without the animating sparkle of glittering reflections produced by backlight, in a landscape (or seascape) photograph water looks more often than not like a meadow or like something other than water.

**Undistorted reflections** (in flat surfaces). Pictorially speaking, this is generally the least interesting form of reflection, for it is usually nothing more than a repetition of the object and therefore contributes no new interest to the picture. Occasionally, however, such undistorted mirror images have been used to advantage by observant photographers. Examples of this are portraits in which the subject and his reflection in a mirror are shown in the same photograph, with the result that front and side views of the head can be seen simultaneously. In such cases, imaginative use of a mirror enables the artist to increase the content of his picture.

Undistorted mirror images can also be used to convey certain moods. For instance, the image of a mountain reflected in a placid lake suggests a mood of calm and quiet. The feeling of the damp of a rainy day in the city can be suggested by photographing the reflections of people and buildings mirrored in a puddle.

**Distorted reflections** (in curved surfaces). As a well-conceived caricature can characterize a person, an object, or a situation more pointedly than an ordinary rendering, so a distorted reflection, through its very exaggeration, can frequently convey a stronger impression of a subject than a straight photograph. A modern metropolis, for example, with its towering buildings, its canyoned streets, its traffic jams, and its madly rushing people, can bewilder anyone not used to its confusion. To capture in a photograph the essence of this madness, a photographer may very well

**228**

wish to portray it in the form of a grotesquely exaggerated and distorted reflection in, say, the shiny fender of a car. For in a way this confusion is also a distortion—a distortion of all concepts of dignity and beauty, well-functioning organization, and clean and healthful living. It is well to remember that, seen for the first time, a big city appears *fantastic*. If one wants to capture this particular aspect, one must naturally use a fantastic approach and a fantastic form of rendition.

In the discovery of the powerful stopping effect of distorted reflections there exists a certain danger: Once a photographer has discovered the potentialities of such reflections, he may go to an extreme and produce pictures of distorted reflections without giving thought to their sense or meaning. Such an approach results in "art for art's sake" pictures, the "so-what" type of photograph.

A good example of the opposite, creative approach to the problem of using distorted reflections intelligently is seen in the work of two Michigan photographers, Dale Rooks and John Malloy. Faced with the problem of taking certain super wide-angle pictures but having no access to a super wide-angle lens, they found their solution in a big mirrored sphere of the type ordinarily used for garden decoration. By photographing their subject (a street crossing and a market square) reflected in this sphere, they got pictures identical to those produced by a "fish-eye" lens which encompasses an angle of 180°. Of course, the rendering is spherical (see discussion on the true nature of perspective), and straight lines appear curved. But the pp. 241–242 fact remains that this original method produced photographs which include *in one picture* all the area that one can see when turning in a full circle and looking from ground to sky.

**Superimposed reflections** (in transparent surfaces). While window shopping, most of us have occasionally been annoyed by reflections in the glass which partially or wholly obscured the merchandise. However distracting they may be at such times, these superimposed reflections can be used to create almost surrealistic effects. Since they permit the photographer to simultaneously show objects in front of and behind his camera, he can say as

**229**

much or more in *one* such picture than he can in two or more ordinary photographs.

p. 183 A good example of this is Fritz Henle's shot through the window of a waterfront bar. This picture, which is not the result of accident but of sharp observation, tells a whole story. Its particular effect derives from the successful integration of things outside and inside the bar—behind and in front of the observer. Without the aid of this semi-transparent reflection, it would have been necessary to take at least two separate shots with the camera turned in different directions. But two such pictures—one of the interior of the bar in front of the observer and the other of the waterfront street behind him—would not necessarily seem related or indicate in any way that they had been taken from the same spot. However, superimposed upon the bar interior in the form of a reflection, the waterfront street with its trucks and cranes and masts of moored ships becomes an integral part of the whole picture story, supplying the background and atmosphere for the man who, surrounded by beer ads and posters, an empty glass behind him on the counter, sits in a drunken stupor while a prospective customer looks at him through the window.

Successful utilization of superimposed reflections depends upon two conditions: objects behind the reflecting screen must be somehow related to those reflected on the screen; no reflection of the photographer or the camera must (normally) appear in the picture. If these conditions are fulfilled, superimposed reflections offer to photographers in search of new means of expression many opportunities for exciting and unusual effects.

## COLOR

There are two approaches to color, depending on whether color is seen in terms of black-and-white or in terms of color photography. Here is a summary of some of the thoughts and observations dealt with in greater

**230**

detail in my books *Successful Photography* and *The Color Photo Book.*

## Color in terms of black-and-white

As far as understanding a black-and-white photograph is concerned, lack of color is normally a factor of minor importance. If color were important to the comprehension of the subject, its absence would tend to make the subject—a face, for example—difficult to recognize. But I never heard of anyone having trouble recognizing a face merely because it was rendered in black-and-white instead of color.

However, the fact that actual subject color is normally of relatively little importance in the comprehension of a black-and-white picture does not imply that a photographer can entirely disregard color as a factor that influences the effect of his picture. The fact remains that differentiation in a black-and-white photograph depends primarily upon contrast and that contrast is produced through transformation of subject color into black and white and shades of gray.

This transformation of subject color occurs, of course, automatically whenever a black-and-white photograph is taken, whether or not the photographer pays attention to it. However, the character of this transformation does not have to be left to luck and chance, but can be controlled with the aid of filters. The need for such control can best be demonstrated by a practical example: A photographer has to make a fashion shot of a green dress with a red belt, collar, and cuffs. The particular effect of this dress depends to a very high degree upon the *contrast* between the red and the green. In a "straight" (uncontrolled) photograph this contrast would be lost, since red and green would appear as more or less identical shades of medium gray. But with the aid of an appropriate color filter (that is, by exerting control) the photographer can differentiate between red and green even in the black-and-white rendition, translate color contrast into gray-tone contrast, and thereby retain the essence of the dress.

For example, taken through an orange (or red) filter, the red belt, collar,

**231**

and cuffs would be rendered as a light shade of gray (or as white) and the green of the dress as a dark shade of gray (or as black). Conversely, taken through a green filter, the dress would appear light and the belt, cuffs, and collar dark. Such considerations depend upon the psychological effect of the individual color and upon the effect a photographer wishes to create. Normally, however, the warmer colors—red, orange, and yellow —appear aggressive and light and thus should be represented by lighter shades of gray (or white). The colder colors—blue-green, blue, and violet—appear more passive, restful, and receding and should be translated into darker shades of gray (or black). Intermediate colors, such as the greens and purples, normally appear best when symbolized by medium shades of gray. The principles of color control in black-and-white photography are discussed in *Successful Photography* and *The Complete Photographer* by this author together with their applications and scope.

Under certain circumstances subject colors can be selected directly for translation into black-and-white. I remember seeing a typical example which demonstrated the unfortunate result of not selecting color in this way or considering the vital problem of color translation into black-and-white. For publicity purposes, a group of young dancers had their performance recorded in a black-and-white motion picture. They wore gaily colored costumes, but unfortunately—in black-and-white, through lack of contrast—dresses, backdrop, and stage floor merged, and the effect of the dance was largely lost. Whereas the actual performance had been a gay, colorful picture of vivid reds, yellows, blues, and greens, the uncontrolled black-and-white version was no more than a "colorless" impression in dullish gray. Had colors been chosen not solely for visual satisfaction but for how they would register on the film, graphic contrast of light and dark could have been created to substitute successfully for the vivid subject colors. The all-important differentiation between dancers, backdrop, and stage floor—so vital to the creation of space impression within the flat plane of the projection screen—could easily have been accomplished. The dance itself would have been graphically exciting in vivid patterns of black and white.

**232**

## Color in terms of color photography

The fact that photographs can be made in natural color is taken by many photographers as proof that, as far as color rendition is concerned, their worries are over. This is an illusion, as proven by innumerable color photographs which, although sharply focused, correctly exposed, and processed in strict compliance with the film manufacturer's instructions, turned out disappointingly. The cause of this disappointment is usually neglect of one or more of the following considerations.

**The eye and the film react differently to color.** Color film "sees" color objectively, showing it more or less "as it is." The eye, controlled by the brain and its color memory, sees color subjectively, showing us subject color as we think it ought to be. For example, we have very definite notions about skin tones. Unless a portrait conforms to these ideas, it is rejected as "unnatural." But photographed at sunset, the color photo of a face would have strong overtones of red, and photographed outdoors on a sunny day in the open shade, it would have a bluish color cast. Although perfectly natural insofar as these color casts actually existed at the moment the photographs were made, they still would be experienced as unnatural by our color memory which tells us that skin has only one "correct" color—the color as it appears when seen in "white" or standard daylight. As a result, most people would reject "uncontrolled" (that is, unfiltered) color portraits taken at sunset or in the open shade as unnatural. Similarly, we assume that snow should always be white (instead of blue, yellow, or red—as it very well can be if photographed in the shade under a clear blue sky, in the late afternoon, or at sunset); that clouds should be either white or gray (instead of purplish as they often are); and that white walls should always be white (instead of having whatever the color of the ambient light). To rid himself of these prejudices and teach himself to see color as it really is should be a prime objective of any creative color photographer.

**Color film is balanced for use in one specific type of light.** Daylight type color film, for example, can be expected to give natural appearing color rendition only if used in *standard daylight* (a combination of direct

**233**

sunlight and light reflected from a clear blue sky with a few white clouds during the hours when the sun is more than 20° above the horizon). If used in conjunction with other forms of light—early morning, late afternoon, at sunset, in the forest, in the open shade, under an overcast sky—familiar objects would not be rendered in the familiar colors which we remember. The same applies, of course, to color film made for use in artificial light: unless the light conforms *exactly to specification,* color rendition is bound to appear more or less unnatural. To avoid this kind of disappointment, if color film must be used in light for which it is not intended, the non-conforming light must be brought back to what is normal for the respective film with the aid of the appropriate filter.

**Natural appearing color rendition does not guarantee good color photographs.** The explanation of this apparent paradox lies in the fact that discriminating viewers of color photographs expect something beyond photo-technical perfection which they take for granted. To satisfy them, a color photograph must also be interesting, stimulating, exciting, new. It must have purpose and meaning; it must evoke associations; it must make them stop and think. In addition, it must satisfy compositional and esthetic demands: color must have been used with skill and discrimination, qualitatively instead of quantitatively. Consequently, creative color photographers distinguish between harmonious and disharmonious colors, related colors and complementary colors; they speak of warm colors and cold colors; they are aware of the psychological effects of color—aggressive red, passive blue, soothing green. They know that, as a rule, a few well-chosen colors are more effective than a rainbow of color and that the potentially most powerful "colors" in any color photographer's arsenal are white and black. They are aware of the fact that color can be good (that is, satisfying) in three different ways: Because it appears *natural,* although strictly speaking it is not (color controlled by filtration); because it is *accurate,* even though it does not appear natural (unfiltered color shots taken in light that did not conform to the type for which the color film was balanced); and because it is *effective,* although openly unnatural (for example, subjects photographed in obviously colored light).

**234**

# CONTRAST

In reality, differentiation between various objects is normally the result of two factors: color difference and parallax (the stereo effect caused by the fact that each of our eyes perceives the same object from a slightly different angle). In black-and-white photography, however, object differentiation is based primarily upon contrast between light and dark (the alternative, which is not always applicable, being the difference between sharpness and blur). Without such contrast between light and dark, we would not be able to make a single photograph, since even the simplest form is nothing but a manifestation of contrast: a light tone set against a darker tone.

In photographic terminology, high contrast is synonymous with *hard* and low contrast with *soft*. An emulsion of contrasty gradation is called hard, and one of contrastless gradation soft. In this connection, it is worthwhile noticing the similarity of concept in photographic and psychological terms: a soft character or mood implies mildness, gentleness, even weakness —perfectly expressed by the soft print of low contrast range; a hard character implies strength and power, harshness, even cruelty—best expressed by the hard print with its high contrast of black-and-white. The concept of dramatization is the same in photography and psychology, and in both it is synonymous with exaggeration. To dramatize a subject in a photograph one must exaggerate its characteristics, rendering a contrastless subject even softer in the print, and a contrasty subject even harder, than it appeared in reality.

The importance of contrast upon the effect of a photograph makes it obvious that a picture will be better the more precisely the photographer was able to achieve the contrast range which he deemed best for his purpose. Contrast control therefore becomes an important prerequisite for the creation of effective photographs. It can be exerted:

> By controlling the contrast of the subject
> By controlling the contrast of the negative
> By controlling the contrast of the print

## Contrast control at the subject level

*Subject contrast* is the product of lighting ratio and reflectance ratio. Normally, it should not exceed the equivalent of 7 f/stops in black-and-white photography and 3 to 4 f/stops in color photography.

*Lighting ratio* is the difference between the maximum and minimum amounts of light that illuminate the subject—the span from highlights to shadows.

*Reflectance ratio* is the difference in brightness between the lightest and darkest colors (exclusive of black and white) of the *uniformly* illuminated subject.

Both the lighting ratio and the reflectance ratio can easily be established with the aid of an exposure meter in conjunction with a neutral gray card, as explained in *The Complete Photographer* and *The Color Photo Book* by this author. In practice, contrast control most commonly involves *lowering* the contrast of a given subject to a level where it will not exceed the contrast range of the film. Outdoors in daylight, one can either wait until the light is suitable (haze, clouds, or shade instead of direct sunlight) or, if the subject is not too far away, reduce its contrast with auxiliary shadow fill-in illumination. Indoors, subject contrast can easily be controlled by controlling the brightness, position, or light-to-subject distance of the photo-lamps. And in black-and-white photography, subject contrast can furthermore be controlled with the aid of filters which, unlike fill-in illumination, are also suitable and most often used for *increasing* the contrast of the subject. Explicit instructions for their use are given in *Successful Photography* and *The Complete Photographer*.

## Contrast control at the negative level

This form of contrast control is possible only in black-and-white photography. It can be accomplished either by choosing a film of the appropriate gradation; by modifying the times of exposure and development relative to what is normal in such a way that the result will be negatives of more or less contrasty gradation; or by selecting a high-contrast, normal, or soft-

working developer. Explicit instructions are given in *Successful Photography* and *The Complete Photographer* by this author.

## Contrast control at the print level

In black-and-white as well as in color photography, the contrast range of a print can be controlled by means of the following methods which are explained in *The Complete Photographer*: Selection of a paper in the appropriate gradation (as far as I know, only Agfa makes color print paper in different gradations); dodging—burning in and holding back—to raise or lower the contrast of more or less limited areas in the print; deviation from normal procedure in regard to exposure and development of the print (applicable only in black-and-white photography); masking the negative with a low-density diapositive to reduce its inherent contrast and produce a less contrasty print.

# DEPTH AND SPACE

Space—reality—is three-dimensional, but a photograph is flat—depth is missing. As a result, depth in a photograph can only be expressed in symbolic form.

Ask a photographer what space is and how it can be shown in a photograph and he will probably answer that space is three-dimensionality and the means for rendering it is perspective—rectilinear perspective. Ask a physicist and he will define space as a thing much more complicated: a four-dimensional, negatively curved, space-time continuum. Study the different forms of graphic space rendition in art, and you will find that in different epochs different ideas of how to symbolize three-dimensionality in a two-dimensional plane existed.

The ancient Egyptians, who produced some of the most remarkable works of art ever created, did not use our type of perspective which is charac-

terized by convergence of parallel lines and diminution of object size toward depth. In drawing the side view of soldiers marching in ranks, they rendered the man at the far end of the row just as large as the man closest to the observer—in a fashion somewhat similar to the perspective of an extreme telephotograph. They may have reasoned that an object *actually* does not become smaller by being farther away, it only *appears* smaller—a temporary effect which tends to obscure the true scale and proportions of things and hence must be corrected in the rendition. In this sense, the Egyptian concept of space rendition in the plane conforms more to reality and is more true than ours.

During the Renaissance, artists went to the opposite extreme. They deliberately exaggerated the space-suggesting effects of convergence and diminution (similar to our photographic wide-angle perspective) and by this created illusions of tremendous depth, often arriving at effects which most photographers would call distortions if they saw them in a photograph. But to the Renaissance artist this type of perspective offered the best means to create impressions of boundless space within the limited confines of a wall or ceiling. As a graphic concept of space rendition, however, this super-perspective is neither superior nor inferior to the Egyptian lack of perspective.

Progressive contemporary artists constantly search for better ways to create heightened space impressions—impressions more in accordance with the latest discoveries in physics and the new conclusions one must accept in regard to the true nature of space. It is not surprising that the average person, already bewildered upon learning that he is actually part of a "four-dimensional, negatively curved, space-time continuum," becomes even more confused when seeing a painting by Picasso in which two or more different views of an object are superimposed one upon another to give at one glance what might be described as an all-around depiction of space—showing the observer front, side, and top views all in one.

The more we learn about the real nature of space, the more we realize how little we actually know and how much of what we see of the universe and

heretofore had accepted as real is actually an illusion produced by the inadequacy of our senses. But even though we might not be able to understand the true nature of space—and perhaps never will because we can never approach it objectively since we are part of it—we can still get a more definite feeling for space. Artists try to interpret their impressions of space, which can never be illustrated directly, by means of symbolization and abstraction. By thus transmitting their visions of space to canvas or sensitized paper, they help to give others who are open-minded and sensitive a better understanding of space and, indirectly, of themselves.

Space extends uniformly in all directions. Its most obvious quality is *extension*, which can be defined photographically as *contrast between near and far*. In terms of photography, this contrast can be expressed in several ways:

**Contrast between large and small**
**Contrast between sharpness and blur**
**Contrast between light and dark**

In addition, three other forms of space symbolization are at the disposal of any photographer who cares to avail himself of them:

**Light and shadow**
**Overlapping**
**Scale**

Since these space symbols together with their applications and controls have already been discussed in the author's books *The Complete Photographer*, *The Color Photo Book*, and *Total Picture Control*, to which the interested reader is referred, I can limit myself to a brief review of essentials.

## Contrast between large and small

An object seen at a certain distance appears in a certain size. If we go closer, it seems to grow in size; if we back up, it seems to shrink. Hence, the

apparent size of an object provides a clue to its distance from the observer and its location in space and thereby becomes a symbol of space. This phenomenon is called *perspective*.

Because our eyes are constructed to produce but one kind of image, we assume that things must be the way we see them. However, if we had the eyes of a bird, a fish, or an insect, the world would appear completely different to us, since an eye of different construction presents a completely different image. For instance, the total angle of human vision is approximately 150° (including peripheral vision), whereas that of a fish or of certain insects is 300° or more. Imagine how differently the world must then appear. In photography, somewhat similar conditions can be created by using lenses with different angles of view and different degrees of correction for rectilinear or spherical perspective; thus completely different images of the same subject can be produced. But which image is the true one: that made by a telephoto lens with rectilinear correction or that made by a super wide-angle lens with spherical correction? Neither one, of course, is actually "true"; each is merely different. Although in a specific case one doubtlessly will be more suitable than the other.

What of object size and proportions? Because our eyes possess an unalterable focal length, it does not follow that our perspective—visually manifested in the form of apparent object size and proportion—is the only perspective that is true. Imagine that one could change the focal length of the eye voluntarily, like a zoom lens. If that were possible, one could see in the manner of either a wide-angle or a telephoto lens and the resultant perspectives, being entirely familiar, would produce no feeling of distortion.

Basically, any form of perspective (i.e., any form of projection of a three-dimensional object into a two-dimensional plane) is distortion. Distortion-free perspective is something which does not exist. If a rendition appears undistorted, it is merely because the degree of its distortion corresponds to that of the image perceived by the eye. In such a case, perspective appears natural, although it still represents a distortion of reality.

As far as the photographer is concerned perspective manifests itself in several different forms:

> **Academic rectilinear perspective**
> **True rectilinear perspective**
> **Cylindrical perspective**
> **Spherical perspective**
> **Diminution of size**
> **Foreshortening of form**
> **Subject location within the picture**

**Academic rectilinear perspective** is characterized by the fact that straight lines are rendered straight and that lines and angles within a plane or planes parallel to the plane of the film are rendered undistorted and unaffected by "perspective": parallel lines receding from the observer appear to converge toward a common vanishing point which, if the lines are horizontals, lies on the true horizon; receding verticals are rendered parallel. This typically *static* form of perspective can be controlled with the aid of the swings of a view camera or during the enlarging of the negative.

**True rectilinear perspective** is identical to academic rectilinear perspective in all points *except* that verticals receding from the observer also converge toward a common vanishing point. It is this phenomenon of *converging verticals* which makes the walls of buildings photographed with the camera tilted upward (or downward) appear to lean. Actually, this is a perfectly natural phenomenon, identical to the apparent converging of railroad tracks toward the horizon, and photographers should learn to accept it as such. Photographically speaking, this "uncontrolled" form of perspective is dynamic and truer to actual conditions than academic rectilinear perspective.

**Cylindrical perspective** is produced by panoramic cameras the lenses of which swing during exposure, describing an arc. This form of perspective makes it possible to produce photographs including the relatively enormous angle of view of 140°—approximately three times that enclosed by a lens of standard focal length—and is characterized by the fact that straight

**241**

lines parallel to the sweep of the lens appear curved, the more so, the farther away they are from the long axis of the picture. Straight lines at right angles to the sweep of the lens are rendered straight. Proof that this kind of perspective is in no way "unnatural," but is the inevitable consequence of the large angle of view which is enclosed, is given in the aforementioned books.

**Spherical perspective** is identical to two renditions in cylindrical perspective superimposed upon one another and crossed at 90°: *all* straight lines are rendered curved except those which appear as radii in the picture. The effect is identical to that of a scene reflected in a mirrored sphere. The angle of view is from 180° to 200°. This is the typical fish-eye perspective produced by fish-eye lenses which, as explained in the books I have mentioned, is strictly speaking not "distortion," but the perfectly natural and inevitable result of including an enormous angle of view within a single picture.

**Diminution of size.** This form of perspective is an optical illusion based on the fact that objects appear smaller the farther they are from the observer. It is a valuable means for creating a feeling of depth in a photograph in cases in which linear perspective cannot be used because the subject does not contain any straight lines. Diminution can be controlled by adjusting the subject-to-camera distance in conjunction with selection of a lens of suitable focal length.

**Foreshortening of form.** This form of perspective manifests itself as distortion. For example, seen in side view, a wheel appears undistorted in its true circular form; seen at an angle, it appears more or less elliptical or "distorted." Seen as a circle, a wheel looks flat and lacks "depth"; but seen in elliptical form, it acquires depth because we know then from its shape that we see it at an angle, more or less turned away from us toward depth. Because of this association, foreshortening evokes the illusion of depth and thereby becomes another effective space symbol. It can be controlled by changing the angle of subject approach (direction of view), if necessary in conjunction with the swings of a view camera: the more the camera back is

242

turned toward parallelity with the principal subject plane, the smaller the degree of foreshortening—and vice versa. If the camera back is parallel with the principal plane of the subject, foreshortening is eliminated altogether, regardless of the direction in which the lens is pointed.

**Subject location within the picture.** In the average photograph, the foreground (and nearby objects) appear near the bottom of the picture, the horizon (or far away subject matter or the sky which is a symbol of distance), appear near the top. As a result, a low subject location within the frame of a photograph is normally associated with nearness, a high one with distance. The greater this span in the picture (which usually means the higher the horizon), the stronger the feeling of depth; and vice versa.

## Contrast between sharpness and blur

The eye can focus on only one plane in depth at a time. Objects in front of or behind this plane appear more blurred the farther away they are from it. As a result, contrast between sharpness and blur creates impressions of depth. It becomes a symbol of depth which in a photograph can be utilized with the aid of the technique called *selective focus:* focus sharply on the chosen plane in depth, then take the picture with a relatively large f/stop to make sure that subject matter in front of and behind this plane will be rendered out-of-focus or blurred. The longer the focal length of the lens, the nearer the subject, the larger the diaphragm aperture, the greater the contrast between sharpness and blur and the stronger the feeling of depth.

## Contrast between light and dark

The earth's atmosphere is not a perfectly transparent medium. Depending upon such factors as weather conditions, location, and altitude, an ever-changing amount of dust particles and water in the form of vapor are suspended in the air. These impurities interfere with the passage of light. The effect is cumulative: the thicker the mass of air which light has to penetrate, the more noticeable the effect. As a result, the appearance of objects changes with increasing distance from the observer. All of us are

familiar with this phenomenon of *aerial perspective* which we constantly use to gauge the distance of faraway objects in a landscape: the hazier a mountain range appears, the farther away we assume it to be. Consequently, aerial perspective becomes a symbol of depth, distance, and space. As far as the photographer is concerned, it manifests itself in three different ways: as distance between object and observer increases,

> overall tones become lighter,
> contrast decreases, and
> color appears distorted toward blue.

The more pronounced these effects are in a photograph, the stronger the impression of depth; and vice versa. Since these effects can be controlled, the photographer can at will make space appear deeper or more shallow in his pictures. Although these controls are normally used to increase the impression of depth in a photograph, occasionally the opposite is desirable. In telephotographs, for example, nearby objects and foreground are often excluded from the picture area which contains only relatively distant subject matter. In such cases, aerial perspective, if uncontrolled, causes the picture to appear too contrastless and flat. To prevent this, the photographer must then *minimize* as far as possible these same effects of aerial perspective which normally he tries to emphasize. How all this can be done has been explained in *The Complete Photographer* and *Total Picture Control* by this author.

**Light and shadow**

This depth symbol has already been discussed, see pp. 222 and 225–226.

**Overlapping**

If one of two objects overlaps and partly hides another, it is obvious that the one that hides must be closer to the observer than the one that is partly hidden. In other words, the two objects are located at different distances from the observer—which means extension in space, which means depth. Overlapping may be the only means for symbolizing depth when other

symbols like linear perspective, diminution, or foreshortening cannot be used (because the subject contains no suitable lines or forms) and selective focus or aerial perspective cannot be used for other reasons.

## Scale

Whereas creating illusions of three-dimensionality in a photograph is usually not too difficult, it is often not enough to insure the success of the picture. For, unless space is defined also in regard to size, the impression of the photograph may be incomplete or even misleading. Typical examples are photographs of scenery which, despite undeniable beauty, make the subject—the landscape—appear disappointingly small, leaving the observer with the feeling that something is missing. This something missing is scale.

Providing a photograph with scale means including in the picture a unit of known size—like, for example, a human figure in a landscape photograph. This unit of scale becomes the measure by which the viewer gauges the size of the landscape: if the figure appears small and forlorn, the landscape in contrast seems huge; if the figure is rendered large, the landscape of course appears small. Consequently, by including in his picture a unit of scale—an object of known dimensions—and rendering it either larger or smaller, a photographer at will can make space appear smaller or larger by contrast.

A fairly large variety of objects of familiar dimensions exists to provide a photograph with scale. Heading the list is the human figure. For close-ups, a hand is usually best. For super close-ups, a pair of fingertips holding a tiny object is a more interesting scale unit than the traditional matchbox or the more scientific ruler. Whenever the human body or part of it is inadequate or unsuitable, other objects of familiar dimensions such as automobiles, telephone poles, windows, trees, animals, and ships (in seascapes) are suitable objects for providing photographs with scale.

By controlling either the actual or the apparent size of his indicator of scale, a photographer can control the scale and hence the space impression in his pictures. Whenever he wants something to appear big, his scale unit must

appear small—and vice versa. For example, to suggest the feeling of boundless space in a landscape photograph, figures (or other objects of known dimensions) must be placed at a sufficiently great distance from the camera to make them appear small. Sometimes, of course, it may be impossible to control the distance between the unit of scale and the camera. In industrial photographs, it may be necessary to indicate the size of a piece of machinery and for this reason the figure of an operator must be included in the picture to provide it with scale. However, if the operator has to be placed quite close to the machinery, varying the distance between scale indicator (the operator) and camera may be impossible. In such a case, employment of a *smaller scale unit*—an operator of smaller-than-average size—still permits the photographer to exercise a certain amount of control over the scale in his picture, making the subject appear in contrast larger and more impressive. Contrariwise, it is sometimes desirable to make a subject appear smaller than it actually is. In a close-up, for instance, instead of choosing the small hand of a girl as a scale indicator, use a large man's hand which in contrast to its size will make a small object in a photograph appear even smaller.

Whereas scaleless photographs of landscapes invariably will disappoint, scaleless *close-ups* can be among the most rewarding pictures. Small objects of nature—insects, flowers—are especially well suited to scaleless rendition and, if sufficiently enlarged, can surpass all else in strangeness of structural beauty, ornamental design, and sheer fantasy of form.

## MOTION

Many of the photographically most interesting subjects display motion, but a photograph is a still; motion, like depth, can be made apparent only in symbolic form in a picture. The question is, should it? And if so, how?

When confronted with a subject in motion, many photographers, proud of their expensive cameras featuring very high shutter speeds, try to render it

as sharp as possible. They are interested only in "freezing" or stopping motion. Often, of course, this attitude is justified; but at other times, it is not. For example, the sharply rendered photograph of an automobile traveling at 60 mph is in no way different from a sharp picture of the same car standing still. In such a case, the question is: does the photographer intend to make a picture of the car as an object, or does he intend to express the feeling of motion—an intangible? In the first case, motion must be stopped; in the second case, it must be indicated in symbolic form. Either way, he has at his disposal a number of different techniques from which to choose. These are explained briefly hereafter because they have already been treated more thoroughly in my books *The Complete Photographer*, *The Color Photo Book*, and *Total Picture Control*, to which the interested reader is referred.

### Freezing motion in picture form

**High shutter speed.** The exposure is made with a shutter speed high enough to stop the subject's motion on the film. How high is "high"? That depends on the *apparent speed* of the subject, its angular velocity, and the degree of motion relative to the camera: a car going 60 mph across the field of view of the lens requires a much higher shutter speed to be frozen on film than a car traveling at the same speed toward the camera or going away from it. And a moving subject close to the camera requires a proportionally higher shutter speed than the same subject moving at the same speed and direction relative to the camera but farther away.

**Electronic flash.** If conditions permit its use, even the fastest moving subject can be frozen on film with the aid of electronic flash (speedlight). In this case, it is the duration of the flash which stops the motion, regardless of the shutter speed which was used. The main limiting factor in regard to application of electronic flash is subject distance—if too far away, flash is ineffective.

**Panning.** The photographer uses his camera the way a hunter uses a gun to shoot a flying bird: center the moving subject in the view finder, hold it there

(Text continued on p. 257.)

**247**

The following insert contains eight photographs which the author considers good. As is true of virtually all the illustrations in this book, each was made with means accessible to any photographer of average capability and resources. What makes these pictures special is the way these photographers made use of their knowledge, their skills, and their phototechnical devices. In other words, these pictures are the product of imagination, interpretation, and ability to see in terms of photography, rather than the result of special opportunities or expensive equipment. This being the case, they ought to be of interest to any student photographer intelligent enough to realize that knowledge is only a prelude to performance.

Nude, by Erwin Blumenfeld. Resembling a lovely piece of sculpture emerging from marble under the skillful hands of the artist, this photograph shows form in the process of creation. Only the main elements of the concept are shown; the rest remains tantalizingly hidden, leaving its completion to the imagination of the observer.

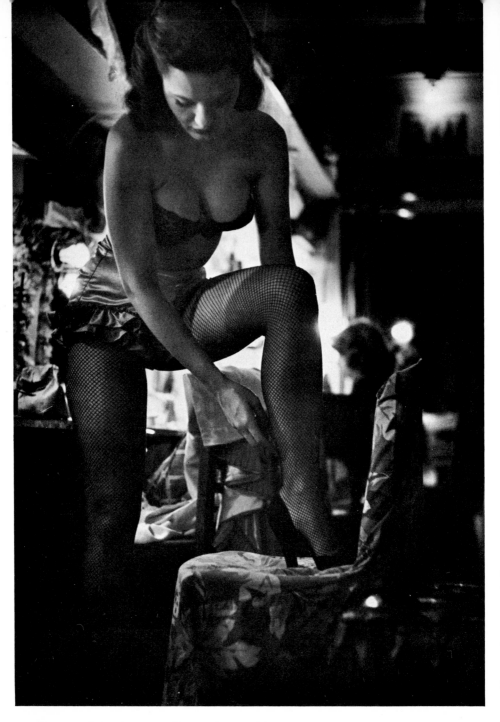

Show girl, by George Silk. High-speed lenses in conjunction with high-speed films make candid shots possible under any light conditions, enabling photographers to capture the mood of any scene. How important this is for the interpretation of mood is discussed on pp. 121, 223.

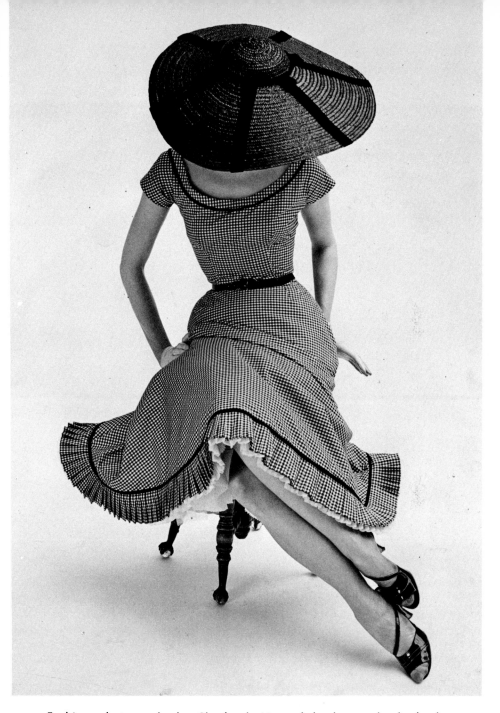

Fashion photograph, by Sharland. Neutral background, shadowless light, graphic black-and-white, and the fact that the model's face is hidden, all combine to achieve perfectly the purpose of this picture: concentrating the viewer's attention upon the fashion, the dress and the hat.

**From realism to abstraction**—five photographs of the nude

The photographs on this and the next four pages, all of which were made by the author, illustrate different approaches to photographing the female form.

The rendition above is typically realistic—a deliberately "personalized" study characterized by a full tonal scale, subtle gradation, and inclusion of the face almost in the form of a portrait.

In contrast, the rendition on the opposite page expressly "depersonalizes" the figure by excluding the face and rendering the body in bold and sweeping black-and-white. Clean outlines and a neutral background further strengthen the semi-abstract sculptural effect.

Edge-lighted nude. In stark, graphic black-and-white, the female figure is stylized and idealized in the form of an abstraction that is impersonal yet retains the essence of the subject. By eliminating secondary detail, an impression not unlike that evoked by good sculpture is created.

Solarized nude. Abstraction is carried one step further than in the picture on the facing page. Nevertheless, the power of the imagination is such that it reconstructs the subject in accordance with the fantasizing of the viewer, leading to a completed image which either satisfies—or means nothing.

Reticulated nude. The overall grain pattern of the reticulation pictorially uni-
fies the various picture elements, prevents unwanted "over-realism," and
gives the photograph a semi-abstract quality. This depersonalizes the figure
and strengthens its symbolic aspects, while still retaining its identity.

while following the moving subject with the camera, then make the exposure while swinging. The result will be a photograph which shows the moving subject sharp and the background blurred. If applicable, this is perhaps the most effective form of motion symbolization because it combines in the same picture sharpness and blur (the symbol of motion) yet produces a completely recognizable image of the moving subject—which a photograph in which the subject is rendered blurred does not.

## Motion symbolization through blur

**Directional blur.** The concept of motion is inseparably connected with the concepts of space and time. Motion is change in space, and any change in space takes time. Hence, by substituting a time exposure for an instantaneous exposure—by deliberately *not* stopping subject motion on the film—a photographer can express motion graphically by blur. This, of course, is analogous to the way we see an object in rapid motion: more or less blurred depending on its velocity (if things move too fast, the eye can no longer follow and registers motion as blur).

In common language, blur is equivalent with unsharpness or fuzziness. But photographers must distinguish between two kinds of blur. *Overall blur* or unsharpness is the result of faulty focusing, insufficient stopping down of the lens, or deliberate softening of the picture; *directional blur* is the result of subject or camera movement during the exposure. It is directional blur with which we are here concerned.

The effectiveness of blur as a symbol of motion depends on its degree: too little blur, and blur looks accidental, like a mistake; too much, and the moving subject becomes completely unrecognizable. Therefore, proper timing—selection of a shutter speed that is just right—is vitally important: the slower the shutter speed relative to the speed of the subject, the more pronounced the blur and the stronger the feeling of speed in the picture; and vice versa.

**Motion graphs.** This is a highly effective form of motion symbolization of

limited application based on the fact that if we expose a bright, moving dot very briefly, it will appear on the film as a dot; but if we prolong the exposure, it will appear in the form of a line the width of the dot, the length of which reflects the duration of the exposure relative to the speed at which the image of the dot (or subject) moved across the film. This is the principle of all motion graphs which can be implemented in practice by mounting the camera on a tripod or otherwise steadying it securely, opening the shutter, leaving it open for as long as necessary to complete the motion graph, then closing the shutter and developing the film.

An indispensable condition for success is that the moving subject be relatively bright in comparison to the background against which it is seen. Otherwise, the background would "burn out" the image of the moving subject. Familiar examples of photographs produced by this technique are time exposures of traffic at night (in which the headlights of the moving cars trace linear designs), fireworks, and the concentric pattern of the wheeling stars.

**Combination time and flash exposures** are exactly what the term implies: a motion graph of a bright object rendered in the form of a line pattern upon which a sharp picture of this object is superimposed at the appropriate moment with the aid of flash. An example of this technique familiar to most photographers is Gjon Mili's famous photograph of Picasso "painting" with a flashlight held in his hand (see *The Complete Photographer*, p. 100) in which the light pattern is the result of a time exposure, while the picture of Picasso is flashed.

### Other forms of motion symbolization

**Multiple exposure.** While double and multiple exposures are normally due to mistakes on the part of the photographer, in motion photography they can provide in graphic form effective records of the progress of a subject in motion. Technically, this is accomplished in two ways: either with the aid of the shutter or with the aid of stroboscopic light (repetitive electronic flash). In the first case, the same piece of film is exposed several

times, each exposure (timed visually by the photographer) recording a significant phase in the progress of the motion. In the second case, a flickering electronic lamp automatically chops up the motion into equally spaced phases and records its flow in the form of a staccato pattern. Familiar to most readers as typical of a manually timed multiple exposure are pictures showing the progress of a lunar or solar eclipse; a well-known representative of a stroboscopically timed multiple exposure is Dr. Harold Edgerton's famous photograph of a golfer swinging his club.

**Multiple printing,** by combining several negatives in one print, enables a photographer to accomplish results similar to those of multiple exposure. The advantages of this technique are that motion rendition can be restricted to a few significant, carefully chosen phases; that missing a shot does not endanger the entire sequence; and that individual pictures can be combined visually for maximum effect. Drawbacks are that this method is restricted to rendition of relatively slow motions and that normally no more than four or five pictures can be combined in one print.

**Picture sequence.** Several individually shot phases of a motion can be shown in the form of a series of pictures, instead of being combined in one print. This form of motion rendition is particularly suitable to express very slow motion, such as the approach, passing, and receding of a yacht or the "growth" of a building under construction.

**Composition.** Unless motion is chaotic (like that of a milling crowd), it has direction. By graphically emphasizing this direction through a dynamic arrangement of the picture components, a photographer can create the illusion of motion through composition. Frequently, merely tilting the image of the moving subject relative to the edges of the photograph is sufficient to evoke the feeling of motion. Placing the moving subject along or near one of the picture's diagonals—or near one edge or corner—accomplishes the same effect. Even if motion is already symbolized by blur, such an arrangement would intensify the feeling that the subject had moved. Readers interested in these and other aspects of composition are referred to the author's book *Principles of Composition in Photography*.

In the course of the creation of any photograph, the most important single instant is the moment the photographer presses the proverbial button—it is so irrevocably final. Once the shutter has clicked, the decision is made, for better or worse, and what remains to be done can be accomplished by any capable technician. *Before* he takes this final step, the photographer is free to select and reject, add or take away, improve and rearrange; change subject distance and direction of view; choose this lens or filter instead of that one; stop or symbolize motion; impose the stamp of his personality upon the future photograph in any number of different ways. All this ends with the click that fixes the image on the film—reason enough to make anyone think twice before he takes this final step. In particular, a photographer should consider the following aspects of timing which have been discussed in more detail in the author's books *The Complete Photographer* and *The Color Photo Book*:

**The psychological moment.** Every action has its climax, a particularly significant phase, the instant which Henri Cartier-Bresson so aptly called "The Decisive Moment." To capture this all-important moment on film is a matter of timing. Release the shutter too soon or too late, and the dramatic moment is missed, the job is blown for good. In action photography, nobody gets a second chance.

**Timing in regard to composition.** Many photographs involving subject motion are undramatic—pictures of people walking, automobiles moving, landscapes with slowly drifting clouds, a bunch of children playing in the street. In such cases where no "psychological moment" is involved, timing the exposure should be based on the compositionally most effective arrangement of all the mobile picture elements involved. Specifically, watch out for position, juxtaposition, and overlapping; it makes a great difference whether a small but pictorially important picture element—a figure, a racing car, an animal—is placed near the center of the picture or near a corner, high within the picture frame or low, facing toward the picture's

center or the edge. It also makes a great difference whether it is seen in its totality or overlapped by some other form, or seen against this part of the background instead of that. Arrangements and configurations change constantly and usually fast, and timing such a shot can make or break the picture.

**Timing in other respects.** Spotting a potential subject, most photographers snap it without considering whether or not the first glance actually shows the subject to best advantage. Of course, this is often the only way of getting the picture. However, at other times (particularly if time is *not* of the essence), further study may show that other ways of "seeing" the subject would lead to more significant pictures. The sun, for example, may not be in the best possible position as far as direction and extent of the shadows are concerned, and waiting or returning another day may produce a better shot, particularly where architectural subjects are concerned. Timing may be wrong in regard to atmospheric conditions: in outdoor photography, it makes a great difference whether a picture is made in direct sunlight, on a hazy or overcast day, in rain, fog, snow. To realize the importance of such factors, to have enough self-discipline to pass up a good subject encountered under unfavorable viewing conditions rather than to compromise, to have the patience to wait until *all* the factors that contribute to the effect of the picture are just right, all this is timing.

# 5

## The Picture Story

This book is based upon the experiences, thoughts, and ideas of a *photographer*. When, in the following, I briefly discuss the picture story, I am well aware of the fact that I sometimes invade the province of the editor whose viewpoints may not always coincide with my own. It may be thought that this chapter should have been written by an editor. To this I want to reply that it is the photographer who provides the pictures with which the editor works; that it is the photographer who meets the people and visits the places which the editor usually knows only from photographs; that it is the photographer who must solve all the practical difficulties involved in producing the pictures—difficulties with which the editor naturally is not concerned; and that it is the photographer with his firsthand experience who is qualified to judge the work of the editor—the picture story as it appears in the magazine or book—since he is one of the few persons who is familiar with the entire background of the story and therefore competent to compare reality and presentation. It is from this viewpoint of the working photographer that the following observations and comments are made.

Now, the original version of this book was written at a time when picture magazines were going strong. Today, at least in this country, all the once important general picture magazines have ceased to exist and the demand for picture stories is down. Nevertheless, because there is still a large number of specialty magazines flourishing and because the number of photographic picture books is on the increase (if not in hard-cover editions

**263**

then in paperbacks), both the publisher and I felt that this chapter on the picture story should be preserved. For what holds true in regard to picture stories intended for general picture magazines still applies in essence to specialty magazines and photographic picture books. The emphasis may have shifted, but the picture story itself is very much alive.

## Definition of the Picture Story

To many photographers, the fulfillment of their ambition is to have their pictures published in a picture magazine or book. Why? Because having photographs accepted for publication means *recognition* for the photographer. But even more than that, it means that his pictures will be seen by thousands and possibly millions of people—which, after all, is the reason why he made them.

Why do photographers prefer to have their work published in a *picture* book or magazine rather than as illustrations in a *text* book or magazine? Because an illustration is subordinate to the text which it illustrates, whereas *in a picture book or magazine the photograph comes first and the text supplements the picture*.

Picture books and magazines use photographs similar to the way in which text books and magazines use words—as components of their specific language. In this case, picture language. And as many words are needed to tell a coherent story, so many photographs are needed to tell a coherent picture story. However, as far as descriptive power is concerned, both words and photographs have certain inherent limitations. A writer, describing a certain face, can write page upon page of precise description yet not create an impression that is nearly as precise as that created by a good photograph. On the other hand, a photographer, attempting to illustrate the thoughts and feelings of two people in love, can take any number of pictures but cannot convey what a good writer can express in half a page of prose. Because of such limitations of the photographic medium, in order to

be *complete* a picture story usually must be supplemented by some sort of text—*headline, subheads,* and *picture captions.*

But *more* than this combination is needed to produce a *good* picture story. Unless the material is presented in a coherent, well-edited, and visually effective form, the meaning of the picture story may not be clear, or the story will be tiresome and dull. Thus, the form in which it is presented in print is as important to the success of the picture story as the technical and artistic qualities of its components.

Only exceptionally will a picture story be the work of a single person. Usually, it represents the combined efforts of a group of people working together in close cooperation as a team, each a specialist in his particular field. Normally, four people, assisted by many others, are primarily responsible for the production of a picture story.

## The editor

He assumes responsibility for the finished picture story. He also coordinates and supervises the work, selects material in accordance with the demands of the project, decides how much space is to be allotted to the story, and slants the story in accordance with the viewpoint of the publisher. Because it is his job to judge the finished story from the angle of the reader—the "man in the street" who is not concerned with the technicalities involved in its making —he usually carefully refrains from acquiring specific knowledge of technical procedures which might prejudice his editorial judgment. Although this attitude is understandable, it can present a difficulty to the photographer who may as a result get little understanding from the editor as far as particular production problems are concerned.

## The photographer

He produces the pictures and is responsible for their suitability, quality, continuity, and coherence. Not infrequently, he also provides the idea for the picture story. Generally, he cooperates with the editor and the writer in

planning the story in regard to approach and execution, contributing his ideas concerning the pictorially most effective form of presentation. In the capacity of a technical advisor he also corrects misconceptions which the editor or writer may have about the practicability of certain picture ideas.

## The writer

He produces the picture captions, text blocks, and headlines. His task is to tell the background story of the subject which cannot possibly be included in a photograph and to identify the subject in addition to people, places, and events. Frequently, his work is complicated by the fact that he must accomplish this within an assigned space—the space provided for the caption. Occasionally, such spaces may be too small to permit the writer to say as much as he deems necessary; on the other hand, they may be too big, making it obligatory for the writer to fill them with more words than are actually necessary.

## The layout man (Designer)

He is responsible for the visual organization of the picture story. In accordance with directions received from the editor, he arranges the picture sequence in the book or distributes the pictures over a certain number of pages in the magazine, paying particular attention to story continuity and variety in regard to visual appearance (change of pace). He also sees to it that important or beautiful pictures are properly emphasized through size and display; that pictures which appear on one spread also supplement one another editorially and enhance one another graphically; that adequate and appropriate spaces are provided for captions, text blocks, headlines and, if necessary, subheads; and that the opening and closing pictures are selected on the basis of their suitability to mark the beginning and end of the story.

## SUMMING UP AND CONCLUSION

A picture story is the product *not* of a single person, the photographer, but of a group of people working together toward a common goal. Each fulfills a specific and important function. The more qualified and imaginative—and individualistic—each is, the greater the likelihood of producing a successful picture story. On the other hand, the greater also is the likelihood of clash between personalities and stubborn opposition to ideas not one's own. However, since failure to cooperate negates not only the efforts of the other members of the group but also one's own, this danger normally suffices to ultimately insure that understanding and agreement within the team which is necessary to the production of good picture stories.

## Types of Picture Stories

The aspects of reality are constantly changing. Even the simplest object can appear in many different ways, depending upon the distance and the angle from which we see it and the kind of light in which we see it. And when we consider occurrences which happen in time and involve changes in space, the number of different aspects becomes truly astronomical. Consequently, if a photographer wishes to convey more than a single limited aspect of a subject, particularly a complex one, he must depict each phase in the form of a separate picture. The result, a number of such pictures held together by a common theme or idea, is a picture story.

Picture stories can assume many different forms, depending upon all kinds of factors—primarily the importance and complexity of the subject, the character and type of the book or magazine, and the available space. In order to approach their assignments sensibly and not to waste time and material in overshooting or to fail through undershooting, photographers must know exactly what is expected of them. They may encounter the following types of picture stories:

**The illustrated text piece.** This is not really a picture story inasmuch as photographs are used merely to supplement the text. Sometimes, only a single picture may be needed—for example, a portrait to illustrate a personality profile. At other times, a larger or smaller number of pictures is required, each to illustrate certain highlights of the story. Coherence is provided by the text.

**The picture-and-caption story.** This is the most common form of picture story. It is based upon a series of related photographs supported and held together by words. The subject, its different aspects and details, its surroundings, and its implications are shown as far as possible in visual form, with captions supplying those aspects that can only be conveyed by words. Coherence is vitally important. Even without captions, a picture story, although it may be somewhat incomplete, must still make sense and give by itself an impression of coherence and unity.

**The pure picture story.** This is a relatively rare type of picture story consisting solely of photographs without supporting captions or text. This form is used most commonly for short "how-to-do-it" picture sequences which are self-explanatory. Since *everything* must be conveyed in visual form, this is the most difficult type of picture story and is normally used in instances involving predominantly factual rather than intangible (literary) subject qualities.

**The combination story.** This is a picture story which includes artists' drawings, diagrams, and maps as well as photographs and text. A typical example is the *Life* series "The World We Live In" in which paintings and drawings of subjects which could not be photographed (for example, cross-sections of the earth) supplement the photographs.

As far as their origin is concerned, three different types of picture story can be distinguished:

**The accidental story.** The photographer happens to encounter a subject or event. In such a case, planning is impossible and whether or not a photographer gets a worthwhile picture story depends primarily upon his

presence of mind. He must act fast, doing almost instinctively the right thing at the right moment. But whereas trained news photographers experience no difficulty in this respect, other photographers frequently become excited and confused, even to such a degree that they forget how to operate their cameras. Although this type of story depends largely upon luck, some noteworthy pictures have been produced under such conditions, among them the classic series of the Hindenburg disaster.

**The anticipated story.** The photographer expects something to happen, but does not know whether it will be worth recording or not. Examples of this kind of story concern subjects such as news and sports events, interviews with famous personalities, conventions, riots, war. Occasionally, the photographer may not even know exactly when or where the anticipated event will occur.

**The planned story.** This is the typical feature story of the picture magazines and certain kinds of photo books. It should be conceived, researched, planned, and executed as carefully as the story which a writer plans to write. To insure proper continuity and to be certain that nothing will be forgotten, the whole story should be outlined in the form of a *shooting script,* which lists all the required pictures, complete with pertinent information as to location, time, contacts, personalities. Although, in most cases, it is impossible (and usually not even desirable) for the photographer to precisely follow this shooting script, it is nevertheless invaluable as a general guide, a checkoff list, a timetable, and a means for planning the practical details of his work.

As far as technique and picture coherence and continuity are concerned, we must distinguish among four types of picture stories:

*The camera remains stationary*. This is the simplest type of picture story, although it probably should be called a picture strip rather than a story. If a photographer, instead of taking a picture with a still camera, would take a sequence with a movie camera and would subsequently enlarge significant frames from this strip, he would produce exactly this kind of picture story. It

is well suited to depict on a limited scale events happening in time, such as an interview or a conversation (different gestures and expressions), a street scene, a child at play, or the construction of a building. Coherence among the individual pictures results from the fact that the background against which the event takes place is always the same since the camera remains stationary. Continuity is expressed in the gradual change over a (usually short) period of time in the depicted subject or event.

*The camera changes position; the subject remains stationary*. Whereas the previous type of picture story enabled the photographer to depict simple changes in time, this type is most suitable to depict variations in the spatial aspects of a subject. Typical examples are the picture stories on modern houses in architectural magazines: the subject—the house—is stationary; to depict it in its different spatial aspects the photographer—the camera—moves around the subject, showing it from different angles in relationship to neighboring buildings and its environment. Coherence is provided by the fact that the subject of the picture sequence remains the same. Continuity is expressed through the progression of the camera in space, perhaps from long shots and overall pictures to close-ups of details.

*Both camera and subject change positions, although the subject of all the individual pictures of the sequence remains the same*. Typical examples of this type of picture story are personality stories like Ed van der Elsken's moving account of love in St. Germain-des-Prés. Coherence is provided by the fact that in all pictures the subject—the person—is the same. Continuity is expressed through changes in time and space.

*Different camera positions and different, though related, subjects*. This is the most elaborate, complex, and ambitious type of picture story. It can be compared to a novel in that it deals with many different subjects and situations, all of which are held together by a central idea—for example, a picture book on New York. Coherence and continuity are expressed through the development of a theme, the subject of which can vary in extent and complexity from the documentation of a small college to that of a large industry or an entire country.

**270**

# Subjects and Ideas for Picture Stories

One of the most important qualities of a picture story is suitability; it must fit the type of publication for which it is intended. Although, of course, it is obvious that an architectural magazine is not interested in a fashion story, not every photographer realizes that *any kind of story* must be approached in different ways depending upon the type of publication for which it is intended. In other words, whereas it is usually simple to decide what kind of subject a specific publisher might be interested in, it is not always easy to find the form of presentation which is most likely to suit the needs of the particular publication. A fashion story, for example, can be conceived with emphasis on either news value or sophistication or sex or such practical aspects as low price and durability—and it can be shot either in a straight documentary or in an imaginative and creative manner. To get the right slant on his story, the photographer must study the "personality" of the particular publication for which his story is intended.

Although the majority of picture stories originate with an editor or writer and reach the photographer in the form of specific assignments, editors are always in need of new ideas. Photographers who wish to submit their own ideas for picture stories (which, if accepted, they will in most cases be asked to execute), should consider the following points:

**Timeless or dated.** It may make a great difference whether a story is time-bound or timeless. A picture story on a specific event may be time-bound insofar as, unless it is used within a definite time, it becomes valueless. Or, a story may be time-bound only insofar as it must run either in summer or in winter. If such a story cannot be used at a particular time, it can often be held over until the right time for using it arrives (for instance, the following year). Again, other stories are completely timeless and thus can run at any time. In general, the less time-bound a story idea is, the greater is its likelihood of being used.

**Timing.** Ideas for stories that are in any way time-bound must be submitted

**271**

at a suitable time. Unless the story concerns an impending news event, the time for submitting the idea depends upon the working schedule of the magazine. Some magazines plan their issues as far ahead as six months in advance, others from two to four. Color stories are always scheduled farther ahead than stories in black-and-white. For this reason, submitting the outline for a story on skiing in winter would be a waste of time. By that time, the schedule is very likely filled, plans and preparations having been made long in advance. However, if submitted late in summer or early enough in fall, an idea for a winter story will probably be considered, and if it is accepted, the photographer will be assigned to shoot it as soon as conditions are right.

**Universal appeal.** Since editors must think in terms of mass audiences and mass appeal, the greater the number of people who might conceivably be interested in a picture story, the better the chance that the idea or story will be accepted by management. Photographers who have special interests often assume that, because a subject is interesting to them, it will also appeal to the average reader. Story ideas which have limited appeal, of course, have little chance of being accepted. On the other hand, the majority of subjects which have universal appeal have in one way or another been done before, and to submit an idea which has already been done is futile, too. The best ideas are often those which present subjects which have universal appeal (which may have been done before) in an unusual form, from a new angle, or in a different light. Subjects that are of universal interest are those that are common to most people or affect the mass of people and those that reflect people's actions, feelings, thoughts, and lives.

p. 97
pp. 115–
119 **Pictorial interest.** As previously mentioned, we must distinguish between photographic and literary subjects. The first, being photogenic, are suitable to visual rendition; the latter are not. Obviously, the more photogenic the subject of a picture story idea, the greater its chance of being accepted for use in a picture magazine or book. In this respect, the photographer, used to thinking in terms of visual images, should have the advantage over the writer who is more used to thinking in terms of word images. When it

**272**

comes to a choice between the two—a photogenic though otherwise rather unimportant subject and an editorially important although unphotogenic subject—the first, being pictorially more effective, will often be preferred. As a matter of fact, almost no editor will refuse a particularly beautiful and pictorially effective picture story, even though the subject of the story may neither be particularly important newswise nor have a particularly wide appeal. But, like the picture of the beautiful girl in the ad which actually has nothing to do with the advertised product (except to catch the reader's attention), an outstandingly beautiful picture story provides an added attraction to any magazine which few editors can afford to overlook.

**Scope of idea.** As far as magazines are concerned, as a rule, an idea which deals with a relatively limited and well-defined subject—because it makes for a simpler, less expensive, more coherent, and often more pictorially effective type of picture story—has a greater chance of being accepted than an idea which pertains to a vast and vaguely defined subject. For example, a story on a specific town has a better chance than a story on a whole state; a story on a family that is representative of a certain community has a better chance than a story on the community itself; a story on a specific person has a better chance than a story on a whole family; a story on one specific baseball player has a better chance than a story on baseball as a sports form.

**Type of subject.** Although the type of subject on which a story idea centers is mainly dependent upon the type of publication for which it is intended, one thing is certain: No matter what the subject, the universal appeal of the idea will be considerably greater if people are involved in the story than if it deals exclusively with inanimate objects.

In particular, the following approaches to picture story ideas deserve consideration:

**News value.** Everyone is interested in anything that is new because new things are different, unusual, exciting. In the case of magazines, this applies not only in regard to political or local news, but also to any kind of subject:

new fashions, new scientific or engineering discoveries and developments, new gadgets for the kitchen, new types of materials with fabulous new properties, a new technique for catching fish, a new way to deflea a dog, and, of course, old things shown in pictorially *new* and thus automatically interesting forms.

**Familiarity.** Readers like to identify with the people depicted in the story, to see their own lives and problems reflected in pictures, and to feel that they are on familiar ground. This is the reason why ideas based upon the everyday routine of average people have such strong appeal, particularly if they emphasize the drama and heroism of everyday life.

**Education.** People like to learn something concerning things about which they know nothing—particularly if such knowledge can be acquired in a painless way in the form of a picture story. In this category belong stories on "how-to-do-it-yourself," out-of-the-way places, foreign countries, and travel. Also stories on cultural subjects, art, history, other civilizations, nature, ecology, science, technology, medicine, health—provided that they are popularized in such a way that the subject appears interesting, alive, and in some way related to the personal experience of the reader.

**Thrills, excitement, and escape.** In this category belong dangerous ventures, mountain climbing, automobile and horse racing, boxing, and gambling. Also milder forms of excitement such as hunting and fishing, sports in general, vacationing, and stories centering on beautiful girls, movie stars, love, and sex. People like to escape from the drabness of their lives, if only for a few moments, and to identify with the heroes, adventurers, and glamorous personalities which picture stories bring into their lives.

### Source material for picture story ideas

The richest sources—veritable gold mines—for story ideas are newspapers and magazines. Some of the most useful items are often concealed in the form of a short paragraph somewhere in the back of the paper. Frequently, they contain the germ of an idea for a picture story that needs only to be

developed and expanded. At other times, an item may be responsible for starting a train of thought which, through association, leads to a worthwhile story idea. But even a full-fledged picture story in a picture magazine may give an imaginative reader an idea of how to present the same subject from a different angle or how to use a similar treatment on a different subject. The basis for discovering story ideas is imaginative thinking: What does this item suggest? What does it remind me of? How can it be improved? How can it be expressed in picture story form?

Other likely sources for story ideas are trade magazines and books. Reading a textbook on zoology, for example, I got an idea for a picture story on "Bones"—supposedly a very dry subject. Nevertheless, it eventually made eight pages in *Life* (October 6, 1952).

And finally, there are the photographer's own interests and experiences from which he should be able to draw ideas for stories which will also have an appeal to others.

## The Components of the Picture Story

A good picture story is a logical, well-organized, self-contained unit in which each part has a specific function. In this respect, the photographer must consider the following:

**Number of pictures.** How many pictures are needed to make up a picture story depends first upon the importance and complexity of the subject and secondly upon the amount of space (number of pages) assigned to the story by the editor. However, the latter factor may vary. I have known of stories which started out small but were gradually expanded and eventually got several times the number of pages in the magazine that were originally allotted. Contrariwise, stories which were planned as big occasionally ended up with fewer pages than anticipated or were not used at all.

To give the photographer an idea of what to expect, based upon my twenty years of work as a staff photographer for *Life*: To produce an average six-page picture essay, the editors of *Life* required from twenty to forty different pictures from which to select between five and fifteen for publication (these figures are based upon the analysis of a representative number of picture stories published in *Life*). To produce forty pictures that were good enough to be submitted, I had to take from fifty to eighty *different* shots. Since I like to take at least two different exposures of each setup (to show it from two different angles, or to get two different expressions when photographing people, or simply to produce two identical negatives—one of which I regard as a spare in case something happens to the other) I used to make a minimum of one hundred but not more than two hundred exposures (out of which from twenty-five to fifty negatives were printed) to produce the material required to fill six pages in *Life*.

**Beginning and end.** The most important picture of any magazine story is the one on which the story opens—*the lead picture*. This picture has a double function: it must attract the reader's attention and make him want to know more about the subject which it represents; for this it must have stopping power (p. 65). But beyond this, it must also contain the essence of the whole picture story and show the reader what to expect; for this it must have content and meaning (p. 75). Among the material submitted for a six-page picture essay there should be at least four pictures that are suitable to be used as the lead.

The last picture of a photographic essay is almost as important as the first. But whereas the opener must be factual and informative, the "closer" is often reflective and moody. By the time the reader sees it, he knows what the story is about in regard to its facts. The closer should help him to see the significance of these facts and draw the right conclusions.

**Change of pace.** To live up to the promise of the lead picture, the rest of the story must be varied and lively in regard to visual rendition and presentation. To accomplish this, the photographer has the choice of the following means:

*Long shots and overall shots* taken from a distance or with the aid of a wide-angle lens show the subject in its entirety, relate it to its surroundings, and clarify the relationship of its different components to one another. They are pictures which at one glance present many different aspects of a subject which subsequently will be further explained in some of the other pictures of the story. This type of picture is sometimes taken from a high vantage point: a lookout, tower, roof, scaffold, or ladder; or from the air.

*Medium-long shots* normally comprise the majority of the pictures that constitute the story. They correspond to the impression which the eye receives in reality. They are used to show people, objects, interiors, action.

*Close-ups* are explanatory pictures which enable the photographer to show important aspects of the subject in greater clarity and detail than they would have appeared in reality to an observer. Only in the form of a close-up can a face, a pair of hands doing things, or a small but important object appear monumental, interesting, and in proper proportion to its significance to the story.

*Full-page presentation* (and presentation in the form of a double spread) should be considered for the editorially most important and pictorially most beautiful aspects of the subject. A photograph which is both editorially significant and pictorially beautiful is automatically a "stopper" and raises the level of the entire story.

*Horizontal and vertical pictures* are usually represented in approximately equal proportions. Because it is normally not practicable to decide in advance how a picture will be used in a layout and in order to give the layout man the greatest possible freedom in organizing the story, it is recommended that, whenever possible, the photographer compose important pictures for possible use in *both* horizontal and vertical form by shooting the same subject in two versions. If this is impossible—there may be no time for a second shot—sufficient space should surround the subject proper on the film so that the layout man can make minor adjustments in the proportions of the picture if this should be desirable.

**277**

**Cover and dust-jacket possibilities.** Photographers shooting pictures for publication should always look out for possible covers. Pictures suitable for use on a cover must fit the following requirements:

1. They must have poster effect, must be simple and bold enough in design to be effective from a distance. The rendition must be graphically strong enough to hold its own among the many other magazines displayed on a newsstand or books in a store.

2. The background should be unobtrusive in color, tone, and design.

3. Suitable space, free from important subject matter, must be provided for the name of the magazine or book, and the subject must be composed in such a way that, in conjunction with the title, the total effect is one of balance and unity.

In addition, experience has shown that as far as general picture magazines are concerned, the most commonly used cover subjects are people; that the close-up of a face has a better chance of making the cover than a picture of the full figure; that the picture of one person has a better chance than that of a group. In regard to technical magazines and magazines on specific subjects, close-ups usually have a better chance of making the cover than overall shots.

## Planning the Picture Story

### Approach

Two different viewpoints must be considered and, what is more, reconciled with each other: the editorial and the pictorial. The editorial viewpoint determines *what* to do; the pictorial, *how* to do it.

In particular, *the editor* is mainly concerned with the following aspects of a picture story: the purpose of the story—what must be accomplished, proved, shown? How thoroughly should the subject be covered? How much

time and money can be spent on it? Who should photograph it? How much space should it get in the magazine, or how big a book is planned? When should it be published? On the other hand, *the photographer* is primarily concerned with the following aspects of the story: is it conceived in terms of visual images or of word images—does the subject lend itself to visual (photographic) representation, or is it one of those that can never appear particularly interesting in photographs but must be done because it is editorially important? How can the story be organized? What is its logical beginning and end? What are its most significant features? When and where can it be shot? What kind of equipment is needed?

## Coherence and continuity

What is it that holds a picture story together? As Wilson Hicks, former picture editor of *Life*, once stated: It is a fact, a feeling, or an idea—in short, *a common theme*. To work out this theme so that it becomes clearly identifiable in one form or another in every picture of the story is one of the most important tasks of the story planner.

However, something more is needed to produce a good picture story: the story must flow; the pictures must not only belong together, but also be connected in such a way that the story "reads" easily—has direction and continuity in time or space or both. If the pictures are compared to beads, a good picture story is not merely a handful of beads that go together in style, but beads strung in a certain order so that they make a pattern and form a necklace.

Among the ways in which a picture story can be organized in regard to coherence and continuity, the following are most often used:

**Repeated identity.** The same subject appears in every picture. Example: a story built around a certain person, family, object, animal. Since every picture personality story belongs to this type, the device of *repeated identity* is probably the most often used means for holding a picture story together.

**Development in time (chronology).** Pictures of an event (or the development of a person, like an album showing the growing up of a child) follow one another in chronological order, the story usually having a definite beginning and end in time. Example: steel production, from the mining of the ore to the finishing of the final product. Coherence is provided by the common theme—steel—and continuity results from the logical development of the theme in time.

**Development in space.** The subject, which usually is extensive, is shown in its different spatial aspects; no particular attention is normally paid to the chronological order in regard to the arrangement of the pictures. Examples: picture stories on a town, a city, a country; the Grand Canyon; a highway across America. As far as achieving coherence and continuity is concerned, this is one of the most difficult forms of picture story since neither the device of repeated identity nor that of chronology can be used. Instead, unity must be achieved through style and character of the pictures, organization, and layout. For example, a picture story on an entire country can start with a map in which the locations of places later shown in pictures are indicated (for overall orientation), followed by aerial shots of typical parts of the country showing its geography related layout-wise to both the map and the pictures of towns and cities subsequently shown, which in turn are amplified by photographs of the people and the way in which they live. Thus, by logically progressing from the larger to the smaller unit and working out related aspects of the subject in terms of layout and visual organization, unity and coherence can be achieved without the simpler devices of repeated identity or chronology.

**Evolution (development in time and space).** Example: all "how-to-do-it" picture stories. But also certain kinds of travel and vacation stories. The subject of the story, which can be the making of a piece of furniture or a journey to some distant place, is developed both in time (step-by-step) and in space (point of departure to point of arrival).

**Contrast and juxtaposition.** Although this device is normally insufficient for the organization of an entire picture story, it is useful to get certain

points across in an instructive and easily understandable way. It usually takes the form of "right and wrong," "good and bad," "do and don't," "before and after" picture pairs.

**Similarity.** This, too, is not a story organization device in the strictest sense of the word, although it is sufficient to hold a story together loosely. Examples: picture stories (or collections) such as "Famous Scientists" or "The Best News Pictures of the Year" in which the common denominator is a category.

**Layout.** By organizing photographs together in groups, panels, or on specific pages, and by tying them together typographically with the aid of subheads, blocks of text, and empty surrounding space, the layout man can emphasize the "belonging together" of editorially related pictures, intensify the coherence and continuity of a picture story, and even give a feeling of these qualities to stories in which they actually do not exist.

## The script

Every planned picture story begins with an idea. But as any writer knows only too well, there can be a world of difference between an idea—a thought—and the realization of this idea in tangible form. What seems easy in thought is often extremely difficult to accomplish in actuality. A picture story idea may seem good before it has been worked out in detail on paper; but then weaknesses which no one suspected may appear and difficulties arise which might have jeopardized the whole project had they been discovered later during the actual shooting. The place to make and rectify mistakes is the *script*.

The script is an instrument of coordination and clarification which links together editor, writer, and photographer. It also relates conceptions and ideas to the reality of research, facts, and tangible images (photographs). It is an aid in defining the focus of the projected story inasmuch as it enables those who plan it to visualize the entire story at a glance—for every single picture is listed in the script. As a result, adjustments can easily be made, important features emphasized, less important aspects played down or

**281**

eliminated altogether, and the whole story tightened and condensed to the point of greatest significance.

To the photographer, the script is primarily a guide which can considerably facilitate his work and yet be disregarded if conditions should warrant. It furthermore serves as a *checklist* (so that no important aspects of the story will be overlooked), as a *work chart* (so that pictures can be shot with a minimum expenditure of time, travel, and effort), as a *backcheck* for the captioning of the prints, and as a *reference list* for the writer of the captions.

A good shooting script is divided into two parts. The first is concerned with the general idea of the picture story in terms of purpose, scope, slant, background, and organization. The second part lists individually all the suggested photographs complete with information which is pertinent to each shot.

The main qualities which a photographer demands from his shooting script are *factual accuracy* and *completeness*. During my twenty years of work as a photojournalist, I have seen too many scripts which read like poetry —containing phrases such as "silence disturbed only by the creaking of saddle leather"—and which were not only lacking in important facts but sometimes were actually misleading. This sort of script also has been encountered by my colleagues, and my complaints are shared by them. Good photographers don't need poetic descriptions to stimulate their imaginations. What they need are *facts:* information in regard to people, contacts, names, addresses, places, dates, and times. Give them these facts, and they will take care of the rest.

## Shooting the Picture Story

Good photographers are highly individualistic, each working in his own personal way. Some work best when under pressure; others cannot work at all under such conditions. Some prepare with an almost scientific thorough-

ness for any story they have to shoot; others rely more on intuition and previous experience. For this reason, although I personally know many of our best photographers and much about the ways in which they work, I prefer to let them speak for themselves if and when they should desire to do so and to restrict the following to my own experience.

As far as I am concerned, the greatest contribution an editor can make to the success of a story is to *give me time:* time to become acquainted with the factual background of the story both through advance research and through study of actual conditions on location—and time to be sure that I thoroughly understand whatever it is I have to photograph. Without such understanding, which occasionally becomes so intensified that it amounts to a real feeling and even love for the subject of the story, I don't believe that anyone can produce significant and meaningful photographs. At least I know I can't.

In most planned picture stories there will be a local contact—often a newspaperman who has the part-time job of working as a stringer for the photographers' magazine or publisher, a public relations man, publicity man, or a man from the local Chamber of Commerce. Such a contact, who is thoroughly familiar with the local setup and conditions and usually knows everyone connected with the planned story, can be an invaluable help if the photographer knows how to handle him—how to get his help without letting him run the show. Whenever such a contact is available, my first move is to get in touch with him and to discuss the job on hand. Usually, such a discussion gives me valuable pointers on how to plan and approach my work and frequently leads, in the light of new facts, to a revision of the shooting script which will make the story more accurate and true to life.

Out on location, I don't even unpack my equipment until I have had a chance to go over the place which I have to photograph and an opportunity to talk to the people with whom I have to work. In the case of an assignment involving an extensive setup—for example, a big industrial story—I sometimes spend as much as an entire day orienting myself in this way, looking for particularly photogenic picture possibilities, talking to foremen and

department heads, making notes on the people with whom I have to work, and writing down whatever strikes me as useful and interesting for the story. I know from experience that a day thus spent will save me much more time later, time which otherwise might be wasted in planless search and needless picture duplication.

The essence of many picture stories is action. However, in most cases the people we have to photograph are not actors. No matter how willing and cooperative they may be, when confronted with a camera they become self-conscious and suddenly cannot do a job which they have done a thousand times before without appearing clumsy. The whole success of a picture story often depends upon the photographer's ability to overcome this camera-shyness of his subjects. This he can do in two ways: one is to patiently rehearse a scene or operation again and again until those involved become used to the presence of the camera and begin to act naturally; as a matter of fact, it is often possible to shoot the picture *during* one such rehearsal when the subject does not expect a picture to be taken—a surprise move which frequently pays off with a picture that appears highly natural. The other and even better though rarer way of getting natural pictures is to work quickly and take the photograph *before* the subject has had time to become self-conscious and freeze. This method is particularly successful in instances in which available light is used and the photographer shoots candidly.

Both self-assurance and nervousness are catching. A photographer who knows his business, quickly sets up his camera and lights in a self-assured, matter-of-fact manner, and knows what he wants automatically makes his subjects feel at ease. Contrariwise, a nervous and indecisive photographer—who tries his lights first here then there, trips over his wires, tells his subjects to do one thing after another without liking anything they do, and, being unable to make up his mind, finally shoots in desperation just to get through with it—of course makes everyone nervous and will never get pictures which appear natural.

**284**

Photographers who shoot people in the act of doing something which is familiar to them must remember that those people know what they are doing as well as he knows his own job. If space conditions or pictorial requirements make it necessary to change this routine, he should never ask his subjects to do something in an unworkmanlike way; for example, to hold a tool the wrong way merely to better show an operation. Although pictorially clearer, such a picture would appear absurd to anyone familiar with such an operation and would reflect unfavorably upon the man who made it and the magazine for which he works. To avoid such embarrassment, whenever a change is unavoidable, I—the layman—first discuss it with my subject—the expert—and follow his advice.

While on location, a photographer should at all times observe not only the things which *immediately* concern him, but everything in sight for many reasons: to detect in time and avoid anything undesirable which might mar the effectiveness, accuracy, and documentary value of his pictures. For example, in the performance of many industrial operations the use of certain safety devices is mandatory. However, because an operation may be easier to perform without using these devices (such as goggles or safety guards on machinery), workmen frequently dispense with them. Pictures which document such a lack of elementary safety precautions would be bad publicity for the plant (officials will not knowingly release them), get the respective worker into trouble with his boss, and reflect unfavorably upon the magazine that prints them (readers have an uncanny ability for spotting mistakes and take great delight in writing letters to the editor). To avoid such errors, whenever I am not thoroughly familiar with what I have to shoot, I make it a rule to get an expert to look it over and okay it before I take the shot. In other cases, the background may be unsuitable, cluttered, containing things which have no business there, or distracting in other ways. If a photographer is engrossed in what takes place immediately in front of his lens he may forget to give the proper attention to the background and not discover its unsuitability until it becomes apparent in the contact print.

However, discoveries don't always have to be of an unpleasant nature.

Often, the opposite is the case, and the alert photographer discovers something beautiful: an unexpected chance effect of light which later makes a full-page picture; a shot which in symbolic form suggests the essence of the entire story and later is used as the lead. Those are things not listed in the script: "lucky accidents" which can raise the entire level of a picture story—bonuses for those who are alert.

The order in which a photographer takes his shots depends upon many things. However, I have generally found it profitable to progress from the whole to the detail: I begin by taking the overall pictures and end by taking the close-ups. In this way, I get an overall view (literally as well as figuratively speaking) of my assignment at the beginning of the story when I need it most and avoid getting bogged down in details when it is still too early for me to see exactly where and how details would fit into the story. I have frequently found it advantageous to take a number of overall shots simply for purposes of orientation—to give the editor and writer the general lay of the land—realizing that these pictures will probably not be used in the story itself. I find this practice particularly useful in cases in which the script is at variance with actual conditions on location.

Most people who watch a professional photographer at work express astonishment at the great number of exposures which he takes. "After all, he is supposed to be an expert; why does he have to waste so much film?" is a question often asked. The answer is simple: Precisely because he is an expert, he takes many seemingly identical shots so that he will be sure to get what he wants in technical perfection (which usually is no problem) and in naturalness of pose and expression. He knows that the cost of a few wasted sheets of film is negligible in comparison to the total cost of the assignment, all of which might be wasted if he fails to take that one extra exposure which sometimes "makes" a story.

Even under the simplest technical conditions, I shoot not less than two identical exposures of each different setup whenever possible. I do so because, even though there may not be the slightest doubt of the correctness of the exposure or the reliability of the equipment, the threat of

accidental damage or loss is always present. Something might happen to the film in the darkroom, or the negative which we can least afford to lose may unfortunately be mislaid (a very large part of my work is done on sheet film). Though such losses are rare, we can ill afford them, especially since we as experts are supposed to be prepared for such mishaps. The best insurance is to duplicate each shot, separate the two sets of negatives as soon as they come from the darkroom, file one in the customary way for immediate and future use, and keep the other elsewhere as a reserve in case of emergency.

Under more difficult technical conditions, common sense alone compels us to shoot several negatives with slightly different exposures to be sure that at least one negative will be perfect. Under such circumstances, working with black-and-white film, I take one shot in accordance with the properly interpreted exposure meter reading, a second with the lens opened by two stops, and a third with the lens closed down one and a half stops. When shooting color, I "bracket" my shots by half-stop intervals.

However, sometimes conditions are such that this is inadequate. Then it is necessary to take a series of shots at different exposures. For instance, when subject contrast is so great that it exceeds the contrast range of the film, it is impossible to produce a technically perfect negative. A compromise must then be made between overexposing the brightest areas and underexposing the darkest areas of the subject. All other recommended and more scientific methods to the contrary, the simplest solution is to take a sufficient number of different exposures, develop the films, and choose the negative or transparency that produces the most satisfactory print.

In other instances, intensity of the illumination may be too low to permit taking a meter reading. Then, the simplest way to get good pictures is to shoot a series of different exposures around a value which experience and feeling suggest as right. Such a "waste" of film is a necessary expenditure. The *real* waste would be in attempting to save by exposing one sheet or frame of film too few.

Anyone who has ever taken photographs of people knows what an enor-

mous difference a fraction of a second can make in spontaneity of expression. At one moment, a smile is genuine and natural; at the next, it is frozen and stiff. A photographer who wants to capture spontaneous expressions must be prepared to waste a great amount of film.

In still other instances, a certain waste of film is unavoidable because a photographer cannot risk missing the peak of an action or the height of an emotional drama. However, not until it is too late for anything but regret can he be sure *when* this important moment will occur. In order not to miss it, he must start shooting early. He sees what he believes will make a good picture and takes it. A short time later he sees something which appears even better. Naturally, he takes another shot, realizing that the previous one is now obsolete. A moment passes, tension rises, necessitating another shot which is better yet than all those previously taken. And so on, until, somewhere in the series, he has that one drama-packed picture he was after, the shot for the sake of which he may have had to sacrifice half a dozen rolls of film.

Provided it is done with deliberation, shooting plenty of exposures is far from amateurish. It characterizes the experienced photographer. I know there are professional "one-shot artists" who boast of the fact that they never make more than one exposure. But, in my opinion, they display more bravado than sense. It is only a matter of time until they find themselves without a picture—and most likely without a job. The fact that even experienced professionals have to experiment occasionally when on assignment ought to give amateurs food for thought. It indicates that two factors in addition to knowledge and equipment are needed to make good pictures: hard work and a touch of luck.

All throughout the shooting, the photographer (or his assistant) must take notes so that later his pictures can be properly identified and captioned. These notes must be keyed to the films in such a way that there is no possible chance for mix-ups and mistakes, even if (as frequently is the case) some person other than the photographer himself develops the films and edits the negatives for printing. In particular, he should note: the names of the

288

persons photographed (if several appear in one shot, each must be properly identified); what they are doing (whenever necessary, notes should be made on the correct technical terms for the depicted operations, tools, etc.); where and when the picture was made. In addition, he should take notes on anything that has a bearing on his story, that strikes him as unusual, unexpected, or in any way interesting, and that might later be used by the writer in captioning the pictures. Finally, he should get a *signed release* from every person who can be identified when seen in his photographs.

## Finishing the Picture Story

Two basically different approaches to picture story organization exist: the literary and the pictorial approach. Editors favoring the literary approach use pictures to illustrate word images, whereas editors employing the pictorial approach interpret the subject or event primarily through use of pictures.

In a literary layout, the value of a photograph is determined solely in accordance with its editorial content, as a supplement to the text which it illustrates. In other words, a photograph which directly illustrates an editorial point—no matter how unphotogenic the subject or how dull the picture—is preferred to a pictorially exciting photograph which is related to the editorial point only through association. This is a strictly utilitarian approach, characterized by layouts consisting usually of many small (instead of a few large) pictures which painstakingly illustrate each step and point of a story. In my opinion, because of its lack of sweep and beauty as well as its implied underestimation of the intelligence of the average viewer, this is an approach which should be reserved for how-to-do-it stories and comic strips.

In contrast, the pictorial approach places the graphic and visual values and the emotional impact of the picture first. Any photograph which is beautiful,

interesting, or pictorially exciting—as long as it is related through association to the editorial content of the story, depicting the subject in symbolic-suggestive form and inducing a desired mood in the mind of the reader—is accepted as a valuable contribution to the picture story. Necessary information which it fails to convey is then given in the accompanying caption. Picture stories organized in accordance with this type of approach are characterized by relatively few, carefully selected photographs displayed in impressive sizes.

Whereas the size of the finished story in terms of pages is a matter of editorial judgment, the form in which it is organized within the space allotted is determined by the layout man. He works according to the following principles.

The main difference between a single photograph and a picture story is the time element. A single photograph can be taken in at a glance, at one time; to take in a picture story, one has to turn the pages of the magazine or book, look at each spread, and progress through the story in *time*. This time element, in conjunction with the fact that the reader cannot see all the components of the picture story simultaneously, are the most valuable and effective means which the layout man has at his disposal to make a picture story interesting and alive.

The time element enables the layout man to do two things: to surprise the reader and thus keep his interest alive by changing the pace of the story from one spread to the next; to develop a story theme in *time* by giving it continuity and flow through logical arrangement of its components—as logical and inevitable as the order inherent in a good novel or a symphony.

To discuss the details of layout organization and caption writing is outside the scope of this book. However, readers who wish to organize their own picture stories should consider the following points.

A picture story is a self-contained unit consisting of *many parts, all of which must fit together* in order to produce the desired overall effect. Conse-

quently, photographs going into a picture story must be evaluated not only in accordance with their individual merit but also in regard to the way in which they relate to the other pictures of the story.

For example: Two photographs, each an excellent picture in its own right, may "kill each other" if shown together—either because they are too similar (and hence duplicate one another), because they are too different (and hence don't fit together at all), or because for one reason or another they cancel each other. In such a case, distressing as it may be to the photographer, only one of the two can be used.

On the other hand, two photographs, shown together, may also enhance each other to such a degree that their combined effect is greater than the sum of their effects when displayed separately. This combined effect, which Wilson Hicks used to call the "third effect," can be the result of some similarity in the two pictures which, though actually unrelated in subject matter, through association creates a new meaning in the mind of the observer. It can be a graphic effect based upon the contrast between either a very light and a very dark picture or one containing a positive form which the other repeats in the negative. One picture may be an overall view which is complemented by the other which shows an important detail in the form of a close-up. Matching photographs so that they strengthen each other is one of the most important tasks of the layout man.

Most layout men begin their work by spreading out all the pictures of the story so they can see them together at one glance (if necessary, on the floor). Then, they arrange them in logical sequence in accordance with the development of the story in time and space. Since there are always more pictures than can possibly be used, the next step is to eliminate those which are pictorially and editorially inferior as well as those which merely duplicate others. At this point, when he sees some of his favorite pictures thrown out, the heart of the photographer usually starts to sink—one reason why very few photographers are capable of laying out their own stories. They simply cannot part with certain pictures (particularly those which were difficult to make) forgetting that the fact that a photograph

caused them a lot of trouble does not necessarily make it an interesting picture.

By this time, the story has been pared down to a more manageable size and the next step is to pick out the most beautiful and interesting photographs—those which should definitely go into the layout. Among these pictures will be the lead picture, the closer, and those which deserve to be shown in particularly large size. These pictures comprise the highlights of the story, the skeleton that now has to be filled out with the more average type of supporting photograph.

When assigning the finally selected pictures to their space on the pages of the publication, the layout man or designer considers the following.

Some photographs, because of their compositional direction, are natural right-hand pictures, whereas others look well only on a left-hand page. For example, a portrait in left profile—eyes looking toward the left—has an inherent direction toward the left, the direction of the gaze. This fact will probably make it a right-hand page picture, since the direction of a photograph should normally be toward the middle of the magazine or book (the *gutter*).

A right-hand picture on a right-hand page and a left-hand picture on a left-hand page, facing each other, appear to belong together. On the other hand, if pictures on facing pages must be pictorially separated because they do *not* belong together, the right-hand picture must be placed on the left-hand page and the left-hand picture on the right-hand page. In this way the pictures, so to speak, turn their backs to one another and appear unrelated.

Pictures that are displayed together in the same sizes appear to have equal value. This is desirable in a step-by-step sequence of the how-to-do-it type. On the other hand, if one picture is considered more important than the others, to bring out this importance in graphic form the photograph must be displayed in larger size than the rest.

The proportions of a print are not unalterable. Frequently, through im-

**292**

aginative cropping, the effect of a picture can be vastly improved —particularly if the picture is shown in combination with others on a spread. For example, a very low, striplike picture printed across a double page can hold the whole spread together, although it might appear too low and long if seen separately.

Some types of subjects, in order to be pictorially effective, must be displayed in a size larger than others. For example, it would be a waste to show a sweeping overall view in quarter-page size or smaller, for too much detail would be lost. As a rule, the bigger the subject in actuality, the larger the size in which it should be displayed. This also applies to close-ups in more than natural size. These appear better, the larger they are displayed. Shown in large size, their characteristics appear most effective through surprise—the shock of clearly seeing something which normally is too small to be perceived. If reduced too much in the reproduction, the close-up effect is negated and the photographer might just as well have taken the subject from further away.

Maximum importance is indicated, and maximum effect achieved, if the picture is shown as a full-page *bleed*, i.e., with no white margins around its edges, the picture filling the entire space of the page.

Captions, text blocks, headlines, and subheads have a double function: to give the reader facts which supplement the pictures editorially; to serve graphically as elements of composition—as darkness, space, and form —accents which contribute to the compositional organization of the page.

## SUMMING UP AND CONCLUSIONS

Cameras, lenses, filters, lamps, all are the tools of our craft. Without them, we could not shape our raw materials which are light and shadow, color, contrast, motion, depth and space. We may think that the things from which we create our pictures are people, objects, and events—and in a sense, this is true. But in the last analysis, what makes our pictures successful is the way we handle the black and white and shades of gray (resulting from the interaction of light and film),

the color, the contrast, the shadows (without which our subjects would look two-dimensional), and the motion-symbolizing blur (which gives our photographs action and life). In short, we create our pictures from our *knowledge* and *control* of our craft.

Many photographers, deceived by the ease with which "recognizable" pictures can be made, accept unthinkingly whatever comes their way, forfeiting their right to self-determination in regard to their work. It is for them that I have written this book. I hope that it will open their eyes to the wide range of controls that can be theirs for the taking, controls which doubtlessly could help them raise the standard of their work, helping them to transform knowledge into performance. But the application of photo-technical knowledge—the WHAT of photography—will always be up to the individual. Presumptious indeed would it be for me to tell the reader what to photograph. This decision is an intensely personal affair which can be resolved only by the photographer himself. How to make use of what I have to offer is up to the reader.

## Suggested supplementary reading

I wrote *The Creative Photographer* assuming that the reader is familiar with standard photographic procedures. However, readers who wish to inform themselves more thoroughly about specific photographic problems can probably find the answer in one of the books by this author listed below.

Specifically, for information on general photographic practices, both black-and-white and color, I recommend:

**The Complete Photographer** (Prentice-Hall, Inc., 344 pages, including 32 pages of illustrations of which 16 are in color). This book offers a complete home study course in the techniques and art of photography. It is divided into nine parts: The Purpose of Photography, The Nature of Photography, Seeing in Terms of Photography, Tools and Materials, How to Take a Photograph, How to Develop and Print, The Symbols of Photography, Scope and Limitations of Photography, How to Make Good Photographs.

For problems related solely to black-and-white photography, I suggest the reader consult the following texts:

**Successful Photography** (Prentice-Hall, Inc.; second, completely revised and updated edition), a book that has been a standard text for over twenty years during which time it went through eighteen printings. It was written specifically for the beginner and contains everything he needs to know to become a competent and confident black-and-white photographer —information that starts with the fundamentals pertaining to camera, lens, film, darkroom installation and operation, film development, contact printing, and enlarging; then goes on to teach the student how to take good pictures in terms of sharpness, contrast, and exposure; provides him with basic concepts and rules of photo-chemistry, and ends with such "advanced" chapters as *Learning from Mistakes, Learning from Experience,* and *How to Use Photography*.

**Darkroom Techniques,** Vols. I and II (Prentice-Hall, Inc., Amphoto, 144, 160 pages). These heavily illustrated volumes deal with the entire complex of darkroom work—organization, installation, and operation of both

temporary and permanent darkrooms; equipment and material for black-and-white processing; contact printing and enlarging; the principles of basic and advanced print control; and basic photo-chemistry.

For problems related exclusively to color photography, I suggest the reader consult one of the following texts:

**Basic Color Photography** (Prentice-Hall, Inc., Amphoto, 128 pages). This modern little guide, illustrated with 98 photographs in color and 53 in black-and-white, 20 line drawings, and 5 tables, is probably the most concentrated source of information on color photography available today. It was specifically compiled for the beginner.

**The Color Photo Book** (Prentice-Hall, Inc., 408 pages). This book, which has been called "The bible of the serious color photographer," illustrated with 82 color photographs, 25 line drawings, 18 tables, and containing 7 handy formulas, covers every phase of color photography from the selection of the most suitable camera, lens, and film; characteristics of equipment and material, and the operational techniques of color photography, to discussions of some of the most advanced aspects of the medium.

If the desired information concerns negative or print control, it can probably be found in:

**Total Picture Control** (Amphoto, 356 pages). This book is unique insofar as it has a picture section consisting of 271 pages of photographs (16 pages in color), which illustrates every imaginable photographic control in regard to sharpness, unsharpness, diffusion, and blur; light, shadow, reflections, and glare; contrast; color; depth and space; motion rendition, and timing. It is divided into five major parts: The Purpose of Photography; The Extent of Photographic Control; Control in Regard to Subject Selection; Control in Regard to Subject Approach; and Control in Regard to Subject Rendition.

And if the reader would like to know more about the pictorial and esthetic aspects of photography, the following three volumes should be of interest to him:

**Principles of Composition in Photography** (Amphoto, 136 pages). Illustrated with 142 photographs in black-and-white and color, it presents

an attempt at clarifying the confusion surrounding the concept of "composition" by discussing, in five major chapters, the *Purpose, Nature, Principles, Elements* and *Forms* of photographic composition.

**Photographic Seeing** (Prentice-Hall, Inc., 184 pages). Illustrated with 50 pages of black-and-white and 16 pages of color photographs, this book teaches the student to see reality in terms of the camera—an ability which the author believes to be the key to good photography. Readers who doubt this statement are reminded of the fact that not every photograph of a beautiful subject is a beautiful and satisfying picture.

**The Perfect Photograph** (Amphoto, 176 pages). This book represents an attempt at analyzing and clarifying those fundamental qualities which make a photograph "good," whether the subject is a person, a landscape, a still life, an event; whether the picture is a documentary report, a scientific illustration, or the work of a creative photographer trying to express his feelings. It is the culminating work by this author, which tells the reader how to make the most out of his laboriously acquired photographic knowledge and skills.

# Index

**299**

**300**

**302**